THIRTY DAYS

THIRTY DAYS

Tony Blair and the
Test of History

PETER STOTHARD

HarperCollins*Publishers*

HarperCollins books may be purchased for educational, business, or sales promotional use. For information, please write: Special Markets Department, HarperCollins Publishers Inc., 10 East 53rd Street, New York, NY 10022.

First published in the Great Britain in 2003
by HarperCollins Publishers.

FIRST EDITION

All photographs by Nick Danziger
(nbpictures.com/Contact Press Images)

Printed on acid-free paper

Library of Congress Cataloging-in-Publication Data is available upon request.

ISBN 0-06-058261-8

03 04 05 06 07 ❖/RRD 10 9 8 7 6 5 4 3 2 1

For Sally

BEFORE

'This is your fiftieth birthday present, Prime Minister,' says Strategy Director Alastair Campbell as Tony Blair comes in through the Downing Street front door. 'Peter Stothard is going to follow you everywhere you go for fifty days.'

The recipient of this gift looks as though almost anything would be better than having a writer at his side as he enters the most difficult days of his political life.

Campbell concedes with a wolfish grin, 'Well, a month then. Thirty days.'

Tony Blair sighs. He had agreed a few weeks ago for a writer from *The Times Magazine* to be with him on the path to war with Iraq. These were extraordinary days. His fiftieth birthday was coming up soon. It had seemed like a good idea.

Like many good resolutions it does not seem so attractive now that it is time to put it into practice. Little is going right. He does not even know that he has thirty days left behind the black door of Number Ten.

Politicians do sometimes take the risk of inviting a journalist in 'to see them as they really are'. This is only either when they need the publicity or when they have a high degree of control. But no Prime Minister, however confident, has ever before taken that risk.

Tony Blair decides to stick with his decision. He will have a closely observed record of his leadership in the war against

Saddam Hussein. He does not know what the record will be. His 'fly on the wall' will be a former editor of *The Times* who supported his programme to become leader of the Labour Party in 1994 but did not support him in the 1997 election which brought him to power.

To have me with him for thirty days will not be like having a total stranger in the corner of the room. But neither will he have a lifelong political supporter with him, or even one who shares many of his views.

6 March 2003, the day Tony Blair invited his chronicler through the door, was no better than any other day at this time. Britain had become an angry country. Millions of voters, particularly young voters who five years before had hailed his 'Cool Britannia', were enraged that a Labour Prime Minister, a New Labour Prime Minister, the first Labour Prime Minister since 1979, seemed about to send bombers to the civilians of Baghdad.

Worse even than bombing Iraqis who had 'never done the British any harm' was bombing them at the behest of a 'Daddy's Boy' American President. Britain, they shouted, should just let George Bush get on with fighting his father's old enemy, Saddam Hussein.

Those who knew a bit of history recalled that another Labour Prime Minister, Harold Wilson in the 1960s, kept Britain out of America's Vietnam nightmare. Why couldn't Tony Blair do the same?

The protesters knew that they had allies at the highest levels of the Labour government. Clare Short was a respected figure of the old Labour left. She had an official position in the Cabinet as International Development Secretary, and an unofficial position as the 'conscience of the party'. She was said to be enraged at what was about to be done 'in her name'.

The 'Not in my Name' slogan was on banners and T-shirts from Bristol to Dundee. A million people had marched in London. The Italians and the Spanish were marching. They too had leaders who backed George Bush when their voters did not.

Tony Blair's first words in the Number Ten front hall were a complaint about how he could not get his message across. I doubt if I sounded very sympathetic. Politicians forever complain to editors that they are prevented by unseen powers, never themselves, from 'getting their message across'.

Inside the building there was a rush of people on the move. We were about to go to Chile, whose President was suddenly a pivotal player in the attempts to swing the United Nations squarely behind the war.

I went back home for my passport, told the magazine that I would take the 'fiftieth birthday' assignment, and barely left Tony Blair's home, office, advisers, officials and political life for the next month. In those thirty days he faced the most hostile attacks from his voters, his supporters and his party. He faced fierce opposition in Europe and he forged a controversial partnership with a President of the United States who seemed at first so unlike him in so many ways. He saw a personal and a political challenge ahead, and seized them both. A man who was once known as consensual, accommodating, even insecure at times, behaved as a man possessed of certainty. He used occasionally to talk about history with journalists. Now he had just given a newspaper interview in which he said that history would be his judge.

Events fell one upon the other with tumultuous speed. The fiftieth birthday was scarcely mentioned ever again. We never went to Chile. We did sit together while the Prime Minister 'worked the phones' with other leaders, spoke to envoys from around the world, was taken for buggy rides by George Bush at Camp David

and repaid the hospitality, according to the strange ways of modern diplomacy, at a castle in Belfast.

We were together in Parliament as he prepared for the debate which nearly cost him his job – and also when he weighed his responsibility for those who, as a result, had lost their lives. For thirty days I was close by him at historic events – in the places where writers never are.

Monday, 10 March

Morning headlines…Minister threatens resignation from Blair
Cabinet…Iraq attacks 'fascist' USA…French Foreign Minister
flies to woo African Security Council members…

'So they are all against me, is that it?' Tony Blair is sitting back on a swivel chair in his 'den' with his finger on a list of names. Around him is his 'team', squashed on the sofas, leaning against the table, hungry-eyed on the silver fruit bowl, perching uncomfortably against a window into the Downing Street garden. An honest answer would be: 'Yes, Prime Minister.' Alastair Campbell does not say anything. The Director of Communications and Strategy does not need to.

Tony Blair knows already. He has asked Independent Television for an opportunity to counter the fears of women opposed to war, women like those who are today shouting outside his house that he is a traitor to the Labour cause, a killer of children and about to be a war criminal. He calls it his 'masochism strategy'.

The 'all against me' question is no sign of paranoia. Virtually everyone who wants to speak to him this week is against him. The leaders of France and Germany, the leader of the House of Commons, the leading figures in the trade unions, about half his own MPs, including Cabinet Minister Clare Short, all oppose a war on Saddam Hussein.

The paper in front of him now, propped up on his desk between a banana and a picture of his three-year-old son Leo, is part of the challenge he has set himself to change minds. It lists the names and life stories of the women chosen for the television 'war special' tonight. If they were not 'all against' him, they would not be there.

'There seems a lot of military?' he queries.

'Yeah, some of them lost sons in the last Gulf War; they don't think we should have to be doing the same job again,' says Campbell baldly. 'And some have got husbands in Kuwait now. They're worried that no one at home thinks the war is justified this time. They think that's your fault.'

Campbell is a man who dominates a lot of space. He is seated on the arm of the sofa, the seat closest to the Prime Minister, in front of the tall blue leather doors which lead to the Cabinet Room. He speaks slowly, with a slight drawl, looking down at his mobile phone for news.

'And there's a girl from Australia who lost her boyfriend in the Bali bomb, and a woman whose husband is a human shield at one of Saddam's power stations.'

The Prime Minister stares hard at the list, twisting it as though to find its weakest point. There is only the barest chance now that war can be avoided.

The vital need now, he says, is that everyone of good will, at home and abroad, keeps up the pressure on the Iraqi leader. He sounds humourless when he makes remarks like this. But he has a lot to be humourless about.

His International Development Secretary, Clare Short, has already left his 'good will' club. She has not only gone on the BBC and denounced his policy as 'reckless, reckless, reckless', an act which by normal rules in normal times should have put her out of her job; she even telephoned the BBC herself and asked for a platform from which to make her attack. She was not one of those

Ministers tricked by a clever question from an interviewer late at night. She decided what she wanted to say, that she was prepared to be sacked for saying it, and, with only the briefest advance warning to Campbell, had said it.

The advice of the team to its boss was that he should not give her the satisfaction of martyrdom. She expressed the worries of too many people outside. It would be too big a risk.

But the irritation inside Number Ten is about more than just another bit of 'Old Labour vs New Labour' feuding. Dissent on such a scale from the top of his own government is another diplomatic hindrance as well as a new political challenge to Tony Blair.

'And how is the programme going to deal with Clare?' he asks sharply.

'They're going to get her over with first,' whispers Campbell, as though the very name were a curse. 'But look at it this way,' he goes on. 'The bulletins are only going to want the stuff on her. So you can just keep the rest nice and general.'

Before facing the fray, Tony Blair faces the long mirror that fills the wall between the two windows onto his garden. It is hard to know what he sees. What his team sees is a man who is thinner-faced and darker-eyed than six months ago. What journalists see, and describe almost daily now, is a man under impossible pressure, whose skin colour testifies to sleepless nights and anxious days.

Officially, he has a cold, a virus 'that won't go away'. There is a make-up man outside waiting, whatever the cause of his troubles, to disguise their worst effects.

'It's all very well being a pacifist,' the Prime Minister says suddenly, still with his back to his team. 'But to be a pacifist after September 11, that's something different. It's all new now: terrible threat, terrorist weapons, terrorist states. That is what people here have to understand.'

For most of his political life Tony Blair has been trying to persuade believers in old ideas that they should embrace new ones. He has had great success. He has made an unelectable socialist party electable again. Clare Short has accused him not only of being 'reckless with his own future', but 'reckless with his place in history'.

The Prime Minister says that he is not concerned with his own future. Some of those around him believe that. Some worry about it. But his place in history? That is plainly important to him. He is gambling his secure place in the history of British politics for a place in the history of the world.

He returns to the list. 'How many anti-Americans?'

Campbell punches out a text-message on his phone in a manner suggesting that the answer is bloody obvious.

For the first time Jonathan Powell shows an interest. This boyish former Washington diplomat does not always seem as dominant as Campbell or as personally close to the Prime Minister as the blunt Political Director, Sally Morgan, currently propped against the front of the desk. But Powell is the Chief of Staff. Ten Downing Street is his domain. He does not want to talk about television programmes. He has United Nations problems, Chileans and Mexicans and a Security Council member in Africa whose leader is ill, can barely even be spoken to by telephone and may need a visit.

Tony Blair makes most diplomatic calls in this 'den'. It is a small office full of family photographs, like the consulting room of a successful doctor.

Civil servants do not recall a Prime Minister who has sat at a desk and 'worked the phones' so much. He has been obsessive in trying to persuade world leaders that they should back the United Nations' so-called 'Second Resolution' which authorises an automatic invasion of Iraq if Saddam Hussein does not disarm.

Whenever Tony Blair is firmly in control of a call, or is gently

keeping a friendship warm, he has his feet up on the desk. If he has his head hunched forward, he is making a case that his hearer does not want to hear. In the past few days he has been more hunched than not.

A Prime Minister is overheard and watched over most of the time. Powell's characteristic position is to be listening in from his desk outside, earpiece jammed to the side of his head, pushing against his curly black hair. He has to concentrate intently on every 'Hi, George' against the murmur of news from a flat-screen TV on the wall.

This is not yet time for an office sandpit and model tanks with flags. The prime and most pressing battlefield is still at the United Nations. The second battle is for public support, particularly from those groups who most hate what seems certain soon to happen. The third is for the support of Labour Members of Parliament.

In the mirror on the wall of the den the Prime Minister can see all the faces in the room. If there is a common feeling among his team apart from fatigue it is impatience. Nothing is going as planned. Tony Blair looks down at the fruit bowl, takes a green apple and chews it very slowly, as though obeying some half-remembered hints for health.

Campbell's pager buzzes. He glances down and announces that an anti-war Conservative has just resigned over his party's support for the government.

'In fact he hasn't just resigned. He decided to quit last Wednesday, but thought he'd keep back the news till a quieter day.' Everyone laughs. The tension is relaxed. It may not be the sharpest piece of political irony, but it is a joke that the team can share.

Mocking Conservatives is where most people here began; and opportunities at the moment are scarce. If the French or the Russians frustrate the efforts at the UN, and if Clare Short's cries inflame more Labour opposition, a victory in Parliament may be possible only with Opposition support. Tony Blair, for seven years

the toast of his party, could soon be 'toast' – or even 'history', as Americans use that word.

The first words from the make-up man confirm every immediate fear. 'I've just come from doing the women,' he says, putting down his transparent plastic eyeliner case and flapping the sweat off his short-sleeved black shirt. 'They're very angry. They've been stuck in the room for ages. The camera lights are on and they're very hot and...' – he pauses to deliver what is, in his view, by far the worst sign of Prime Ministerial danger – 'hardly any of them wear make-up.'

After Tony Blair's forehead has been powdered for the cameras and the most analysed facial lines in Britain have been hidden beneath kindly 'concealer', he clarifies a few last points. 'Shall I say anything about the UN timetable?' The den is suddenly filled with overlapping cries of 'wiggle room', 'full and immediate compliance' and 'dramatic change of mind by Saddam'.

'Am I frustrated by Clare Short's action, or distracted?' he asks. This is just to fill time till the three-minute stage call. The coming ordeal may be in the Foreign Office Map Room, a hundred yards across the street. But this is theatre now. Campbell and Co. are the producers, wishing they had a better audience, cursing modern television for seeing ranters and emoters as the only 'real people' but helpless to do much about it. The bums are already on the seats. The star has to perform.

The 'three minutes' extends longer than would be allowed in the West End, almost up to rock-star levels of lateness. The Prime Minister is still at his desk, not so much 'working the phones' as being worked by them. There are anxious calls now not just from the White House but from Labour politicians, all of a seniority requiring a Prime Ministerial chat, all wanting to know 'what Clare (and he) are bloody well up to'.

Clare Short today represents the fear and rage of many in the

Prime Minister's party who oppose war. She has also found new friends among marching voters who would not normally have the slightest sympathy with the Labour Party's 'conscience' at all.

When Tony Blair has dealt with his last panicking colleague, his 'security column' eventually assembles in the hall behind the Number Ten Downing Street door. The decoration at this end is dull, almost domestic, by comparison with Cabinet Room and den. The black-and-white tiled floor is piled with refills for the fruit bowl, boxes of oranges, apples and bananas. This was originally the back entrance to the office, and it is still where the 'Sainsbury's To You' van comes.

The team goes ahead of its leader, ignoring shouts from reporters about his future. The Prime Minister is told to wait twenty seconds to let everyone else get out of his camera shot. The small patch of sky above is grey and cold. But by this stage he is reminded of the rising heat and sweat of his interrogators. He catches up quickly. 'The boss didn't want to wait,' says the detective apologetically as together they all stride up to the room.

The Prime Minister steps gingerly over clumps of black cable. The 'warm-up act', the studio manager, who has used up all her usual jokes for entertaining guests, retreats in relief. The star of the afternoon apologises and is immediately assailed from all sides by women who do not believe him, do not trust him, and will never vote for him again. He hears the sound dreaded by any performer anywhere, violent volleys of slow handclapping. Portraits of Wellington and Nelson look down for an hour on a sight that neither of those great British heroes would have seen as very pretty.

'No, it wasn't very pretty,' the inquest back in Downing Street agrees. The slow handclappers were a disgrace. Maybe ITV wouldn't broadcast that bit.

OK, so probably they would. But there were only four slow-

handers. And they were about as representative as a Socialist Workers' circus. The presenter couldn't control them. One woman was suspiciously expert on Yemen. Not even Nelson in his hero-of-the-Nile days could have handled the humidity. Had Blair thought when he first joined the Labour Party that he would end up sending B52s over Baghdad? What sort of question is that? And as for 'I married a human shield,' God help us.

Tony Blair seems the least bothered of anyone by the fiasco. At least no one will ever be able to say that he slunk in his bunker. He had to begin almost every answer with the phrase 'I know I am not going to change your mind, but…' He had a fresh powdering at each commercial break and would have benefited from more.

Why does he do it? That is what very few yet understand. This is not a place he would have been in five years ago. He would have hated the mockery and ridicule.

Ten years ago few of even his closest friends could imagine him in the place he is now. Tony Blair was not always the most certain of men. He had decent modern ideas for an almost dead party in Britain. He was persuasive and popular. He liked to persuade. He liked to be liked.

What has happened?

There are simple answers. He is taking the heat because he knows that he can. He has grown used to winning arguments, to winning elections, to defeating opposition in his party, to almost destroying his official Opposition in Parliament. He has discovered that he can absorb attack after attack and still be standing.

There are awkward answers. He is restless. He is realistic about how long political success ever lasts. He wants to get things done and get out. He does not want to look back later on missed chances to make his view of the world count. He is less patient than he was. A young fifty-year-old in a hurry? Rash? Reckless?

There are also the Christian beliefs that he shares not only with his family but with George Bush. These beliefs are powerfully held, sometimes publicly expressed, and appear to be an ever more important part of his life. They include a moral revulsion at how Saddam Hussein treats his own people. Religion in a British political leader makes everyone nervous. The team prefers not to talk about it.

Supporters and friends who remember the more diffident Tony Blair see a different Tony Blair today. Some love the 'Mark 2' version. Some hate it. Some have not yet noticed just how different it is.

Tony Blair won influence over George Bush with a gamble. He promised that British forces would be ready to fight alongside Americans against Saddam Hussein. He asked in return that the United States seek the maximum United Nations authority. It is not clear how precise the bargain was. But the gamble was made. Today it seems to be failing.

Limited United Nations support has been won. There has not been full support. The man who is accustomed to be a winner stands about to lose. He will be asked to make good on his pledge of troops without the UN backing he thought he could secure. He knows that George Bush will not wait long enough for the diplomats and persuaders to do everything that they want to do. This part of the battle is coming to an end.

He himself has recognised that reality but not yet fully faced it. He has not stopped being a persuader on TV and a diplomat on the telephone. He sees those arts as virtues in themselves. He may look like a long-distance runner, winding down in slow laps when the race is long over. He may seem like a once-famous actor, still working on a seaside pier. He will still keep arguing. He does not mind the rejection as much as he did. The 'masochism strategy' was well named.

Soon, however, he has to tear his mind away from unpersuadable voters and foreign leaders who have failed to live up to his hopes. He must move single-mindedly on to his own Members of Parliament. If he cannot persuade a majority of his own party, his promise of British troops will fall. He will be a young fifty-year-old looking for a new career earlier than he intended.

Back at the door to Number Ten, Campbell shrugs the TV mess away. The rest of the team returns to answer 'slow handclap' questions from the press and 'no UN support, no support from me' threats from Westminster. Tony Blair walks back to his den.

By the time he is 'on the phones' again, battering the ears of diplomats for signs of hope, the final bad news is filtering in from Paris. President Chirac, it is said, will commit himself on TV tonight to vetoing any Second Resolution that permits an automatic attack on Iraq. The UN game is as good as over.

The Prime Minister does not like to be angry, still less to show anger. But he is angry now. 'This is such a foolish thing to do at this moment in the world's history. The very people who should be strengthening the international institutions are undermining them and playing around.'

Why should Chileans or Africans take the risk of voting for war at the United Nations if France is going to ensure that their vote is never counted? This is 'irresponsible'. He goes upstairs to the flat to see Leo.

Having a young son in Number Ten is a help, he says. 'It keeps everything in proportion.' At the moment this seems a very heavy burden for a three-year-old to bear.

Other bits of Downing Street life do not stop. This evening the Blairs are hosts to 'special needs' teachers. By 6 p.m. the state dining rooms are thronged with educators of the word-blind, the

half-deaf and the behaviourally challenged. It is the first reception for them ever held here.

The Prime Minister barely mentions Iraq. 'Domestic delivery' must survive foreign demands, he insisted in an NHS reform meeting at breakfast today. He is drumming out the same message now. He denies fiercely that he has embraced the moral complexities of 'abroad' because he is bored now by the 'bog-standard' battles for better health and education at home.

'Special needs' turns out to be a field that is hardly less full of mines and feuding than the borders of Kuwait. Some party-goers want children with 'learning difficulties' to be educated separately; some want them to be taught in the same schools as other children; all want more government money; most think that government money would be better spent on their own project than on the project of the woman with the cheese straw across the room.

With his mind split between the fleshy bulk of the French President, broadcasting his veto now somewhere in Paris, and the tiny fragile interpreter for the deaf, to whom he offers the stool from which he has already begun to speak, Tony Blair gives an address which, as a man at the front says to his neighbour, has something for everyone without really giving anyone anything.

This man is a Labour supporter and a connoisseur of the Prime Minister's style. 'I don't know how he does it. If I were him, I'd be on Lomotol by now.'

Lomotol? Is that some new chemical cosh for the classroom?

'No, it's the stuff you take for diarrhoea. I'd be shitting myself right now if I were him. God knows how he sleeps at night.'

Tuesday, 11 March

Morning headlines…Chirac pledges to veto UN war resolution 'whatever the circumstances'…Russia ready to back French…UN begins withdrawal from demilitarised zone between Kuwait and Iraq…

Tonight Tony Blair goes to Buckingham Palace to see the Queen. He has to cancel Her Majesty's trip to Belgium next week. Or rather, to put it in the form preferred by protocol, Her Majesty has to postpone her visit to Belgium. This is considered 'sad for poor Louis Michel', President Chirac's sanctimonious supporter in the Belgian Foreign Ministry, but this is a sadness that the Blair team enjoys.

The Queen has had a good day up until now. She has held her first investiture for new Knights Bachelor, new Companions of the Bath and other Most Excellent Orders since twisting her knee earlier this year. While Blair's advisers worry that their domestic agenda is swamped by Iraq, the Queen's equerries are quite pleased that Saddam will take attention away from the imminent report into rape, corruption and general management chaos in the household of the Prince of Wales.

Behind the red ropes of the receiving lines, there are only a few signs of war. The head of armed forces' dentistry is here. He tells fellow recipients that while the Prime Minister works 'flat out' for the Second Resolution, his own units are working flat out to fill

soldiers' teeth before battle begins. Apparently, the urge for a pre-fight check-up is contagious when troops are hanging around with nothing much to do.

The Admiral in charge of naval supply is to be promoted in the Order of the Bath. He has a mildly distracted look.

Her Majesty's Ambassador to Mexico is here to receive the Most Distinguished Order of St Michael and St George. Mexico is a member of the United Nations Security Council. But the Ambassador, it seems, can be spared for a trip to the Palace.

So, for a few hours, can Britain's senior RAF man, the Deputy Chief of the Defence Staff Sir Anthony Bagnall, who is to be made a Knight Grand Cross in the Most Excellent Order of the British Empire. He is the first to receive his new sash and gong, and then waits while the Queen rewards more than a hundred other assorted policemen, hospital workers, a newspaperman, a pageant-master and a North Yorkshire folk dancer. The war cannot be quite here yet. Only a violin-maker eschews the approved grey 'morning dress' for the chance to advertise his profession on his tie.

When Tony Blair's green Daimler passes through the Palace gates tonight, he can tell the Queen all that he knows of when her forces are likely to be in action. She is the only person in the country to whom he can talk of war in the absolute certainty that the words will not be repeated outside, half understood, garbled, given 'off the record' to a friendly journalist and end up back at Downing Street in Alastair Campbell's in-tray.

Wednesday, 12 March

Morning headlines...Tony Blair faces first reports of challenge to his leadership...Washington wants UN vote 'this week'...thousands protest in Pakistan and Indonesia...

Behind the door with the combination lock that leads to the Blairs' Downing Street flat, the 'Questions' team is slowly assembling. It is 7.45 a.m. Sally Morgan is already upstairs with her boss in the cramped sitting room.

Jonathan Powell comes into the dark hallway, which has certificates of legal qualifications on the walls and Leo Blair's train set on the floor. The Chief of Staff likes to take precise diplomatic strides around his building, but this is not easy when track and carriages extend across the carpet as though some junior Vanderbilt were plotting his expansion to the American West. Campbell's loping journalist's gait is more suited to this terrain.

These are the three closest political advisers to the Prime Minister. There is always a low-level tension between them. Each has a different bit of the battle that demands priority.

Morgan, a Labour activist since her Liverpool schooldays twenty years ago, is now a Blair baroness. She sees the war through party eyes.

Powell, the organiser, learnt his politics watching Bill Clinton win elections. He sees through foreign eyes.

Campbell, former journalist and focused survivor of alco-

holism and mental breakdown, is the man Tony Blair depends on the most. He does many things, but he has the eyes of the media.

Others enter the hallway a few minutes later. There is no sign of Leo himself, but his mother, harassed and in a housecoat, calls down at random to the passing crowd, 'Tell Tony to call Jack McConnell by 8.15.' No one looks up. It seems an intrusion to be here at this time of the morning.

Cherie Blair says she doesn't mind living in someone else's office. Or that, at least, is what she normally says.

Back in 1983, when both wife and husband were struggling to find seats in Parliament, she might easily have won and he might easily have lost. She rarely shows signs of resenting that outcome, although others, on her behalf, often stress that hers is the more powerful brain and the steelier determination.

Both were then Christian socialists of independent mind. But Tony Blair had the more winning way with people and the better luck. Just before the 1983 election he found a refuge in the safe northern constituency of Sedgefield. From that point onwards, he could be a Labour Member of Parliament as long as he wished. His wife had to fight the difficult southern Conservative seat of Thanet North.

It is said that three Tonies gave Cherie Booth comfort when she fought her only election campaign in her own right twenty years ago. The first was her father, the then famous television actor Tony Booth. The second was the even more famous left-wing Labour MP Tony Benn, the man whose influence at that time ensured that a Labour Prime Minister could never take power. The third, both in fame and in effort then, was her husband, who is now in the Downing Street sitting room.

Cherie Booth was heavily beaten in Thanet. Since then she has been a lawyer and mother, and a political wife who has never taken easily to the role of politician's wife. She resists strongly having to

be on show all the time. She had little interest in how she looked until her husband's success made an interest essential. She has endured rather than enjoyed the demands that no sleeve, collar or cuff be out of place.

She makes no secret of being an evening person, not a morning one. Her first public appearance on the morning after the 1997 election victory was tousle-haired in a dressing-gown going out to collect a delivery of flowers at her Islington front doorstep. It was a bad welcome to the life of a Number Ten wife – though far from its worst moment.

This early-morning procession past her bedroom door has, however, become a custom on 'Questions to the Prime Minister' Wednesdays. She says she is simply used to it now. Today there are even more strangers than usual slinking by her, as quietly as they can, so that her husband can take his first briefing of the day before he goes down to his office.

The wife of Sir Anthony Eden, a former occupant of this house whose tenure was curtailed by a Middle East war, used to complain that she had the Suez Canal running through her drawing room. As she shouts her 'Don't forget' message down to anyone who will hear, Cherie Blair could be forgiven for seeing her own room as running fast too – with Washington's Potomac River, Iraq's Tigris and Euphrates, all sweeping along more than a dozen of her husband's staff.

Tony Blair sits stiffly on the end of the sofa nearest to the fireplace. He sips tea from a red mug with a lizard running down its side. He almost always drinks from a mug, even in meetings where others have china cups. It is a sign that he is at home and everyone else is not.

He has not had the easiest of nights. After returning from his ritual with the Queen he found that American Defense Secretary Donald Rumsfeld had written Britain out of America's war plans.

If the British government could not sort out its political problems, Rumsfeld had said, then too bad: Washington would go it alone.

Tony Blair did not see that as an opportunity, however much many of his supporters would like him to have done. He has strategic fears of the isolation of the United States if it 'goes it alone'. But he had personal objections too. To be stabbed by Britain's traditional French rival is one thing. To be kicked by his transatlantic ally, to be told that all his efforts to win a Second Resolution at the UN and a parliamentary majority at home is a waste of time: that is something else. It had taken two late calls to President Bush to establish that Secretary Rumsfeld was 'only trying to help'.

The Questions team has to wrestle, as it often does, with what the Prime Minister would like to say and what it is suitable for him to say. What he might like to tell the House of Commons is that the US President's Cabinet members are appointed, not elected, are not always skilled at calming American voters, still less British ones, and that Britain's place at America's side is solid and secure. But he has to be cautious, making it clear that his policy is unchanged, that the UN route is still being taken and that Parliament will be fully consulted if the time for war comes.

For meetings like this the Prime Minister calls in specialists in anticipating what both Opposition and backbench Labour MPs will ask. Only some of the questions are known in advance. These are on the list in the hands of David Hanson, a Welsh MP who is Tony Blair's Parliamentary Private Secretary, his official 'spy' in his own ranks. Hanson has the look of a young preacher and a shirt stained with leaks from 'bloody useless Downing Street pens'.

The Prime Minister says little himself. On Iraq he does not need briefing. He wants to know how his Conservative opponent is likely to act. Will he ask only half his permitted questions on Iraq,

where he has the temporary disadvantage of agreeing with the government? Or will he make every question about Iraq? What other issues are out there?

There follows a brief discussion of plans to curb anti-social behaviour in Britain. The press, he is told, is concentrating on proposed penalties against homeless beggars, which not everyone approves of, rather than schemes to punish graffiti-writers and car-burners, which are more universally popular. Tony Blair tries hard to seem interested.

At other times this would be the kind of political fine-tuning at which this team excels, sometimes excels too much. Today the 'spinners' take their cue from their leader. He takes another sip of tea from his mug and asks what is in the morning newspapers.

There is the report out tomorrow of the inquiry into sodomy and freebies below stairs at St James's Palace. The Number Ten Press Office is about to be briefed on its contents, but despite the fascination of the subject for all who are interested in the Prince of Wales, there is not expected to be much in it to occupy the political editors, the 'clients' of Downing Street.

There are also reports about a plot to detonate an al-Qaeda bomb, Bali-style, in a British nightclub. 'Mmmm,' is the Prime Minister's only response.

It is just before 8.15 a.m. now. Cherie Blair's message about Jack McConnell, Labour's First Minister in the Scottish Parliament, is passed on, but not immediately acted upon. Coffee arrives in white-and-gold Downing Street cups. 'Service first for those who have been here longest,' Morgan says, holding out her hand.

'What will I be asked about Clare Short?' the Prime Minister asks.

'Oh, it will just be stuff about Labour divisions. How the Tories dare talk about divisions, I just don't know,' Morgan replies briskly.

Tony Blair thinks that what he ought to be asked is: 'Why don't you just go in and get rid of Saddam now?' It would be harder for

him to give that question a fully honest answer. He sees almost no chance of a second UN resolution, but, for the sake of his own party's support if for no other reason, he has to clutch at the vanishing ideal.

A Private Secretary's next job is to make the single tabbed briefing file which the Prime Minister will take to the House of Commons just before noon. Tony Blair has suddenly lost an important bit of paper. He apologises. 'In all my myriad phone calls I must have misplaced it,' he says, his voice trailing away as the Foreign Secretary comes through the door. This meeting is not so much over as 'morphing' into the next.

Jack Straw has become Tony Blair's closest Cabinet ally. He is the Alastair Campbell of the politicians, more frank sometimes than the Prime Minister wants him to be, rumbustious, irreverent, a sharp-witted left-wing student leader who became a right-wing Home Secretary. As Foreign Secretary, he has just a hint of the 'Little Englander'.

This morning he has to brief the Prime Minister on the last echoes of the Rumsfeld intervention and the latest attempt to persuade the Chileans about the vanishing resolution. He has then to be briefed by Tony Blair on what to say to calm this morning's meeting of the Parliamentary Labour Party before the midday Questions begins.

The flat gradually empties. Down below, outside the den, the chairs are being put out on the balcony in case the Prime Minister wants to sit outside in the sun. There is shelter here from the sight of the 'Not in our Name' protesters, if not from their cries of 'Tony, Tony, Tony, out, out, out.' The view from here is over St James's Park, the one that the planners of the house intended its occupants to have. Downing Street is always one of the coldest, most windblown alleys in London, even on a brightening blue-skied day.

* * *

Walk through the door marked 'Number Ten', go straight ahead down the yellow-wallpapered corridor, avoid the recumbent Henry Moore statue, and you are in the red hall that leads to the Cabinet Room and the den. To the left is Sally Morgan's political office, decorated with the work of women artists in memory of the one time that Tony Blair freed her to do a job, as Minister for Women, that was not directly in his line of sight.

Morgan is a plain-speaking, plain-dressing, no-nonsense Liverpudlian whom the Prime Minister relies on heavily both for political intelligence and the personal kind. The experiment of setting her free did not last long.

To the right is the passage to the 'outer office', which has desks for the private secretaries and Duty Clerks. There is the TV and the three clocks, unchanged since the Cold War, set to Washington, London and Moscow times. Here sit the key-keepers for the red boxes, the men who make the phone-working work, and Jonathan Powell, the Chief of Staff who listens out and listens in.

If you are an Ambassador, if you are seeking diplomacy more than politics, you will go right immediately from the front hall, down a more institutional corridor to rooms behind a combination lock where Tony Blair's 'diplomatic knights' do their work.

In a fine half-circular Georgian room, one knight looks after Chirac and the Europeans. In another, with a huge maple-leaf window out towards Whitehall, sits the chief knight of this current battle, Sir David Manning, who has a slight figure and a fierce stare and cares for what is known here as 'the real world': reality includes America, North and South, the Middle East and Iraq.

Political advisers and press officers, party veterans and trusted young civil servants turn left after entering Number Ten, past the staircase to the Blair family's flat, past the dark lower rooms of the Chancellor of the Exchequer and on to Alastair Campbell's zone.

Here, in a set of large, dark-panelled rooms, the largest hung about with drying marathon kit, steaming trainers and posters of past campaigns, the business of public opinion is done.

There is much to do.

Next month Tony Blair is fifty. How is he planning to spend the day? 'At the Labour exchange,' says Campbell with his best four-miles-to-the-finishing-line grimace.

The London Marathon is still a month away. Campbell has never run the twenty-six-mile distance before, and is training as hard as political distractions allow. He has never had his boss in such a bad position before, either.

On the wall is a poster of Number Ten's last occupant, John Major, in the guise of 'Mr Weak', a reminder of one of Campbell's most vaunted coups. This poster could never have been put on billboards in the 1997 campaign; it was a clear abuse of the copyright owned by the creator of the 'Mister Men', children's best-sellers all over the world. But somehow the image found its way onto newspaper front pages regardless, and it has stayed on this wall ever since.

Tony Blair has not yet reached 'Mr Weak' status among his colleagues. But he is beginning to look as grey as John Major did.

The television on the newspaper-strewn table shows a few MPs, some of the more glamorous New Labour kind, cooing with admiration that Tony Blair 'has put his leadership on the line'. Campbell sighs.

The TV reporter has also found other MPs who want to use the Prime Minister's support for George Bush to make him greyer and weaker. 'Leadership isn't just Tony Blair, it's us as well,' says one Old Labour member. Campbell grunts and changes to a sports channel with theatrical contempt.

One group of MPs is rumoured to be planning a bid for a new leader, arguing that a Labour Prime Minister should not be 'a

threat to the institutions of world order'. Is that a real danger, or just a bombastic stunt? Campbell tries to assess the problem and the difference.

The Prime Minister has finished his briefings and has come downstairs. He walks all these corridors restlessly, back and forth along the three ground-floor axes of his home.

It is just after 9 a.m. A large white 'Délice de France' food van is parked opposite Horse Guards Parade. A man in a bowler hat, with furled umbrella, yellow carnation and a copy of *The Times*, swings his arms like a Guardsman as he walks towards the Foreign Office. This archetypal man of Whitehall stops at the sight of the words 'Délice de France' and gives them a hard stare, as though to a disobedient dog – or even to 'a cheap strutting tart', as another newspaper, not one he is likely to read, describes the President of France this morning. After a moment's pause, he moves on up past the Cabinet War Rooms of World War II and into Whitehall.

At the same time Tony Blair stops in the Cabinet Room. He looks onto the balcony as though he would much rather be outside than in, and begins the day's work.

By the front door, a schoolmasterly man in a salt-and-pepper tweed suit and breakfast-stained tie is wondering whether it is safe to go up to the flat. The regular Wednesday routine for the Prime Minister's team may be Question Time. For this man it is the day for winding the Downing Street clocks.

There is a grandfather in the Entrance Hall which the messengers tell visitors, 'quite wrongly', was stripped of its chiming parts by Churchill, who couldn't stand the noise. There is a 'nice piece' in the waiting room. It has an unusually loud tick. But the best one is the 'Vulliamy' in the flat, which he likes to wind when the family is out. He also has a good clockwork connoisseur's interest in the workings of Leo's train.

'Set it at five minutes to midnight,' says another waiting-room visitor, with a confident smile and the current cliché of how close the country is to war. The clock man looks slightly bemused. In five minutes he wants to be away from here, on to the next of the British government's antique timepieces and then to Buckingham Palace, where there are some 'very fine' examples and he will have 'elevenses' with a couple of friends.

At about 11.30 a.m. there is the sound of singing from the cleaners upstairs. The words are 'Good morning, Tony', to the tune that fans used to sing outside rock stars' hotels, and ending 'Oh, Tony, we love you.' This noise is accompanied by the sound of mops and brushes and a sharp supervisory retort: 'You mustn't call him that. He likes to be called Prime Minister.'

There is a moment's quiet, and then the 'Good morning, Tony' song begins again, just as the man himself almost runs along the corridor, holding a cup and saucer in front of him as though in an egg-and-spoon race. Immediately behind, and in exactly the same posture, is Alastair Campbell.

Tony Blair is not one who seems to mind too much what he is called. Some refer to him as 'TB', some as 'the boss', many as 'Tony'. The diplomatic knights call him 'Prime Minister', but the phrase 'Yes, Prime Minister' has been destroyed by television comedy, and is never used except as a joke.

For the next twenty minutes the Downing Street 'pagers' receive blow-by-blow messages from inside the Parliamentary Labour Party meeting about how Jack Straw is faring against the critics. By the time the Prime Ministerial motorcade is ready for the two-hundred-yard 'dash' to the Commons, the news is already seen as 'quite good'. There are 'lots of dismissals of a Special Conference', the mechanism necessary to change a Labour leader', and 'lots of rudeness about the French'.

At 11.40 a.m. the 'dash' has begun. After a blur of journalists' flashbulbs, protesters' flashbulbs, gates that are normally kept closed, mirrors in underground tunnels, Tony Blair and his Questions squad reassemble on foot among post-workers and sandwich-makers for the last walk up to the Prime Minister's Westminster office. Jack Straw is waiting outside, buoyed by the success of his 'anti-French' card. He holds out a page of *Le Monde* as a possible prop for his boss: 'It's the Napoleon route – and remember who won.'

Tony Blair checks his tabulated answers for a few minutes under the stern oil-painted eyes of Sir Walter Scott. He rejects the copy of *Le Monde*. The offending page falls down onto the pink carpet and stays there, propped against the golden gothic dragons on the wall.

Outside in David Hanson's office, which for these few minutes each week is like 'feed the animals day' at a zoo, there is a Junior Whips' convention. These are the ambitious young MPs whose routine job is to ensure that Labour MPs vote Labour. They want to catch the boss's eye with their imagination, devotion and skill.

They are swapping names about which doubters are likely to vote for the war ('He had a meeting with Cherie the other day which was very helpful') and which will definitely be against them ('He's a runner; you can tell it in his face'). There are fashion edicts: 'Never trust a man in a pinstripe suit if the white stripe is thicker than the blue one.' There is coded abuse: 'That man's a woodentop – and that's a Whips' Office technical term.'

The Americans are said to be abandoning their efforts at the UN. Is there a phone for calling the White House? The question is posed by Campbell, but is not answered. These secure phones are called 'Brents', and have operators who seem normally to be scrabbling on the floor for the right socket. There is not a 'Brent' here.

'Don't eat that,' Morgan tells the horde around her, pointing to a bruised and not very appetising banana. 'It's his lunch.'

The Prime Minister and his personal spy sweep out, and into the Chamber. There is just a minute to spare before the Speaker calls for the first Labour MP to question 'US pressure for precipitate action against Iraq'.

The Conservative leader Iain Duncan Smith asks all his questions about Iraq, but not the one which Tony Blair fears. He does ask about Donald Rumsfeld and Clare Short, as predicted. The noise from the Labour benches is not of loyal hoorahs; but there are no boos either. The big parliamentary day is not yet come. There are questions too about lost jobs in farming and lost education in Leicestershire, each of which gets a neat tabbed reply from the file.

Back in his room, Tony Blair begins his lunch, feet on the table, eyes on the whisky bottles and birthday cards which he signs for MPs at this time every week. Once every 'Best wishes, Tony' is done he turns to the letters to world leaders. The knights of Downing Street think that extra reassurance to large Islamic nations like Pakistan and Indonesia might be wise.

'Dear Pervez...' says the Prime Minister, as his pen glides along the top of a letter. 'I'm never quite sure what name to use to Muslims,' he says, looking up at his staff and down dubiously at his handiwork so far.

'"Dear General" normally goes down well,' says a voice from behind. Tony Blair keeps doggedly signing.

Campbell has some urgent pager messages. 'Who was the first black footballer to play for England?' he asks. The name of Viv Anderson is offered from the room outside.

'John Toshack,' says Morgan, not prepared to be left behind on a macho quiz afternoon.

'He wasn't black; he was Welsh,' says Campbell with scorn.

'There are lots of black Welsh people,' says Morgan, moving onto the safer territory of what is politically correct.

Tony Blair has finished his signings but not the blacker bits of his banana. He is to stay in the Commons till it is time for today's call from the den to President Bush at 3.15 p.m.

'Don't be late,' says Powell as the team returns to the people-carrier. The driver takes one of the more circuitous security-approved routes back to Downing Street, giving a tourist ride around a selection of London statues that are boarded up to protect them from anti-war protesters. 'I wonder where we're going to put the statue of Donald Rumsfeld,' jokes the cheery Chief of Staff.

In the evening Tony Blair is to have dinner with the German Chancellor Gerhard Schröder. To the relief of the team's junior members, whose lives are regularly tormented by instructions to find the finest Indian restaurant, the perfect country pub, the best riverside table at which Prime Minister and foreign guest can just 'drop in', the meal will be in Downing Street.

Now is not the time for long, relaxing public appearances. Tony Blair does not have his country with him. The German Chancellor, with votes in mind, has declared himself against the British and American stance. But British protesters might not know that.

First the two leaders visit the Royal Academy's exhibition of 'Masterpieces from Dresden', paintings by Canaletto, Dürer and Velasquez which survived both the British firebombing of 1945 and the flooding of the Elbe eight months ago. This gives Schröder a chance to make generalisations about the international message of art, the President of Saxony to praise Saxony, the sponsor to praise himself, and museum curators the opportunity to hope that the art treasures of Baghdad are equally successfully protected.

Tony and Cherie Blair stand together, holding hands, listening to the speeches and looking at Tiepolo's *Vision of St Anne*. When it is his turn to speak, he says that this is the best part of his day. No one doubts him.

Thursday, 13 March

Morning headlines…Tony Blair gives six tests for Saddam Hussein…Washington threatens Moscow with consequences of veto…Tony Blair denies that British place in war depends on new UN resolution…

'It's Cabinet time,' says a voice from the diplomatic knights' zone.

'Oh, yes,' comes the unenthusiastic response.

The arrival of some twenty-five men and women from various government departments, however regular on a Thursday morning, is not welcomed with joy at Number Ten. Cabinet days are like Christmas at a great country house, when all the relatives who think they own the place – who do in certain circumstances own the place – descend for their share of the inheritance. The master and his servants greet the guests cheerfully enough; they can hardly turn them away, but they are mightily pleased when they are gone.

If the Secretaries of State want to make a visible entrance (which mostly they do) they are driven up to the front door, get out of their car with just a slight turn of the head to see if a TV reporter might ask them a question, and go in past the policeman. It then takes just a few seconds to walk straight ahead, past the Henry Moore and three small paintings of rural scenes, and into the back hall where the early arrivals will already be drinking coffee.

Most of the decoration in this corridor is exactly what you

would expect in a prosperous house inhabited by people who do not care too much for art. But there is one stark picture, of a cottage freshly blasted as though by some clean, bright light. The roof is off and the walls are smashed, but none of the wood is charred. It is dated 1940, but there is no name-plate for its artist. Sometimes visitors give this painting more than a single look.

The shy, the about-to-be sacked or anyone who happens to be in the neighbouring office on Whitehall can enter from a side door, past the office of Jonathan Powell and the Duty Clerks. Gordon Brown, the second most powerful man in the country, comes to Cabinet from the other side, along the corridor from Number Eleven that he shares with Alastair Campbell, into the front hall, left turn and down to his colleagues.

The Chancellor of the Exchequer seems cheerful, almost jolly this morning. But no one here would make much of that. His relationship with Tony Blair is one of Downing Street's greatest mysteries. The team knows that today he will go out and talk to TV and radio and support the Prime Minister. How this was agreed they do not know.

Every day or so there is time blocked out in Tony Blair's detailed appointments diary with simply the initials 'GB'. What happens in these meetings, no one else knows. No one else is there when the Lord of the House and his disinherited brother plan what needs to be done on the estate.

The stability of the British government since 1997 has depended on a pact whose terms have never been revealed. Even its existence is not always admitted.

Before Labour's previous leader, John Smith, died in May 1994 there were two rising stars in the slowly changing party, two friends, Gordon Brown and Tony Blair. Brown was the senior, the more intellectual, the more passionate speaker; but he was a Scot,

and had a narrower appeal to the English Conservative voters whom Labour needed to attract.

Brown was persuaded not to stand for the leadership. But he did not give up his hopes of attaining it one day. He felt he had a deal whereby he would take the Treasury and run British domestic policy, which for the most part he has, and would succeed Tony Blair at some point in the future, not too far in the future – which so far he has not.

Every time there is political trouble, it is whispered by someone that Gordon Brown is behind it. It is whispered today that 'Gordon is behind what Clare is doing,' that 'Gordon did not exactly incite Clare to call Tony reckless, but hopes to benefit from it.' Even the team members most charitable to the ambitions of the Chancellor say only that 'He is biding his time.'

What is clear to everyone is that Clare Short, in penitent white scarf but not looking otherwise apologetic, is taking her coffee with her friend, the Chancellor of the Exchequer. There are eyes too on Brown's long-standing rival, the Leader of the House of Commons and former Foreign Secretary Robin Cook; the two have a mutual distrust stretching back to power struggles for territory in Scotland decades ago.

Brown is like a large planetary mass, attractive to satellites. Cook is a small, bare rock, sparking huge energy at high speeds but leaving less that is permanent behind. 'Robin looks shifty today, but then Robin always looks a bit shifty,' says a rare close friend of them both.

If Tony Blair falls, there will be winners and losers here. Gordon Brown still has the best chance of taking over the house which he thinks he has already in his grasp. But no Chancellor can escape blame when the voters begin to feel more taxed and less prosperous, as at the moment they do.

If Brown is careless, or is seen too clearly to have wielded the dagger, there are others. Alan Milburn, the smooth-faced, smooth-tongued Health Secretary, has been assiduous in condemning Clare Short.

What if Tony Blair wins the vote but the war is a catastrophe? Might a resignation from Robin Cook now win him power later?

Some of the Cabinet Ministers most fiercely in support of Tony Blair are those originally from the farthest left of the party. John Reid, Party Chairman, lapsed Glasgow Catholic and Communist, stumps around the hall as though looking for a head to stamp on. He sees Saddam Hussein through a prism of Scottish politics and Scottish football. He lets his leader concentrate on Iraq. His concentration is on the bad guys and back-alley chancers who are trying to chop his leader down. This wary teetotaller and gum-chewing giver-up of cigarettes is Tony Blair's top enforcer. He talks freely this morning to the only other claimant for that title, John Prescott, Deputy Prime Minister, long-time trade unionist and famous square-faced strangler of the English language.

Prescott found new fame during the 2001 election campaign by punching a protester in the face. Like a boxer who has proved himself and is gracefully approaching retirement, he looks a little less the pugilist now. He makes no claims to know whether the policy on Iraq will work, but every claim, quietly but forcefully expressed, that his Cabinet comrades should support it.

After an initial display of coffee-sipping amity, entertaining only for onlookers and junior family members, the Cabinet assembles around its traditional long table, each in an allotted place. Both inner and outer doors are shut. A messenger sits guard to ensure that none of the team outside, the people who really run this heart of government, makes too much noise.

* * *

In the waiting room to the left of the front door of Number Ten is a sallow, elderly man with a long lock of hair twisting down over his left eye. He has heavy gold rings on his fingers and is pointing at a report in the *Daily Mail* of the new 'final tests' which Britain and America have set Saddam. If the Iraqi leader is serious about obeying UN calls to disarm, let him show it by meeting these 'benchmarks', destroying his weapons and telling the world personally that he has done so.

The visitor does not seem impressed. He smiles, sits back, strokes his thigh, pushes back his skein of hair and waits. His eyes circle around the orchids on the table, the loud-ticking clock, a child's picture of food parcels falling by parachute and a set of large framed photographs illustrating the shipping forecast. 'Southwesterly veering Northwesterly 4 or 5': some Asian women are playing cricket on a beach. The man looks mildly mystified until he is rescued from his reverie by Sir David Manning, jacketless in pink shirt and light maroon tie.

'How nice to see you again,' says the diplomatic knight, recognising the Indonesian envoy from past encounters.

'The President sends you her best regards,' replies his visitor.

'Let's go up and talk,' says Tony Blair's man. It was Manning, writing at his round table under the maple-leaf window last Sunday, who devised the new 'benchmark tests' in order to keep the dying flame of diplomacy alive.

'Thank you,' says the representative of one of the many Muslim countries which are sceptical of British and American motives.

When the Cabinet Room doors open there is the sound of brittle laughter. Clare Short's presence, after she has broken the laws of collective responsibility, has unnerved them all. Tony Blair has taken a risk in keeping her here. If she can criticise his policies and keep her job, why should not others be emboldened to do the same?

The mood is one of nervous mockery.

'It was good of Clare to offer Tony that advice on getting the second UN resolution. He would never have thought of such a clever idea himself.'

'What is Robin suggesting? That the whole war would be illegal?'

'The French must not be forgiven for this.'

'When the Prime Minister said "Good Morning," who said "Bonjour"?'

There is general jollity but not much good will.

Clare Short herself, straight-backed, big-bodied, scarf trailing down, is also talking cheerfully. The subject is 'new jobs'. She suggests that 'We all soon may need one.' For the moment, though, the Cabinet is intact. The International Development Secretary has not been sacked and the Leader of the House of Commons has not resigned.

Tony Blair takes the back stairs next to his den, the main staircase in this back-to-front house, and goes up, past the photographs of his predecessors, past the place where his own photograph will one day be (at this point, who knows how soon?) and into the White Drawing Room to see the envoy of the Indonesian President.

The Prime Minister sits facing his guest across a low table, accepts the Indonesian's thanks for agreeing to see him at a 'difficult time', and, as he has been doing all morning, listens to worries.

'Ours is the largest Muslim country in the world. Now the moderates are in control. If war breaks out and lasts a long time it could be extremely difficult.'

Tony Blair nods.

'Is there anything that a third party can do? The non-aligned nations have had success before in convincing Baghdad. We have shown results.'

The nods turn to a polite but doubting gaze.

'Is there any way we moderate Muslim countries can talk to both sides? We agree that Baghdad must stick scrupulously to the first disarmament resolution, 1441.'

Tony Blair thanks him for that final bit of his message and says what he has just told his Cabinet. 'We are still pursuing every avenue. Everything is made much more difficult by France. It is only by the credible threat of force that Saddam has ever responded at all. We have set new tests. Anything that the Indonesians can do to get them through to Baghdad would be important.'

The envoy has done what he came for. He says he is going to Paris next. He wants to make sure that no signals are being misinterpreted.

The Prime Minister's tolerance of diplomatic language is reaching its limits. 'The bottom line has to be that a strong, united message to Baghdad from the rest of the world means peace. A weak message means war.'

Host and guest walk out into the upper hall. On one side of them is a huge painting of an empty cinema which bears an eerie resemblance to the front cover of the Labour-supporting *New Statesman* magazine this week. The cover, though not the item from the Government Art Collection, bears the slogan 'Blair Bombs'.

Downstairs in the Campbell zone, the news has arrived of one of Robin Cook's answers to routine Business Questions from MPs. There is to be a debate on war next week. 'Would the Cabinet share collective responsibility on a decision to go to war?' Cook was asked.

'Yes,' he replied. 'Collective responsibility will apply to all those who are in the Cabinet at the time of the debate.' Those last thirteen words are given careful and fearful thought.

Robin Cook did not like losing his job as Foreign Secretary to Jack Straw, but he bore the demotion to Leader of the House of

Commons with dignity. He has always been highly respected in Parliament. If he argues that the result of war will be a weakened UN, a collapse of moderate Muslim states from Indonesia to Saudi Arabia, more extremist places for terrorism to flourish, more dead Iraqis to enrage potential terrorists in Israel and elsewhere, he will be heard with more respect than many others mouthing the same views. The Leader of the House is pointing his way out – and may take others with him.

Tony Blair's sense of what war will bring is wholly different. He sees a UN which frees itself from helpless torpor, a lesson to extremist nations that terrorism will be met by massive force, a message to Palestinians and Israelis that America will not tolerate conditions of permanent instability.

Neither man knows whether he is right or not. Each knows what he thinks.

The Prime Minister stretches his arms above his head, doing light exercises against the blue leather backdrop of the Cabinet Room doors. 'It's all the broad sweep of history now,' he says to Campbell.

'The papers say you're in a lot of trouble,' his adviser, the one who is in genuine athletic training, replies.

'It will be tough,' says his boss, picking up a green apple and wiping it on a napkin. Before he takes a bite he gives the skin two more careful wipes, polishing away every last spot.

History seems to be much on his mind. Two weeks ago he told a newspaper that 'History will be my judge.' He was not only drawing comparisons between those who want to appease Saddam Hussein now and those who appeased Hitler in the 1930s. He was also, and rather more usefully for himself, drawing attention away from the many adverse judgements on him at the present time to future verdicts, all of which are unknown and some of which may be better.

Historians will one day consider whether Tony Blair is more like a wise Winston Churchill or a rash Anthony Eden, just as historians are filling pages of newsprint now with argument about whether Saddam Hussein is a Nazi or a Nasser, whether we are in 1939 or 1956. But for the moment, it is better to call on judges who may not yet be born than on those who are waiting for him in the House of Commons.

It means almost nothing to say that history will be Tony Blair's judge. But that does not make it a stupid thing to say. When Blair is safely retired, his decisions in these days will be analysed closely. Questions will be asked about his influence on George Bush and George Bush's influence on him. This is familiar territory for students of the transatlantic relationship.

Churchill, it is generally agreed, had many great virtues. But honesty about the 'perfect understanding' between him and Franklin Roosevelt was not one of them. He exaggerated it – to others and to himself.

Harold Macmillan had an Ambassador to Washington who was part of the Kennedy family. Macmillan had clear influence on the young President but did not, as he claimed, take part in, and share responsibility for, Kennedy's ultimatum to Moscow to remove its missile bases from Cuba.

Historians will examine Tony Blair and George Bush and judge them in the same light. Was the policy right? How much was it a British policy?

Tony Blair was both a political and a personal friend of the previous President, Bill Clinton, and had worked with him, publicly and privately, over many shared problems. Central to their understanding of the world and of each other was the task of persuading traditional left-wing activists and voters to support new, less collectivist policies.

These two men talked to each other for hours about the Third

Way – and bored others for hours about it too. They shared the same thoughts, and similar student experiences at Oxford University. They both had academic lawyer wives whose lives had not always been made better by their own.

How was it possible that Tony Blair could switch so quickly to a close relationship with George Bush, a Texan conservative with whom he shared almost nothing in his life and barely a single belief about how a country should be taxed and run? The only powerful belief they seemed to share was Christianity – and surely, at the beginning of the twenty-first century, religious beliefs were the most dangerous of all?

Was it true that the two men prayed together? Did George Bush genuinely believe that God guided his hand? Tony Blair did not go that far. He was a more traditional English Christian, High Anglican, almost Catholic. He was knowledgeable about Islam and sympathetic to its adherents. What did he and the President say to each other about their religious beliefs, and what difference did it make?

History will judge Tony Blair, whether he asks it to or not. Today the immediate task is to write a speech for the House of Commons debate. The Prime Minister may need the comfort of history for that. He needs to build the case for a new approach on the success of approaches in the past. He needs to make the most effective historical comparisons just as he needs to give his troops the best weapons. It hardly matters whether those comparisons are justified or not.

He is not calling history to be his judge in any other sense than as a practical preparation for war. Every other judgement is for a future which now seems far away.

Tony Blair continues his stretching exercises and his fruit lunch in the den until a note arrives from the Duty Clerk. The Polish Prime

Minister, Leszek Miller, is waiting on the phone. 'Here is a man with a good sense of history,' says a jovial voice from the outer office. 'Poles have not forgotten 1939. This one is a tough guy, a good guy and very anti-French.'

The Prime Minister leans back in his swivel chair. His friend from Warsaw, like his friend in Washington, is worried first about the House of Commons vote.

'Yes, it will be tough for me,' he says. 'I will take the case to Parliament and, hopefully, win it.'

Is the Second Resolution losing its life?

'It may be, Leszek, but we can't tell at the moment. There are good reasons why the diplomacy has to continue, not just diplomatic reasons but presentation reasons too. If it wasn't for the French, we would have the swing-countries behind us.'

What is the support?

'Militarily, there are the Americans and ourselves and the Australians. And there are your special forces out there. Politically, we have Spain and Bulgaria.'

Miller, Polish Prime Minister for the past eighteen months, former Communist and fierce advocate of his country's accession to the European Union, is alarmed at threats from Chirac against the 'new Europeans' for not backing the foreign policy of Paris and Berlin.

'He must not do that,' says Blair, leaning forward onto his desk and raising his voice. 'He has been very clearly warned by us and the Americans that he can't do that. He has to be told that in no uncertain terms. You have to mention all this to George, Leszek, when you speak to him.'

There is a long speech from Warsaw which Tony Blair punctuates with 'Mmm' and 'Well' and 'Yeah' while pulling at the side of his face. He still looks pale today. He is spending hours without much chance of a joke or any other distraction.

'Yes, Leszek. Europe must not be an anti-American alliance. I had dinner with Chancellor Schröder last night, and he does not want to be part of an anti-American alliance. When this is all over we will have to get back together. But if Europe wants to be a rival, count us out. If it wants to be a partner, count us in.'

Telephone diplomacy gives no opportunity for Tony Blair's warmth or charm. In a crowded room he has accomplished skills in making the person he is talking to feel like the only person. At the end of a telephone line there is usually only one person – plus a few listeners-in, whom it takes a while to learn to ignore.

Tony Blair is now grasping his desk tightly with one hand and the telephone just as tightly with the other. 'What the French have to realise is that they cannot impose their view of Europe on any-one – basically. That is not just my view but George Bush's view, Aznar's view, Berlusconi's view.'

When the conversation is over, the Prime Minister takes a walk out into the hall and stands, shaking out his limbs, between Sally Morgan's office door and a dark oil painting of Pitt the Younger, the Prime Minister who steered Britain during the French Revolution. Morgan is away from her desk.

He looks into the empty interior as if the answer to the latest state of the vote-count will emerge from her filing cabinets nonetheless. He comes back out, disappointed, and looks around him.

'What amazes me is how many people are happy for Saddam to stay. They ask why we don't get rid of Mugabe, why not the Burmese lot. Yes, let's get rid of them all. I don't because I can't, but when you can, you should.'

Friday, 14 March

Morning headlines…it is inappropriate for Her Majesty the Queen to be out of the country…London and Washington attack Chirac veto threat…Israeli and Jordanian airspace available for war on Iraq…

People who are never seen running are running now. Aides whose memories of political nightmares go back to the darkest years of far-left Labour leadership are running. Young assistants for whom this is the first drama of Downing Street survival are running.

Everyone is running hard after something. Sally Morgan is running. Campbell himself is running – and not like a man training for the marathon, more like a mugger escaping down a street of wrecked cars.

This morning in the *Daily Telegraph* he has spoken of the alcoholism and breakdown which marred his first career in journalism. He was doing newspaper jobs which hardly seem very demanding to him now, but which then he could not do. He cracked – and only gradually came back.

He still remembers the place where he was driving on 12 May 1994 when he heard the news that the Labour leader, John Smith, was dead. He says he knew then, on that junction of spirals where Paddington Station meets the peace of the Little Venice canal and the roar of the road to Oxford, that Tony Blair would be leader. He also knew that he would work for Tony Blair.

Nine years later, he is the man to whom Tony Blair still speaks the most. It is when the two are alone together that the Prime Minister's face is most the face of a friend at a party, an actor offstage, a person who is not Prime Minister. Campbell has a well-founded reputation for low stratagems on his master's behalf, but he is the one who dares speak most fiercely and directly to Tony Blair. He speaks directly too about himself, more than he has before; more about his mental and physical preparation for the marathon, more about his past mental and physical collapse.

Campbell's own confidant in Downing Street is also running now. Pat MacFadden is a thin-faced, vulpine political strategist who looks like an 'enforcer's enforcer', the sort of assistant who might clean out the nastier places where Glasgow Celtic football fans meet Glasgow City Councillors. In the striped Regency corridors of Number Ten he is recognised as one of the most thoughtful men in the building.

When he and Campbell sit together it is like watching two copper wires before the electricity crackles across the air. No reputation is safe from being scorched. But now they are running together, Campbell first, MacFadden behind, like a couple of greyhounds.

There are suddenly shouts from the green-shirted builders in the basement. The 'Sainsbury's To You' van has arrived and is strewing the hall with Coca-Cola and frozen meals. There is a faint sense of an emergency ward where the patient is puffing his way out.

Only Gordon Brown and John Prescott are still the stately galleons of the corridors. Whatever is happening does not seem to be any business of theirs.

The patient is fine. But Tony Blair's travel plans, it seems, are being made, unmade and made again – even as his groceries

arrive. There was a possibility that George Bush might come to Downing Street for a pre-war summit. But there were snags. Security was a problem. Protesters were a huge problem. Politics was an even bigger problem; nothing would make Labour MPs more likely to oppose Tony Blair than the presence of his friend from America.

Barbados was a possibility too. But the summit is to be in the Azores, the Portuguese islands in the middle of the Atlantic. As long as war is not formally declared from their soil, the Portuguese are apparently happy to be host.

The Spanish Prime Minister, José Maria Aznar, who has become one of the most frequent and trusted telephone-callers to the den, will be there too. Tony Blair says the name 'José Maria' with almost the same affection as he says 'Sally' or 'Alastair'. Some of his friends find this attraction to a man of the European right as hard to endure as the closeness to George Bush. The two men have grown used to swapping stories of how weak their domestic support is. Aznar's was once at 4 per cent. 'Crikey, that's even less than the number who think Elvis Presley is still alive,' Tony Blair told his friend. 'Crikey' is a typical Blair expletive, a bit dated, a bit comic, designed to avoid trouble.

The Azores announcement brings the added bonus of angering the French. Jacques Chirac loves summits and is known to place Spaniards and Portuguese among the lower zones of European life, at least until the 'old EU' is augmented by Baltics and Poles, whom the French esteem even less. There is general satisfaction, as the various arrangements are made for Prime Minister, team members and press, at how the news will be received in Paris.

The policeman at the door asks the Sainsbury's man whether 'all this stuff has to be signed for'. The white plastic bags stretch

now in a double row from the front window almost up to the portrait of Sir Robert Walpole on the opposite wall. 'No,' says the driver. 'We know where you are. You're not going anywhere.' That is one vote of confidence.

On the hall table to the left is a mosaic of mobile phones. The rules of the house say that no alien phone can pass this point. Each has to be switched off, named with a yellow sticker and left on this table. There are always a few of these modern-world electronic pets here, waiting patiently for their owners to return. Today there is a major exhibition, a dog-show of phones.

By early afternoon, calm has returned. In the Campbell zone there are calls to journalists who may want to join the Azores day-trip.

MacFadden, still powered as though by wires beneath the skin of his neck, is pressing buttons within the Labour machine that might make an MP think twice before voting against the leader. He is preparing moral arguments, political arguments, and identifying those who are beyond argument. These may soon need the attention of the 'big boys', a serious call from one of 'the Johns', Reid and Prescott.

The best news for persuaders today is that President Bush has agreed to publish the so-called 'road map' to Middle East peace. Labour MPs want to know that the President's concern for regional stability and the upholding of UN resolutions extends to Israel as well as Iraq. To adapt a Blair catchphrase, if he is to be 'tough on terrorism', they also want him to be 'tough on the causes of terrorism'.

The most important phone-call today is about to be put through to the den. The Prime Minister is at his desk, a large, hopeful picture of Nelson Mandela to his left, a white mug marked 'Daddy'

straight ahead and, next to it, one of Whitehall's most overworked handsets.

The ringing does not come from the place where it is expected. An unused, finger-marked extension pushed into the far corner of the room beneath Leo's birthday plate begins to beep instead. It is as though a small animal has escaped. There is cursing and scrabbling until the right phone is ready for use.

'Hello, Mr Chairman. It's Tony Blair here.'

The Prime Minister leans forward in front of the backdrop of high blue leather doors. It is a bad line from the West Bank for such a conversation.

'It's good to speak to you. And how are you?' Tony Blair nods as though neck movement might force the words through the noise.

He looks much stronger today. If the Palestinian leader were to ask in return 'How are you, Mr Blair?' he could receive an honest 'Better, thank you' in reply. The cold has subsided. Any last traces of his panda look are hidden under full make-up for his next event, a televised press conference to promote the 'road map' announcement to journalists from the Middle East.

'We've got to take this forward, Mr Chairman.' There is a gentle pleading in the Prime Minister's voice.

The 'this' is the map, the directions to a hypothetical place in 2005 where there will be two peaceful states. The lines have been drawn in Washington, Moscow, Brussels and at the UN. In Jerusalem it is not much liked. In the West Bank it is not much trusted. President Bush has announced a few minutes ago that he will publish it as soon as Yasser Arafat has handed effective power to Abu Mazen, the new Palestinian Prime Minister.

Whatever Arafat says is overheard by an intent Jonathan Powell through his earpiece outside. This is a short call, but one which could easily go wrong.

George Bush will not talk to Arafat. The man with his elbows hard against the Downing Street desk has to do reassurance for two. After a few minutes the receiver at the other end is handed to Abu Mazen, the symbolic shift, as Tony Blair hopes it will be.

'Congratulations,' he says to Abu Mazen, relaxing visibly now that he is working the phone with a man he can do business with instead of an awkward legend. He looks out of the window. There is sun on the lawn, and a gardener pushing idly at a moss-covered trampoline.

Tony Blair's aim is to ensure that the road map is not torn up on the Gaza Strip before it is even seen. 'You have heard what Mr Bush has said. We will do all we can to bring this to a successful conclusion.'

There is a pause, and unwanted sounds.

'I know, I know,' he says impatiently when Arafat returns to the line. He sighs and looks hard ahead. 'What President Bush has said is that he will send it to Abu Mazen. The sooner the better.'

'Yes, Mr Chairman, this is precisely to end the suffering of the Palestinian people.'

He rubs the side of his face, where the make-up is irritating him. He listens for several minutes more. 'We will do what we can. Thank you, Mr Chairman.' He puts the phone back on its cradle and notices a stain on his tie.

'Get Alastair,' he calls to the office outside. 'And get some more ties from the flat.'

The room is suddenly full of identical shirts all bent over the text of the press conference statement. The backs of Jonathan Powell, Peter Hyman, a speechwriter with a livid bruise on his neck, and Matthew Rycroft, the permanently amused Private Secretary from the zone of the diplomatic knights, make up a waving flag of mid-blue.

Campbell arrives, and a fevered argument ensues about the

order of paragraphs and the time that is required for them to be printed out in big enough type. The Prime Minister needs reading glasses, but does not like to wear them on television.

Campbell leaves. There is then a more muted discussion about whether there is anything genuinely new in the Bush statement on the road map. 'It's the fact that he's said it that is new,' says a voice from one part of the blue wave. 'The President is there. He has spoken. We know from Northern Ireland that the momentum of progress, whatever the size of the moves, is everything.'

Campbell returns with a memo in his hand and a thin smile. 'Sorry,' he says, 'President Bush doesn't like your script. He's rewriting it now.'

Tony Blair scowls. 'One day your sense of humour will get you into big trouble. Or, more important, me into big trouble. Now, where was I?'

'This is not a one-off gesture,' says another voice from the mêlée.

'That's right,' says the Prime Minister. 'That's what I'll say. Where are the ties?'

A great skein of pink and blue silk neckwear is brought into the den. Tony Blair selects one, checks himself in the mirror and goes to face the cameras.

Thirty minutes later he is walking by the flat-screen in front of Powell's desk. The press conference is over. He has managed to turn most questions to the Middle East and away from Iraq. The road to a Palestinian state may be long. But, more than ever now, he sees it as the necessary route to reassuring his own MPs in the war vote which will be held next Tuesday.

Tony Blair is keen to know whether the Azores or the road map is going to be the main story on the evening bulletins. His aides, like all political aides, like to give their boss good news. But a 'War Council' in the middle of the Atlantic will have stronger appeal,

says Hyman bluntly, his purple bruise almost glowing now above his collar.

The Prime Minister looks disappointed. He looks up at the television, on which a Palestinian representative is damning Bush's motives.

'They've got to be told, Jonathan,' he says. 'This is their chance. If they don't use it, they'll lose it.' He turns into the den by himself and closes the door.

Saturday, 15 March

*Morning headlines...emergency summit in Azores...Bush
to publish Middle East 'road map'...Washington rejects
Chilean compromise...US commanders say Iraqi forces
in civilian area will be targets...*

When the Prime Minister spends the weekend in Downing Street
there is not much 'weekend' in Downing Street. There is blue sky
over St James's Park and a sense of bright weather ahead. Upstairs
in the flat two teenage Blairs, seventeen-year-old Nicholas and
fifteen-year-old Kathryn, are preparing for a London day.

Inside the dark front hall of Number Ten there are four dead
orchids, ready to be collected by the garbage-men, and the first
signs of a conference for political 'enforcers'.

Hilary Armstrong, Labour Chief Whip since Tony Blair's sec-
ond election victory two years ago, has abandoned her grand-
motherly office grey for a soft cream leather jacket. John Reid is in
leather too, harder and black. Gordon Brown is wearing a black-
and-white rugby shirt. Sally Morgan is in a blue sweater. Only two
are dressed for work as they would be on a weekday morning:
Alastair Campbell is in his tracksuit and marathon trainers, and
John Prescott in his regular stiff suit.

'The next few days will be very twittery,' says Armstrong, lean-
ing on the burgundy Chesterfield where the Campbell corridor
meets the hall. She wants to put 'weekend pressure' on dissident

Members of Parliament when they are meeting their constituents.

Here at Westminster political revolts are likely to gain momentum. Each new meeting in committee room or bar gives rebels the confidence that they are not alone. Once 'wobblers' are back at home, local Labour leaders, chairmen of constituency parties, may remind them why they were elected in the first place, why, without Tony Blair, there would not be a Labour government. 'So, if John Reid were to call some of these Constituency Chairmen, he could make that point...'

Armstrong is expressing the conventional Whips' Office wisdom. 'In the bad old days,' she says chattily, 'when a "Big Boy" phoned your Chairman it made a big difference. We have to fix that up now.'

Reid is not so sure. This is not a conventional case. The Labour activists are more angry with the government than the Members of Parliament are. He worries that the Constituency Chairmen are likely to be the most opposed to the war of all. He does not want to phone a Chairman 'behind an MP's back'. He will help, but 'only if it's not going to be counterproductive'.

'Have you seen Jack Straw?' Armstrong asks coolly. The Foreign Secretary has problems in his own constituency this weekend. Muslim voters are well represented in Blackburn, Lancashire. They dislike the idea of their elected representative helping the American takeover of a Muslim country.

The Whips are not so enthusiastic about Jack Straw either. Much of their political problem arises from the government's earlier excessive confidence that there would be an unambiguous second United Nations resolution giving an ultimatum to Saddam Hussein. Doubting Labour Members were allowed, even encouraged, to tell their Chairmen and their local press that they would support the Prime Minister's policy once that resolution was passed. Now any such clear UN support is a dream.

The meeting begins in a dark Number Eleven reception room with Armstrong's latest account of 'wobblers and runners'. She speaks with a flat northern voice which is her main weapon of threat. The friendliness and humour, the weapons of the cajoling Whip, are all in the lines around her eyes.

Tony Blair is seated in a large gilt chair which the Treasury uses to impress foreign bankers. He looks slight, in open-necked blue shirt and chino trousers. On either side of him, like a Praetorian guard, are Prescott, cold and frowning on the left, and Brown, who has now exchanged his rugby kit for a dark suit, on the right.

Morgan is more cheerful about the anguishing MPs. 'They haven't seen the abyss yet. When they've seen it, they will come back from it.'

There is a quiet moment while they review the latest security reports from Iraq. Some of the Baghdad government is resigned to war; there is a certain amount of 'summary punishment' being meted out to dissenters. The Chief Whip concentrates hard.

Gordon Brown, sitting judge-like on his Chancellor's bench, is the only figure from the war team who can highlight the chief flaw in the policy as it is seen from the streets. 'What people ask me is, why is there not just a little more delay?'

The Prime Minister knows that this is a legitimate question. This afternoon he must have a last telephone call with the most active of the junior UN Security Council members, Chilean President Ricardo Lagos, who has been making exactly that argument.

The right answer to the Chancellor of the Exchequer and his questioners is that George Bush has had enough of the United Nations, and will begin war within days. Tony Blair snaps impatiently at the meeting, 'The reason is that you just go back to 1441: time, time and more time.' It is clear from Gordon Brown's eyes

that better language than that needs to be found if the case is to be won.

The number 1441, shorthand for the resolution against Saddam Hussein which the Security Council agreed but did not want to act upon, is one of many bits of war jargon which are not easily understood by outsiders. If Ministers could say that the war was being fought because of intolerable abuse of human rights, because of torture, mass murder, even some of the casual last-minute mutilation of Iraqis on which the meeting has just been briefed, the case would be much easier.

If Ministers were allowed even to rest their case on the need to remove barbarian tyrants, the strategic interdependence of Europe and America for the common good, their words of persuasion might have a better chance of being heard. But the language demanded by the immediate negotiations is of acronyms, paragraphs and numbered resolutions.

Pat MacFadden, in black T-shirt, black shirt and jeans, looks like an accused man in court making pages of notes for his own defence. He is working on what the better language might be. The veins on his forehead do not suggest that his task is going well.

The Attorney General, the meeting is told, will announce on Monday that war against Iraq is legal on the basis of past UN resolutions. The Sunday newspapers can be told that for tomorrow. There is thus no need for the new Second Resolution upon which so much has been built.

The legal niceties defeat all but the most determined political students. Cherie Blair would be more use on this point than anyone in the room, except that she might well not come to the right conclusion. One of her senior colleagues has already determined that past UN resolutions give no legality for war.

Fortunately the Attorney General, Lord Goldsmith, who is not

here today, thinks otherwise. If he did not judge the coming war to be legal there would be no British troops fighting it. There will still, however, be a lot of explaining to do. Last week the second UN resolution was a magic chemical formula to clear away all ills. This week it is a bit of herbal medicine, desirable, beneficial, good for the soul, but wholly unnecessary.

Morgan tells her boss that his arrival time back home from the Azores is 2 a.m. on Monday.

'That's ridiculous,' comes the reply. 'We don't want dinner. We just want to get the business done.' Tony Blair goes back to the den.

The informal political meeting resumes in the corridor outside.

'What many MPs really want is for us to ask for their votes only when troops are already in the field. Then they can tell their constituencies that circumstances have changed, there was nothing they could do, that "our boys" had to be supported…'

'And then they could cry "outrage" at us forever afterwards for not giving them a say.'

'These are the people who see themselves as leaders of the country.'

The persuaders disperse to their different offices to make their calls. A British Prime Minister is under no obligation to win a vote in Parliament before he sends soldiers to war. But Tony Blair has committed himself to winning. If he loses the vote, or even if he is seen to lose it, he will lose his job. He has asked the Cabinet Secretary and his colleagues to have the resignation papers ready. These are the senior civil servants whose offices are to the right of the den, at the end of the corridor to Whitehall, and are quiet on a Saturday morning.

After a few minutes Tony Blair comes back from the den and meets his daughter Kathryn at the bottom of the stairs to the flat, where Leo's pedal car is parked. He gives her a big hug, hears that

she is going to stay the night with a friend, asks in a fatherly way which friend it is, and tells her he is out tomorrow, in the Azores. He walks back with her a little way towards the orchid pots in the hall, then turns up to the flat.

In Alastair Campbell's office the television is turned to a food programme. A 'celebrity chef' is making breakfast with exotic ingredients that seem to shimmer against the polished wall panelling.

The Director of Communications and Strategy has put his strategic hat aside for a moment and is doing a little communication to the Sunday press. To the background sound of sizzling oranges and crispy bacon, he is circling his desk and responding to a report that Saddam has destroyed some VX nerve gas.

'This is not a concession, it's a claim,' he tells the reporter. 'So forgive us if we're a bit sceptical.'

Campbell has seen the British-Asian novelist Hanif Kureishi on TV. He was 'making the right kind of points'. Would the editor think of giving the writer of *My Beautiful Laundrette* some space to develop his theme? The editor would.

The fried-fruit breakfast is gleaming before the cameras. But the sun through the windows from the garden is beginning to make the finer points of the television picture fade to white. Campbell presses a button on the remote control.

'Yes, war is legal even without the Second Resolution. We never release the Attorney General's arguments, but the answer is definitely yes.'

The TV chef has been replaced by TV athletics. Campbell is talking to the news desk of the Press Association, whose words go into every media newsroom.

'Yes, John Reid is today going to tell Labour's Eastern Conference in Cambridge, or wherever it is, that...Can someone out there get John Reid? Then tell him exactly what he has said.'

There is a pause. 'Yes, tell him exactly what the news wires are saying he has said. And then he can make sure he says it.'

Campbell listens closely to a discussion on the TV about whether athletes who stray out of their lane should be automatically disqualified. He is waiting to watch the Mozambican Olympic gold medallist Maria Mutola in the 800 metres. 'There are more pictures of her on the streets of Maputo than of Saddam in Baghdad,' he says, as though that is already a victory for British forces.

The phone rings.

'We are not going to war for oil. The oil money will be in a trust fund for the Iraqi people.' He sighs. 'I don't have any "colour" for your story. I don't know what people were wearing for the meeting.'

Morgan has just come in.

'Baroness Morgan is wearing an old blue jumper which makes her look middle-aged. How about that? Good enough?'

If Morgan is pleased to be offered a costume role in some unknown newspaper's 'focus on the week', she disguises her pleasure well.

Mutola begins her run.

There is a call from the Azores, where a civil servant from the two-person Downing Street advance party is in discussions with her battalion-strength counterparts from the White House. She is worried that a press conference in an aircraft hangar may look too militaristic.

'I don't mind an aircraft hangar as long as there isn't a bloody aircraft in it,' Campbell reassures her. 'There just has to be enough room for all our press.'

The Atlantic forecast continues. 'The Portuguese are apparently being very helpful,' says Campbell afterwards as Mutola accepts her cheers. 'We said we wanted to stress the diplomacy, not the war

planning, and they've taken down all the photographs of generals from the airbase walls.'

Upstairs in the sitting room of the flat Tony Blair is listening to the distant sound of a Guards band and waiting for what may be the last bit of 'phone work' in this diplomatic phase. He has learnt a good deal about the political telephone in the past few weeks. The Spanish like long calls with every last detail in extended periods of prose. The Italians hardly work a phone at all. George Bush's calls are conversational, staccato, full of short, sharp perceptions of people and things. When transcribed for the records, they look like film scripts.

The coming call is with Ricardo Lagos, the President of Chile, one of the countries which had the misfortune to be taking its turn on the Security Council when the UN was facing both war with Iraq and the question of its own survival as a serious international force. Lagos, an American-educated lawyer and the first left-wing President of Chile since the murder of the Marxist Salvador Allende in 1973, is one of the few of the so-called 'Uncommitted Six', the 'U6' in the war's shorthand, to have improved his reputation in Downing Street during this time. Tony Blair has come to trust him.

'Hi, Ricardo,' he says, leaning back on the yellow sofa. For a few minutes there is no sound in the room but faraway bugles. There is an open, accusing red box on the coffee table, papers on House of Lords reform, private hospital funding, letters to see and sign.

'Yes, the Chilean proposals are very close to our position now. There could have been more time. This could all have been very different.'

There begins a muffled thud of rock music from the room of Blair's son Nicholas, and a very much louder 'oompah pah' from approaching tubas outside. The Prime Minister smiles and covers

the mouth of the receiver until it is time to speak.

'The United States will be worried that your statement – even if it is tougher than the U6 – will just encourage more delay. If a week ago we had been where we are now, who knows? And yet...' The Prime Minister pauses. 'And yet, I spoke to Jacques Chirac yesterday and his position is very, very hard.'

Tony Blair does not know what the man at the other end of the line is really thinking. Perhaps the Chilean President is very pleased that the French have saved him from the need to vote for war. The Prime Minister does, however, know what President Lagos is hearing. The Guards band is almost beneath the window.

'I'm sorry, Ricardo, there's the usual band playing. That's what's going on here. No, we haven't started the martial music already.'

Tony Blair listens for several minutes, looking at the dead roses in the grate of the fireplace, the plastic helmet on the floor and the undone work in the box.

By the time he speaks again, the band has turned and the trumpets are fading away. 'The US does not want to be tricked into compromise. Yes, maybe we can speak again tomorrow. Maybe there's just a chance of squeezing through to some suitable position. There may be some time left, but it's a squeeze now. I'll keep trying right to the end.'

He puts down the phone and stretches his legs. He takes a blank piece of paper to a table by the window. He has to begin writing his speech asking Parliament to vote for war. There will be little other free time before Tuesday.

There is just the daily 'Bush call' to come. He begins to muse about the dangers of a world in which Europe and America drift apart, where everything becomes a game in which old rivalries are played out forever. Tony Blair is an optimist. He believes that bad old patterns can be broken. He is a dreamer too. He thinks that patterns have already been broken which in fact are still firmly in

place. He believes now that if Europe had been strong and united, he might not be needing to write this speech, and could be enjoying the Saturday sunshine instead.

'Dad,' comes a male teenage cry from the kitchen below. 'Pick up the ph-ph-phone.'

Sunday, 16 March

Morning headlines…Tony Blair faces toughest fight of his political life…Chirac confirms veto of any new UN resolution authorising war…

'You look all right. You've got to go.'

The flat Liverpool tones of Sally Morgan sink from the top landing of the flat into the hall. In the half-darkness the rooms resemble the site of a hastily finished children's party. The Thomas the Tank Engine train set is overflowing its box. At the bottom of the stairs, as though beguiling the Prime Minister to stumble, is a baby-sized drum kit with 'BAND' in large letters on the bass. The music on the piano is the second page of 'I Tawt I Taw a Puddy Tat a Creeping up on Me'.

Morgan's voice is tense. Everyone this morning is tense. A good guide to the mood in Number Ten is Vera, the laughing Irish messenger, normally in her newly issued government uniform, today in a generous brown jumper. She is visibly anxious. Messengers are more than tea-makers and paper-movers here. They are continuity and a kind of comfort.

'If you want to know who really keeps this place going, here she is,' says the Prime Minister of the woman who now walks in with a cup of coffee, moving her free outstretched hand like a balance, palm down, rocking side to side from thumb to little finger. Too much is still in the balance.

Later tonight, when news comes in from the Azores, the result has somehow got to be more support for the Prime Minister – or 'my boy Tone' as Vera calls him – not more MPs who want a new boss in Number Ten. The man himself is in his bedroom now, changing from Sunday-morning clothes to his summit suit.

At this morning's meeting for the team the mood was a little lighter than yesterday. John Reid looked more bullish than ever, in builders' loose jeans as well as his black leather jacket. Gordon Brown, in his banker's black suit, had just given Sir David Frost a statesman's version of the government case on breakfast TV.

As for the others, it was hard to keep the mind off their startling range of 'smart casual' and athletics kit. The Prime Minister said that the day was unexpectedly 'tough'. The *bonhomie* of his colleagues made him feel better. Or so he now says.

While Morgan waits to give the final check to shoes, shirt and tie, she gives him the most optimistic political report that she can. The Whips are 'on course' to win Tuesday's vote. But they have not won it yet. He could still lose the House – and his job.

What would happen then? Labour would still be the biggest party by far. Its Acting Leader would temporarily be Prime Minister. Would John Prescott move in here? The team worries a little if Prescott takes even a single meeting of the Cabinet. Business on those days is brisk. Discussion – or dissent, as the Deputy Prime Minister tends to see it – leads easily to explosion.

But if Tony Blair were no longer Prime Minister it would not be Campbell's or Morgan's problem. They would be looking for other work.

Campbell could start writing *Blair: The Official Story*, before moving on to *Campbell: The Official Story*, and then to making guest appearances in all the media that he moans about so much.

If he were prepared to work for giant capitalist corporations, he would not lack offers.

Morgan is the one whose job would be harder to match elsewhere. Only at the heart of a White House or a Downing Street are there roles for aides who can admonish Ministers, flatter heads of state, plan the highest strategies for elections and make sure that the boss's shoes are clean, shirt is pressed, tie unstained – and even, in emergencies, do his make-up.

The minutes are ticking away. Morgan calls again. The British do not want to be the last ones on the Azores beaches. They must not arrive after the Spanish.

There would be one advantage to no longer being Tony Blair's Political Director. Morgan's own teenage son, whose approval rating of the war is lower even than the national teen average, would have no more cause to complain about her employer. Family divisions on peace and war are painful. Morgan is not the only one in Downing Street whose devotion to the government's war policy is best left behind at the office.

She gives the summit clothes another last look – and waits. Tony Blair is checking ties and papers.

This is the lowest point so far. The Blairs have been to church, but it does not seem to have calmed him much. With the permanent company of detectives, even worship is not now what it was.

The Prime Minister is the only one of his family not formally to be a Catholic. He has the powerful Christian seriousness of the not-quite-yet convert. Religion plays a great part in his life, opening up the possibility of the fixed and the certain in politics too. Yet since the Iraqi crisis began he has had to choose different churches each Sunday, as though he were Yasser Arafat or Saddam Hussein keeping one step ahead of their enemies.

He is restless as he readies himself to leave, wanting certainty

before there is certainty to be had. He is on a road to war which is not the one he planned. He and the President had discussed the doctrine of pre-emptive attack last June, the inadequacy of Iraq's arms declaration in December, the need for international support in January. He had come to believe that by now he would have the United Nations securely behind him, and thus the great majority of his party securely behind him. Outside Downing Street it is a rumour that Robin Cook will resign from the Cabinet tomorrow; inside, it is a certainty.

Now the problem is presentation. The time is past when he could think that Saddam is serious about giving up his weapons. But it is vital that no part of the trip today, neither the communiqué nor a careless word at the press conference, makes war absolutely inevitable and tempts more Ministers to follow the Leader of the House. There has to be an ultimatum to Saddam today. But there needs to be a way out; not one, Blair concedes, that the Iraqi dictator is likely to use, but one that can be used to calm MPs. There must be a recognition that the UN will be back with a role in Iraq when the war is over.

Tony Blair appears at the top of the stairs. Behind him is a family photograph of his friend Bill Clinton, whose failed and cautious second term he holds as a permanent reminder of what he does not want for himself. In the same picture is Jacques Chirac, now his foe, with Leo as a baby – 'symbole de la Royaume Uni', as the French President's handwritten inscription runs.

He pauses as though he is about to make a sweeping entrance, remembers his soft brown leather bag, clean shirts, new ties, and sets off through the front door of the flat with his Political Director behind.

The last politician to shake his hand before he climbs into the green Daimler is John Reid, who promises him, with somewhat

weighty Glasgow wit, that he won't have resigned before he gets back home. The Prime Minister responds to his leather-jacketed enforcer with a look of tired, leaden irony of his own.

Motorcades are not a common British sight. In America, since the assassination of John Kennedy in 1963, Presidents have either endured or enjoyed the most suffocating protection, never more so than since the attacks of 11 September 2001. In France, even a band of journalists and aristocrat wastrels on the way to the Prix de l'Arc de Triomphe may merit motorcycle outriders. But in Britain, in normal times, even the Prime Minister is obliged to wait in traffic.

These are abnormal times. When the line of two limousines and two people-carriers lurches out of Downing Street, even from this cul-de-sac at the highest possible speed, a stream of white motorbikes stretches out in front and behind. It is still early morning, and no one takes much notice. The yellow-jacketed dogs of Kensington jump out of the way, but few of their owners turn a head.

A tricky slither through a chicane of parked cars on the West Cromwell Road reminds the silent, dark-shaded Number Ten sound recordist of the high-speed Rome motorcade last month. 'The Italians had masked special forces pointing automatics at us front and back. It was terrifying.'

'It was just as well he was going to see the Pope,' comes a voice from the front.

'It was Berlusconi,' says the sound man, who was guitarist with a band called Apathy before he changed his line of work.

'Well, next day it was the Pope.'

That was the trip when Tony Blair arrived in the wake of a two-million-strong demonstration against the war and found a city still toasting the visit of Saddam's bespectacled ambassador, Tariq

Aziz. Berlusconi was behind Britain and America but the Italians, led by the Pope, were not.

There is a desultory conversation about the last days in Number Ten of Margaret Thatcher ('You can just see us in some of the pictures, poking aside the net curtains') and John Major ('That was so sad').

An hour later, in the first-class cabin of the Boeing 777 bound for the Azores, Tony Blair studies papers for the summit under the inquisitorial eye of Sir David Manning, who has a sheaf of telegrams in his hand, and the lighter gaze of the young Foreign Office Private Secretary, Matthew Rycroft, who is negotiating the words for the final communiqué.

The balance between politics and diplomacy has shifted. When the Prime Minister listens to Campbell and Morgan he is a man hearing news from home; he knows most of it already. When he listens to Manning, he is hearing news from far beyond himself, probabilities and problems that he does not always know.

This veteran knight of Moscow and Middle East peace process, soon-to-be Ambassador to Washington, is slight in body, the palest in a group of often very pale faces. When Tony Blair calls for him, his voice rises a tone. He does not like him to be very far away.

Alastair Campbell is now exchanging faxed drafts of Robin Cook's resignation letter and the Prime Minister's ritual thanks. This reply has to be seen as generous, warm enough perhaps for Cook to hold out hopes of preferment as a European Commissioner if Tony Blair survives – as well as succession to Number Ten if the vote is lost or the war is a disaster.

The seat marked 'Baroness Morgan of Huyton' is empty. After her early morning of sartorial and political reassurance, Sally Morgan has stayed behind to battle for votes.

The diplomats are working with the Prime Minister on lines for

the press conference. A stern blonde press aide, charged with keeping the journalists at the back of the plane under control, is passing their requests to Campbell. It is a long way to the middle of the Atlantic for nothing more than a seat at an event which is televised live to the world. She tries to ensure that newspapers get some extra value for their money.

Manning has a paper with lines highlighted in green marker. 'The difference is between those who are prepared to fight and those who are not.'

Tony Blair scribbles on the back of scraps of paper. 'Alastair, get that typed up.' Campbell continues the conversation with his young press officer before ambling slowly forward.

Rycroft has a short note pressed against the back of his seat. The Foreign Secretary has been on the phone about the communiqué.

'Jack is worried about the Portuguese view.'

'What do they mean by saying it's too warlike?' says Campbell. 'They're trying too hard to appease the French. It's ridiculous.' He scores out a line with a thick black-tipped pen.

A dapper government spokesman, who today is doing the job that Campbell did before adding 'strategy' to his title, writes his own thoughts on airline notepaper. He now has to go to the back of the plane and brief the travelling press.

He apologises for being 'a pale shadow' of the Prime Minister, whom the journalists were hoping to see. The former Apathy man, still in his dark glasses, crawls around the aircraft floor to make sure that every question is heard and preserved.

'Is this a war summit?'

'If this is a diplomatic summit, why aren't Russia and France going to be there?'

'Are you trying to tell us that they will be discussing the pre-war and the post-war, but not the war?'

More gratefully than any normal first-class traveller temporarily sent to steerage, the spokesman wipes his bald head and returns to the front of the plane.

British Airways has decorated the Prime Minister's cabin with a black-and-white photograph of shifting desert sands, a thoughtful touch to relax a man ticking his way through Iraqi telegrams. No one has felt the need to remove the in-flight magazine, *Shopping the World*, from the side pockets. Back in Westminster that is exactly what opponents think Tony Blair is doing today: saving his relationship with George Bush, but shopping the rest of the world without a care.

Two hours later, amid the wildflowers of a Portuguese airstrip, four thousand miles from everywhere, a green-uniformed officer with his name, Carlos Barbosa, on his breast pocket is parading six military medals and ticking off the names of his guests. He has only three words on his piece of paper: Aznar, Blair, Bush, like part of a children's party game. The first two are ticked. All he needs now is Air Force One and he can claim his prize.

This is the biggest international event for these islands since 'At Flores in the Azores Sir Richard Grenville lay'. Or so say the waiting TV men. The quotation is from Tennyson's poem 'The Revenge', the reminder of a minor English defeat in 1591, just one fifteen-hour sea battle and the loss of the heroic captain, Sir Richard. Thanks to a great poet the Azores became part of every public schoolboy's memory.

Who worries? Who cares? It is a bit of 'colour' to brighten an otherwise dull commentary.

The waiting goes on.

Air Force One is still not in sight. Any poet might struggle here this morning. Perhaps a heroic moment at this summit will be identified by a future poet.

At last the great pale-blue jet arrives, escorted by enough sur-veillance outflyers to invade a small country.

The talks begin quickly in a brick airport building – and pass without untoward incident. George Bush makes suitable, if some-what halting, remarks about restoring the authority of the United Nations: 'In post-Saddam Iraq the UN will definitely need to have a role and that…that way it can get…begin to get…its legs…legs of responsibility back.'

The press conference commences without mishap. Saddam gets his ultimatum. Tony Blair gets his extra time for Parliament.

Prime Minister and President are separated in the line-up for the cameras. The Downing Street team did not want to risk too enthusiastic a hug of Tony Blair by George Bush. That might have cost votes.

The setting is far from 'militaristic', a stage of green velvet amid posters advertising the Subway Community Theatre production of *The Sleeping Beauty*. The main interest for the British is the confi-dential prepared text of the President's announcement to the American people, to be delivered immediately war has begun. This brief statement is ticked and blue-pencilled and passed around the shabby hall where, on everyone's insistence except the Portuguese, the fastest possible dinner is taken. A similar British text has to be produced on the same lines.

The leaders are on one table, the chiefs of staff on another, the foreign policy advisers on a third and the media men on a fourth. Vegetable soup is followed by beef and fruit, with the best Iberian wine for those bold enough to take it in this ascetic company of ex-alcohol-abusers and fitness fanatics.

Back in the plane for home, Tony Blair muses about his relation-ship with two US Presidents. 'Bush has never been concerned about my closeness to Bill Clinton. He sees that the problem of

terrorist states and terrorist weapons of mass destruction is the problem of our generation. We may have come to that conclusion from different political traditions, different ideological directions, but we both see that. We're both working to see that others see it too.'

The former American leader, despite his doubts about the Bush policy, has agreed to write an article for a British newspaper on the day of the House of Commons vote, saying why Labour MPs should back Tony Blair. The Bush team thinks this is an excellent idea.

Campbell suggests that his boss needs to take a call. The Prime Minister continues. 'I like George's directness. I like the way he has understood my political problems. Has he offered to ring seventy of my MPs, say he's going to end global warming, sign up to the Kyoto Accord and return America to an agrarian economy? No. Has he been as helpful as he can? Yes.'

He sits down and talks to Sally Morgan in London. 'Tomorrow is going to be a very difficult day.'

Monday, 17 March

*Morning headlines…war almost inevitable after Azores
ultimatum…Washington advises UN officials and journalists
to leave Iraq…Saddam Hussein divides Iraq into military
defence zones…*

Turn left from the hall into the Campbell corridor, first right
through a panelled door, and down to the Downing Street base-
ment. At the foot of the stairs there is a machine dispensing food
too unhealthy for the team to eat – except at times of stress. There
are wooden cabinets displaying books that are too leather-bound
and multi-volumed for anyone here to want at any time.

This is the place of the detectives, whose postcard-covered
office protects the back door. There have never been more detec-
tives than there are today. Cherie Blair has protection. Even Leo
Blair has protection. Number Ten is a home, an office and a prison.

The caterers work here too. Party kits of soup cups and saucers
sit by stainless-steel sinks. There are crates of smeared wine glass-
es which need a second ride around the dishwasher. Piles of boxes
are stamped with the label 'Golden Persephone' as though this
is where the Princess of the classical underworld has found her
permanent rest.

There are rooms with massive metal doors where 'communica-
tions men' with special badges live. And immediately alongside are
green-shirted builders, whose collection of heavy-duty locks and

hi-active adhesives looks like a good Saturday morning's shopping at B & Q.

Through here come politicians and presidential envoys when they do not want to be seen. They can wait on battered chairs by the sets of Waverley novels. The only book which looks as though it is ever read is about how the dot.com industry is going to take over the world.

In the official waiting room, one floor above, a woman with metallic red hair and bright green overalls is changing the date on the wooden calendar.

This is St Patrick's Day. She takes a long, thoughtful look at the black Mediterranean head which keeps the door open and mutters, 'I would have worn my shamrock but it died.'

Vera follows. Despite the troubles looming for her 'Tone', she is a more cheerful Celtic celebrant of Ireland's saint. 'Would anyone like a Jammy Dodger?' she asks. 'These are best government biscuits – Fox's, not the cheap ones.'

Campbell's confidant Pat MacFadden is here. On his own he is a paler personality. There is still a sense of electricity, but without Campbell it is only static. He passes out to the hall, past the dead orchids, and checks whether a 'guest' has arrived.

This is a day for political enforcement. MacFadden does not see himself as an enforcer. He likes to be a persuader, a man who makes skilful appeals to the conflicts within an MP's conscience. Few put an argument so well or seem to feel its force so fully. He has a sad face, set firm to convert the waverer. But if that fails, there is still time for the more direct Scottish approach.

Behind him, at the end of the corridor to the Cabinet Room, Sally Morgan is discussing the odds on survival with Campbell's partner Fiona Millar, a no-nonsense political adviser who until the so-called 'Cheriegate' affair looked after Cherie Blair.

For years the Blairs and Campbells made a very convenient

foursome, with kitchen-table talk taking the place of inter-office memos. But nothing has been quite the same since a series of newspaper stories in 2002 about the Prime Minister's wife's New Age therapist, that therapist's conman lover, that conman's help in buying cut-price student flats in Bristol, and what Mrs Blair told the Downing Street Press Office about it and when.

The details of the affair are forgotten now by all but aficionados. Its effects, however, remain. The sight of his wife being pilloried for weeks in the press caused miserable stress to Tony Blair. If anyone asks what has hardened him in the last few months, this certainly did not soften his soul.

Cherie Blair may have been foolish to ask the lover of her therapist to help the family buy property. But she was ridiculed almost daily for making use of alternative therapies at all. Every report about the flats, one of which was for their eldest son Euan to use during his studies, made her husband look foolish too, or at best detached from an important issue of family life.

This was a domestic issue; but in Downing Street it is hard to keep politics away. Campbell and Millar felt that they had been kept out of the Number Ten loop, a rare experience for them both. Although the Prime Minister and his Communications Director remain as close as ever, the women in their lives do not. The four are like friends who have been on holiday together too long. Millar now helps to organise Tony Blair's visits around the country. Today her short pink coat is the only cheerful thing about her.

'Those Azores pictures last night,' she complains. 'They didn't look good at all if you see them from the viewpoint of an MP who might not vote for us.

'It's not just George Bush,' she goes on, 'although I'm not sure I really understood his stuff about the UN getting its legs back. There's Aznar too. Some of our lot have long memories of right-wing Spaniards with brown eyes.'

Morgan smiles and tries to get back to safer subjects. She describes how she told Tony Blair by telephone on the plane back home how the day of canvassing and cajoling had gone. 'Then he rang me first thing this morning and asked again. I told him that unless loyalty had come to them in their dreams, nothing much had changed.'

A small group has gathered in front of a large eighteenth-century oil painting of the Thames seen from Richmond Hill, the view enjoyed today by elderly rock stars.

'That's Pete Townshend's house.'

No one wants to talk any more about votes or wars. It feels for a moment like a celebration party after a bad exam.

'And that's Mick Jagger's view.'

When the Prime Minister enjoyed his brief musical career with the Ugly Rumours at Oxford, Jagger was one of the performers he imitated. Tony Blair still likes to play the electric guitar – and the Downing Street sound recordist, the man from Apathy, makes no secret of his ambition to join him 'if he ever wants a jam one day'.

At the moment the Prime Minister is upstairs. He is not jamming or strumming. He is writing his speech for tomorrow, taking some exercise, and does not want to be disturbed.

Rock stars' retreats cannot keep out reality for long. President Bush scores highly with some of the team for his remarks about the French, how they 'showed their cards and said they would veto anything that held Saddam to account'. Anything that makes the French the villains will be useful today.

And yet…Was the President really criticising Jacques Chirac in the way that Tony Blair has? He almost seemed to be praising the French for having the guts to vote, to do as he wanted, to follow the 'old Texas expression' and 'show their cards'. It was Chirac's promise of a veto which proved to George Bush that his suspicion of the legless UN had been right all along.

Just before noon comes the news that the French have finally and publicly made it clear that there will be no change in their position. The phone lines at the UN have fallen silent. Ricardo Lagos, for these few days a household name in Downing Street, can return to being a name only in Chilean households.

Prime Minister and President are to speak at 1 p.m. A Cabinet meeting is called for 4 p.m. Jack Straw is to speak at 7 p.m. The emergency room under the Foreign Office, a hundred yards away across the courtyard, is put on twenty-four-hour alert.

Campbell takes long steps down the central corridor. 'I don't know why we're going through this charade.' He puts Robin Cook's resignation letter and Tony Blair's reply on the polished table. 'He'll be seeing Clare, then Robin, before Cabinet.'

Inside the den the high blue leather doors are open into the Cabinet Room. The french windows at the other end are open too. There is a rare long view from the Prime Minister's round conference table, through past the bookshelves known as the Prime Ministers Library, past the pillars and the Cabinet table, out onto the balcony.

It is a cold day. Outside, by the gates to Whitehall where demonstrators are massing by the hour, the policemen are stamping their feet. Inside, the messengers keep the garden doors tightly closed.

The den has just been cleaned. The fruit bowl is empty. The table is clear apart from a blue napkin and a polystyrene box for the Prime Minister's sandwich. The only reminder of last week is the skein of ties brought down before the Middle East press conference on Friday. Someone has arranged them in a neat fan-shape in case he might want to select another.

Tony Blair comes in. His dark jacket goes straight over the back of the chair. He is smiling. He puts his feet up on the desk.

There is no ringing for calls to the White House. They are

arranged by clerks and communications men. In the office out-side, Jonathan Powell will listen through his earpiece. Down below in the bowels, behind the 'Golden Persephone' wall, Alastair Campbell will listen in the secure room.

There comes the sound of 'I'm passing you to the Prime Minister,' then a pause.

'Hi, George.'

'Excellent.'

'How are you doing?'

'Yeah, yeah, pretty much the same. People know what's coming.'

'One or two problems with people leaving the government over this one…'

The high blue doors are closed.

Up in the White Drawing Room are politicians whose futures will be affected even more directly in the next days or weeks. Ala Talabani is a leader of the Patriotic Union of Kurdistan, one of the two main groups which run the Kurdish part of Iraq that has been protected by American and British planes since the first Gulf War. Her family home is in the nearby oil-producing city of Kirkuk, a major source of Saddam Hussein's wealth, and she is dreaming, she says, of the day 'I can fly there, take a taxi and go to the house where I grew up as a child'.

This commanding woman, whose handshake alone could turn back the tap on a Kurdish oil well, is here with her colleagues to make sure that Tony Blair and his friend have no second thoughts. 'There are three people who can free Iraq,' she says once the Prime Minister has arrived and sat down. 'The first is God. The second is George Bush. The third is Tony Blair.'

In case he has any doubts, she adds: 'You are one of the most courageous Prime Ministers Britain has ever had.'

He thanks them, asks for assurances that they will not try to

form an independent state, hears what he wants to hear, and returns to the den.

How was the President, he is asked. 'He was fine. A bit tense at a time like this, but fine.'

It is a pity George Bush could not have heard himself ranked second only to God.

John Prescott, the man whose job it is to relax the Parliamentary Labour Party, sets off for the House of Commons. Outside in Whitehall the anti-war protest has been swelled by a chorus of black schoolchildren, singing gospel slogans around the statue of Field Marshal Montgomery.

At about 3.20 p.m. there is a small huddle by the waiting-room door. The Kurds have gone. So have the pots of dead orchids.

The topic is resignation days: memories of Lord Carrington, the Conservative Foreign Secretary who failed to stop the Argentine invasion of the Falkland Islands in 1982; of Michael Heseltine, who four years later failed to stop the Americans taking over a British helicopter company; and of Estelle Morris, who only five months ago failed to persuade herself that she was capable of being Tony Blair's Education Secretary. The subject has just turned to Robin Cook when there is a tap on the panelled door down to the basement, and up pops the man himself.

The Leader of the House has often been described as a 'jack-in-a-box'. He is small, tightly sprung, unpredictable, a man who, if he is an opponent, is best kept under close confinement. He can never have looked more like a jack-in-a-box than he does now.

He bows lightly to the corridor conversationalists, answers the 'How are you?' with a firm 'I'm fine, thank you,' and, clutching a brown leather bag tightly in his hand, sets off into the hall and turns left. 'It's going to be a busy day,' he says.

There is an immediate bustle from the floor above. Alastair

Campbell's chief assistant, Alison Blackshaw, is unusually flustered. She is tall, long-haired, strong-featured and is wearing a thick embroidered pashmina. She might be off to organise a gymkhana. Instead she organises Campbell. Her job, for the past few minutes, has been to ensure that Cook's secret entrance to Downing Street does not end in a kitchen or a cleaner's cupboard.

'Have you seen Robin?' she asks anxiously.

'Yes,' she is told. 'He's gone in.'

She returns, relieved and still slightly breathless, to her place in the wood-panelled realms of Communication and Strategy.

Five minutes later, the former Leader of the House is on his way back down the same corridor, past the portrait of Henry Addington, appeaser of Napoleon, past the offices of Gordon Brown, which he would like to have possessed, and out.

'Ay, ay, ay, ay, ay,' he almost sings to himself as he leaves.

Outside on the pavement the reporters have the resignation letter but not the man himself. With the forensic razor that once helped put Tony Blair in power, Robin Cook has slashed the weakest limbs from the government's case, the 'evident importance that we attached to a Second Resolution', which 'makes it all the more difficult to proceed without one', and the 'precedent' created for 'unilateral military action' by other countries in future.

While the Cabinet Room is occupied, Fiona Millar is giving a short Downing Street tour to a woman in a black beret and bayonet-stilettos who does not look like a Kurdish freedom fighter. Nancy Dell'Olio is the partner of the England football manager, Sven-Goran Eriksson. Her purpose is to promote a charity campaign to provide football pitches to lighten the aftermath of war.

Anything that links football and politics ought to be welcome here. Dell'Olio is a celebrity herself. For two weeks last summer,

her part in Eriksson's 'love triangle' with the TV presenter Ulrika Jonsson made her a famous face. This afternoon there is more interest in Clare Short, who is wearing a white-and-brown scarf, has stayed in her job, and is now checking assurances of post-war food and water supplies.

Short's problem in having to support the war is not just political, but personal. Her allies on the left see her now as a turncoat, a worse charge than that of supporting the policy in the first place. Her son is deeply unhappy too. Political abuse she can take. She does not like upsetting her son.

War is not good for friends and families. There are deep divisions everywhere in the country. War is especially divisive for the people with the direct responsibility for ordering it to be fought. Tony Blair gets almost nightly calls of support from his son Euan, who is in Bristol for the university term. Others are not so lucky.

After Cabinet a podium is pushed out of the Number Ten front door for a statement to press and TV from John Prescott. Over loud and rhythmic shouts of 'Don't Attack, Don't Attack Iraq,' he announces what everyone knows. The diplomatic process has 'broken down'. Tomorrow the Prime Minister will be asking Parliament to support 'the ultimate action of last resort'.

Prescott makes no mention of Robin Cook, who later tonight, reporters now know, is to make his resignation statement. This is a rare chance for a former Minister to make an uninterrupted attack from the floor of the House on the man and the policy that has cost him his job. For the reporters the words which are now still in Robin Cook's brown leather bag are almost certain to be the best story of the day.

Inside, Tony Blair is saying goodbye to Leo before himself going to Parliament to talk to waverers and to hear his new chief oppo-

nent. Hilary Armstrong, holding her Chief Whip's lists, is alongside him by the entrance to the den. So is Sally Morgan. Behind them Alastair Campbell ponders aloud about which Ministers will best make the arguments on TV and radio tomorrow morning.

'Daddy's going off for a bit now,' says the Prime Minister.

Tuesday, 18 March

Morning headlines...George Bush offers Saddam Hussein 'exile or destruction'...UN pulls out weapons inspectors...Robin Cook resigns...France, Russia and Germany oppose use of force...

The doors to Number Ten and Number Eleven Downing Street are not normally open at the same time. They are like doors in a cuckoo clock: either the Chancellor of the Exchequer may emerge, presaging economic rain or shine; or the Prime Minister may pop out, proffering peace or war or the latest preferred solution to foot-and-mouth disease. The machinery of government is not meant to be glimpsed through both entrances at once.

This morning, as Tony Blair and Gordon Brown prepare to leave for the meeting of the Parliamentary Labour Party, the first task in a day that will eventually decide the Prime Minister's hold on the House of Commons itself, it is as though the government clockmaster has turned his key one time too many. Both doors flap open and shut every few seconds. The cold wind, which usually troubles only the reporters on the Foreign Office side of the street, blows in through Number Eleven and out through Number Ten, exposing the sometimes forgotten fact that behind two architectural façades is one office of state, and today – though not always – one political purpose.

Dried leaves and old newspapers blow into the Chancellor's side, where a severely dressed aide steps in and out as proxy for her

master. At the door of Number Ten the security guards are tired from excess of traffic.

There are mud marks and pigeon feathers on the russet carpet which, in the view of one voluble visitor, has long reached the end of its respectable life. The dirt highlights an arrow-shaped tear: 'Robin Cook's last stand,' quips the unknown emissary from some distant part of the Labour world.

'Could you just deal with this now?' he asks, handing a piece of paper to one of the duty policemen.

'I'll sort it out for you when things are a bit less fraught,' comes the reply, along with another blast of cold air through the door, and the sight of Gordon Brown setting off in his car.

There are still twenty minutes till Labour MPs gather, alone, without other parties, to be persuaded of the case for war. The Prime Minister is in the den with Sally Morgan, writing notes on the final draft of what he will say. His Political Director is worried that the speech is 'too academic', more suited to a UN seminar on 'how wars start' than to Labour MPs who love Tony Blair for his leadership in elections and loathe him for his leadership against Iraq.

Sir David Manning is closeted behind his door and its combination lock in the diplomatic knights' zone. The knights are grander than the other occupants of Downing Street. They are former Ambassadors, officials who were at the heart of John Major's governments and served Margaret Thatcher. Alongside them are men like Matthew Rycroft, carefully selected successors. But, in case anyone thinks the knights are unsociable or too far removed from the fray, a notice announces that the entrance is kept shut only to keep out the draughts.

The green Daimler waits outside. The people-carriers stand ready across the street. The 'dash' to ensure that team and leader arrive in Westminster at the same time is even more dervish-like

than last week. The final man pushed into the middle row cannot fix the back of his seat upright. The Daimler disappears through the courtyard. 'Just sit on the back. Just sit on it,' shouts Morgan to the unfortunate box-carrier, who spends the journey crushed up to the roof and checking that his fingers are all in place.

For the two-minute trip there is nothing visible from inside the people-carrier but a blur of side streets and back entrances. The pursuers catch up somewhere in a subterranean kitchen corridor and walk, with somewhat greater decorum, the last fifty yards.

On the narrow stretch of staircase where the team is stretched out in single file, Pat MacFadden is giving instructions into a red mobile phone: 'Get John Reid and Gordon Brown into the Special Advisers' office straight away.'

It is recognised, if little spoken of, that Brown will be the key to any success today. If last Monday he had encouraged opponents of the war with his support, however tacit, it would have been a genuine Number Ten crisis. If he had merely stayed in the cuckoo clock, leaving his door closed while Tony Blair's was waving open, it would have been much more dangerous than it is now.

Instead, the man who has Labour's votes lined up for his succession at the right time has decided that this is not the right time. No Chancellor ever likes the cost of war. But this Chancellor is more intellectually committed to the American way than anyone else in the Cabinet. His loyalist MPs, better drilled than any faction in the House, are seeking Blair votes tonight.

The Prime Minister spends barely three minutes practising his speech before the portrait of Sir Walter Scott before he leaves for the conclave of the Parliamentary Labour Party. Once he is gone, Alastair Campbell begins the phone campaign.

The first call will not help the vote tonight, but is designed to make the Communications and Strategy Director feel better. The

Guardian, which is against the war, has published the planned piece by Bill Clinton, but has 'somehow omitted' his most direct appeal to Labour MPs.

Campbell calls Ben Bradshaw, an ambitious junior Minister who, while Robin Cook's job is empty, is standing in as Leader of the House. 'Get onto the *Guardian* and protest,' he says. He then listens for just a moment. 'No, you can go over the top. Malice is the word. Tell them. It was only a few words. Pure malice.' He laughs and puts the phone down.

He next makes a prediction. 'Sixty–forty. We'll be going to Washington tomorrow.'

No one rushes to pack.

Then he calls the top television political editors, whose words are pouring quietly and without pause now from the tiny office set.

'Adam, hi, you might like to know that…' he says to the face of Sky News.

'Andrew, yes there are some resignations but…' he tells the man from the BBC.

'Nick, yes, yes, he's definitely gone but, well, he's not exactly the…' he explains to ITV.

He tells them who may be resigning and who is not. Then he hears his own words played back to him from the political editors' mouths. This is true interactive television.

Campbell's greatest worry is a junior Home Office Minister who is not well known but who, in the informal ratings given to government members by the Number Ten team, has earned the high accolade of 'serious'. This man's reason for going, it seems, is not conscience but reason, a much more dangerous cause. If he believed the bombing of Iraq would work, he says that he would swallow his moral qualms. But he does not think it will work.

Campbell cannot change this decision, but he can affect how it

is perceived. He questions the soon-to-be-former Minister about how his announcement will be made, what he will be saying and when. Satisfied, he turns to a call from the White House.

The desks in the outer office are strewn with Foreign Office papers showing alleged inconsistencies between what Robin Cook said when he was Foreign Secretary and what he said last night. The resignation speech was impressive, it is grudgingly conceded, but not as deadly as it might have been. Much of the ammunition against him is therefore left unused. The unstable truce, negotiated on the way to the Azores and represented in the resignation letter and the Prime Minister's response to it, has to be maintained.

There are no Americans in the room, but they are there in spirit. David Manning is their medium. George Bush has complimented Labour Whips on being the 'best in the world'. At the White House they will be happy to forget the 122 MPs who voted against those Whips three weeks ago if the revolt can be held at roughly the same level. That is what is needed to keep the Prime Minister's hold and the Anglo-American policy secure.

If Tony Blair fails, the invasion of Iraq will go on regardless. A week ago Donald Rumsfeld may have been incautious in saying that Washington would not be stopped by Britain's political doubts. He was not being untruthful. The effect on the world of a unilateral American victory is one of the outcomes of defeat tonight that Tony Blair fears the most.

The television pundits are now surveying the post-Blair landscape. They predict that he will 'scrape through' the test, but ask each other enthusiastically about what will happen if he does not.

In other corners Downing Street business goes on. The Queen will have to make a broadcast to the troops. Since the Palace works at a somewhat slower pace than Number Ten, 'perhaps work could begin'.

Big Ben strikes eleven o'clock. Tony Blair has been closeted with his colleagues for an hour. Campbell has been picking up text messages from friendly MPs who are listening to the Prime Minister's address to them. He expresses a perverse kind of confidence to the team in the office. 'If this is going horribly wrong now, then we're all finished. But if it isn't – and I don't think it is – the most wobbly MPs will not want to be on the wrong side of the winning argument tonight.'

Ten minutes later the current draft of the afternoon speech is carried to Gordon Brown's office, next along the corridor. The two men's Westminster doors, almost side by side, are a miniature version of the cuckoo clock in Downing Street.

Ten minutes after that, Sally Morgan's return signals the end of the Labour meeting. 'He was brilliant,' she says, seconds before Tony Blair comes into the room. 'The speech was just what we needed it to be, not too difficult, not too intellectual. That's what we need this afternoon.'

The team turns immediately to the new text.

Some of the words were written on Saturday, the day before the Prime Minister survived the passage to the Azores. He has written most of them alone, in longhand in blue ink, high in the small sitting room of the flat, surrounded by books on Islam and John Lennon CDs.

The thoughts behind the speech go back farther, to 11 September 2001 and before.

Even when Bill Clinton was President there were British and American missile strikes on Iraq in support of the United Nations effort to disarm Saddam Hussein. Seven months before the attacks on the World Trade Center, Tony Blair and George Bush discussed the danger from Iraqi chemical and biological weapons.

But the day on which black clouds replaced the concrete in the

sky over Manhattan was decisive. Almost immediately, what had been a worry became a priority.

Has Tony Blair become some sort of reckless crusader over Iraq? He thinks not. In September 2002 his analysis of relations between Washington, London and Baghdad was clear and cold. It rested on six essential points to which he and his aides would regularly return:

- Saddam Hussein's past aggression, present support for terrorism and future ambitions made him a clear threat to his enemies. He was not the only threat, but he was a threat nonetheless.
- The United States and Britain were among his enemies.
- The people of the United States, still angered by the 11 September attacks, still sensing unfinished business from the first Gulf War twelve years before, would support a war on Iraq.
- Gulf War 2 – President George W. Bush vs Saddam Hussein – would happen whatever anyone else said or did.
- The people of Britain, continental Europe and most of the rest of the world would not even begin to support a war unless they had a say in it through the United Nations.
- It would be more damaging to long-term world peace and security if the Americans alone defeated Saddam Hussein than if they had international support to do so.

These six points – when scribbled on the back of an envelope or set out on a printed page – are not exceptional. What is exceptional is the certainty required to follow their logic. It is Tony Blair's certainty that has been the surprise for many Labour MPs.

Those MPs who today are shocked to find themselves having to lobby their leader against war have not been listening to him carefully enough. They are like friends of a man who has long said he

is going to leave his wife or take holy orders. He has given every sign of doing what he has decided is the right thing. He has put his affairs in order and spoken about his plans to anyone who cared to listen. But few did care to listen, because few believed that he would actually do it.

There are about fifty 'wobbler' MPs who might be persuaded in these last hours. There is no point now in bringing in either those who have always hated Tony Blair or those who have hated him since he sacked them from their jobs. The MPs who will be invited onto the Prime Minister's sofa are those who have come to see themselves as Blairites, but have been left behind by what Tony Blair has become.

The Prime Minister and his team are themselves partly to blame. Although there is less 'spinning' of stories to press and Parliament than in earlier years of this Labour government, some MPs have moved directly from not believing Blair speeches to not bothering to read them.

Most of the incomprehension of Tony Blair today comes simply from Labour MPs preferring their own view of him, as someone with a magic instinct for winning elections, to his own view of himself, as someone prepared to use in his own way what he has won. His ambitions have changed. He has built up what he calls 'layers of toughness', and not everyone has noticed.

There are thirty minutes left before the speech to the House must begin. On the refectory table in the long side of the L-shaped room, the Prime Minister sits staring at a newly typed text, a fountain pen and a dozen bottles of whisky.

The bottles are for signature, not sustenance. Every week, whether they like their leader or not, MPs send up bottles and photographs to be signed for supporters. Perhaps some of that

wristwork and ink (there is a certain dexterity required to write one's name against a curved piece of glass) will bring an extra vote or two tonight. In the meantime each new signature is a brief pause between waves of thoughts.

Suddenly there is a sound of rustling paper that is almost orchestral. As pages with blue-inked amendments are pushed out to the typists outside, everyone has a point to make. David Manning does not like the word 'concessions' for the thousands of pages of 'incomprehensible Arabic' offered to the UN by Saddam last December. Morgan still thinks it takes a long time for the speech to get any rhythm.

With fifteen minutes remaining, Tony Blair stands up and asks: 'History – in or out?' There is a long section in the text about appeasement in the thirties. Some like it. Some don't. There may be veteran Labour MPs, those who did their thinking soon after World War II, who will support a war only if it is dressed up in anti-Fascist clothes. But there are no votes to be won in attacking 'new appeasers'; there are too many of them. Perhaps a 'general link between then and now' may do some good, says Manning. His look suggests that the result would not grade highly in an Oxford history paper.

Ten minutes before the deadline, the Prime Minister asks what precisely Jacques Chirac said about the UN veto and when. He does not get an immediate answer. There is no raising of voice. An e-mail is sent – and to general amazement is returned from the Foreign Office in ninety seconds.

Questions ping about the room. Has Abu Mazen been appointed Palestinian Prime Minister yet? If we go to Washington tomorrow, can we see Kofi in New York? Have any trade union leaders said anything useful? Would it be useful if they did? Why is that bloody 'woodentop' MP always on the TV?

With three minutes to go, it is still not clear about the US trip tomorrow.

'The Americans would do better showing off some other allies,' says Campbell. 'How about Denmark?'

Manning looks perturbed: there were phone calls last night which suggested that a British visit to the White House was what Bush wanted.

This is where Tony Blair the parliamentarian is separated from Tony Blair the leader of a Downing Street team. He alone has to make the choices now about what he will say and not say, based on the audience in the Chamber down below. He is no longer focused on Campbell or Powell. At other times they seem to be managing him. At this time they are only watching him.

Various dates and details are still in dispute right up until the moment that Morgan calls 'That's it.' The difference between Monday nights and Tuesday mornings has become clouded by fatigue. Santiago time? Washington time? No more time.

With a minute to go, as Tony Blair is putting on his jacket, Campbell comes away from the paper-strewn table and gives the answer. 'We're not going to Washington tomorrow. He doesn't want to go and he doesn't think that Bush wants us to go.'

There is little time for the relief to sink in. The team has to scramble for its places in the House of Commons Chamber. The Prime Minister carries his speech in the same file in which it arrived. Some of the words are different. Many wavy blue lines remain under passages that may or may not be used.

Just before Tony Blair left school in Edinburgh in 1971, before he became a student rock singer and long before he entered politics, he performed his last starring role of boyhood in R.C. Sherriff's play about the First World War, *Journey's End*. This is not a great classic, but in 1928 it had been good enough to attract Laurence Olivier, and it was a great favourite of Sir Winston Churchill.

In Tony Blair's student age of peace, love, music and protest it

was a popular play for schools – not just because it was a hoary old melodrama of the sort proven to survive classroom acting, but for exactly the reason that it had first been popular, its portrayal of mud and blood and the madness of those who send young men to fight. Tony Blair followed in Olivier's footsteps onto the Fettes school stage and enjoyed a small triumph as Captain Stanhope, the single-minded officer who, by means of barbed wire, blinkers and bottles of whisky, turns a section of the Western Front into his own private war.

Since becoming Prime Minister Tony Blair has had to focus his mind on more wars than he could then have imagined. But the man who has committed British troops in Africa, the Balkans and Afghanistan, and who is about to commit them on a massive scale in Iraq if he succeeds today, still recalls the play well.

Journey's End is more than just an anti-war play. Through its scenes in the trenches of St Quentin it explores the nature of an officer's behaviour, the laying bare of that moral part of a man's nature which makes him reckless. This was the aspect that originally interested its writer R.C. Sherriff, more than any cry for peace.

'That play had a real effect on me,' as Tony Blair remembers it thirty-two years on. 'You have to isolate yourself when people are dying from what you have yourself decided to do. You have to put barriers in your mind.' He is already a British war leader. Now he is bidding to put more British troops in the field than at any time since 1945.

He certainly looks the part much more now, as he speaks to the Commons, than he can have done as a schoolboy.

'*Tall, slimly built but broad shouldered. His dark hair is carefully brushed. His uniform is well cut and cared for. He is good looking, rather from attractive features than healthy good looks. There is a pallor under his skin and dark shadows under his eyes.*' That is how

the playwright introduces his Captain, and it is not so far from how Tony Blair's admirers on the front bench see him now. Some of them seem quite damp around the eyes.

Even Clare Short seems moved. She was right in a way: Tony Blair has been reckless of his own reputation. He has not always been the type of man who would risk what he is risking now. He sets out the stakes for MPs, 'the pattern of international relations for the next generation'. Someone has to take a risk for that; and he is taking it.

He doggedly sets out his case. If we weaken now, Saddam Hussein and all dictators will know they can do as they will. The Iraqi government has had twelve years in which to meet the promises it made after its last defeat. Saddam is evil: he punishes dissenters by cutting out their tongues and leaving them tied to lampposts till they die.

The interventions from MPs are feebler than in many less significant debates than this. This is less of a debating speech than a dialogue, dull in parts, as Sally Morgan knew, a man weighing arguments with himself. The dissenting Labour MP, former actress Glenda Jackson, tries mockingly to make a point. He just ignores her. The one-time star of the school stage at Fettes disdains the attentions of the Oscar-winner.

The logic is strong. David Manning nods approvingly as Morgan looks nervous. The 'appeasement' passage passes with embarrassed quiet and only one or two cries of 'Come off it.' After all the editing upstairs, he says little more than that the future cannot be known before it happens – with which all can surely agree. But the piling of argument on argument is brutal.

Logic, however, will only take him so far. Those whom he wins over, he wins by showing so powerfully his confidence that he is right.

To many of his critics such certainty is the way of madness.

Some have decided that he is already mad, made so by too long in power, too many admirers, too many enemies and too little listening carefully to either friends or foes. The isolation of Downing Street, even friends say, has changed the warm, open, accommodating young MP and lawyer they used to know. The man who could always talk around an issue is now taking one view and holding it like a creed.

Others stress the actor in Tony Blair, the promising courtroom barrister, the somewhat less promising imitator of rock stars. They say that he is feigning his peculiar mad certainty, that he needs something to hide his obedience to American orders.

His supporters, at Westminster and in his own team, see a different certainty, a powerful private conviction, on show today, which they trust and can take for their own.

By the time he has reached the rhetorical ending, his words have run as well as they could ever run. He sits down to cheers and cries of shame from precisely where he expected them to be.

By Commons custom, he must now sit and wait for a decent interval before he can leave the Chamber. This is a bit of private space. He may look as though he is under heavy assault, but he is barely listening. He is busy planning what comes next.

The enemy bombardment is not as strong as it might have been. If the 'appeasement' passage has succeeded in any way, it is in drawing the opening speaker for his Labour opponents, Peter Kilfoyle, to say that the only person he has ever appeased in his life is Mrs Kilfoyle. This resort, so soon, to Commons badinage hurts the opposition case. By 3 p.m. the Prime Minister can return to his office to find out what matters most: if minds have changed.

While the commentators are already penning their praise ('...never made a more difficult speech, or a more important one, or a better one': *The Times*), the mood back in David Hanson's

office is flat, deflated, still anxious. The team has heard all the lines before. Morgan wonders aloud whether MPs abandoned the usual dramatics of debate merely in deference to the seriousness of the occasion. Was it as good as it looked? How many 'wobblers' would hear the Prime Minister's certainty and support it? The job is not over. There are votes to be turned and people to be seen.

Just as the first candidates for the sofa are queuing outside, there is a call from Washington. The Americans are straining at the leash.

'What are you saying?' asks Campbell. The long frame of the marathon runner looks suddenly stiff.

'Well, if you could just hold it till we've got this out of the way, it would be very helpful,' he responds, looking around in case there are any strangers in the room.

'Your special forces? They have journalists with them?' Campbell is not easy to surprise. He looks seriously surprised now.

'Do you mean middle of the night our time?' he asks. It sounds as though somebody somewhere is soon going to get a nasty shock.

'Just bear in mind that we have to be in Brussels on Friday, and the Prime Minister will want to be here when…' Campbell gives a sigh and goes into Tony Blair's office just as the first MPs are about to arrive. The door is slammed shut.

The 'wobblers' queue up like children protesting to the head-master about compulsory sport. They know why they are here, but they do not know quite what to say.

'What shall we ask him?' asks one of Morgan's 'malcontents'.

'I don't know,' says one of Campbell's embittered ex-Ministers, the 'sackees'.

'Let's see how it goes,' says one of Tony Blair's long-time opponents, whom only the most optimistic Whip would wheel in.

Morgan leafs through one of Armstrong's lists and points at a

name. 'Is he religious?' she asks. 'If he is, I'll put Paul Boateng onto him.' Gordon Brown's deputy, the only black face in the Cabinet, is put on standby for Christian persuasion.

A solid Scottish MP called Brian Donohoe is waiting by the back wall. The room is so cramped that he is keeping close company with a yoghurt-making machine. He does not claim to be particularly religious himself, but he has several thousand Catholic constituents who put the Pope's views before their Prime Minister's. He goes in for his chat.

The team is getting hungry. 'I haven't eaten so much pizza and crisps since the election,' says Morgan, one of the few in Downing Street not to adopt, or at least pretend to have adopted, a fierce fitness regime. 'And what's happened to these new crisps?' she muses. 'Blue used to be salt-and-vinegar, and green cheese-and-onion. Now it's the other way round.'

Sandwiches arrive. Anyone who goes out for dinner has great trouble getting back. Parliament Square is blocked by police and protesters.

Robin Cook is talking in the Central Lobby, making what seems like a trial run for a TV statement. 'The Prime Minister and his team are shocked, totally shocked. They persuaded themselves that they would get the Second Resolution. Now they are on a precipice. And just because you find yourself on a precipice, it does not mean you should jump off.'

The debate is straggling to a close. There are dire predictions of a new Hundred Years War, dire reminiscences of the Blitz in World War II. But it does not matter by now. The MPs are merely talking amongst themselves, or for their local newspapers.

Tony Blair returns to hear the final speeches. He has no speaking of his own ahead of him now, only waiting. He is not quite here with either his barrackers or his backers.

The Chamber is packed. The vote is called. The first and most critical is on the dissenters' amendment. Allies and opponents, friends and enemies, all jostle together through the voting lobbies. Brian Donohoe, one of the last MPs to be personally spoken to by the Prime Minister, is one of the abstainers.

A few minutes later Hilary Armstrong returns to her Chief Whip's place on the government front bench, whispers the result in her boss's ear and receives a congratulatory smile in return. The government has held its ground. It has suffered an enormous rebellion, but prevented a catastrophic rout.

Robin Cook approaches almost as though he still had his old place. Tony Blair smiles. John Prescott sneers. The others turn aside. The man who thinks the coming war (it may have already come) to be unjust and unwise is left to join the small fry of Parliament, the Liberal Democrats, the Welsh and Scottish Nationalists, the others who are all now wondering.

Back in the Prime Minister's office, Tony Blair thanks everyone in a short last speech of the day. There is relief, but no air of triumph.

More whisky bottles are signed. None is opened. A single can of beer sits, half full, among the teacups. The Prime Minister returns to Downing Street.

David Hanson is left to close his office.

Pat MacFadden is left searching for some way to ease the adrenalin from his veins.

Are they happy?

MacFadden is not happy.

'It's the size of it,' he says.

The size of the revolt, one of the biggest in modern times?

'No, not the size of the revolt, the size of the issue. The war.'

Wednesday, 19 March

Morning headlines…British Parliament votes for war…level of Labour rebellion higher than in last Iraq vote…139 Labour MPs defy Tony Blair…Saddam Hussein rejects American ultimatum…

This is not called a War Cabinet, but it looks very much like a War Cabinet.

A tall, stooping man places his gold-braided cap on the table beside a cheap cream telephone, grasps his shiny black case, goes in and sits down by a pillar.

'Good morning, Sir Michael,' says a messenger. Sir Michael Boyce, Chief of the Defence Staff, does not seem to notice. He is a former submariner, a cerebral strategist rather than a charismatic commander. His service has been in a solitary profession which even naval men see as favouring the single-minded. Too much looking through periscopes, they say.

Another tall man, with no stoop, a domed head and an elegant pale grey suit arrives. He is not a military man. He is too quiet and contained to be a politician. The papers in his hand bear large red St Andrew's crosses. This is John Scarlett, former British spy, now chief recipient and judge of British spying, the Chairman of the Joint Intelligence Committee. His job is to know what is happening in Iraq, to know anything that can be known about Saddam Hussein, to predict what will happen when war begins.

The Cabinet Secretary is here, the head of the Civil Service, rough-faced, rough-suited-and-tied, a Treasury man by training and temperament. Since the vote last night he has been able to put away his file on the constitutional niceties of a Prime Minister's resignation and concentrate on how the warriors can get what they need.

In wars of the past the Cabinet Secretary would not only have run the government, but also been the key man at the Prime Minister's side. He would have done not only his own job, but much of Campbell's and Powell's too. But this is a different Downing Street, more modern and efficient as the team claims, more maverick and political as their critics allege.

On the other side of the room Gordon Brown is talking to Clare Short, who looks gloomy, as though she has just seen the picture of herself on a newspaper front page and the headline 'REVOLT-ING'. Gordon Brown, who perhaps has not yet read the *Daily Mirror*, looks no more burdened than usual.

Tony Blair enters the Cabinet Room directly from the den, with David Manning and Jonathan Powell at his side. He looks nothing like the tired man of ten days ago. The adrenalin is still flowing fast. He says he has slept well.

Jack Straw, who is swapping football stories with Campbell, is normally proud of his ability to sleep anywhere at any time, 'on my feet, like a horse, if I have to'. It was 5 a.m. before he could calm down sufficiently to sleep after the debate, he says.

These first members of what is known in the Cabinet Office as an 'Ad Hoc Committee' have to learn 'the form' for what will be daily early-morning meetings until the war is deemed over. Scarlett, the intelligence chief, will open with a briefing on Iraq itself, defections from the regime, daily news of its leadership and strength. Straw will brief on the overnight 'diplomatic traffic', the Chief of the Defence Staff on his soldiers, sailors and airmen, and

the International Development Secretary on the 'Phase Four' plans for humanitarian aid. The Prime Minister will speak whenever he wants to – which, on the evidence of the first meeting, is very often.

Afterwards he is going back to Parliament to thank the MPs who voted for him. The newspapers are hailing him this morning for his triumph, predicting that success will put 'iron in his soul'. His critics in the Labour Party, even those impervious to the persuasion of the Prime Minister, are sensitive to the moods of the press. Tony Blair ought to be safe, unless there is some catastrophe of war.

Preparation for Questions today is desultory by comparison with the tense planning last week. The Whips and strategists, even the civil servants, are still replaying to themselves the scenes of last night, exchanging anecdotes of 'wobblers' who went the right way, 'runners' who did not, and how it all looked from the 'box', the officials' pews beneath the Press Gallery where those who write the speeches can give their masters points for delivery.

Pat MacFadden still looks anxious. He is leaving later today for Scotland. This weekend is the Scottish Labour Conference in Dundee. Tony Blair is due to make the main address. The natives are not quite rioting, but they are very restless.

Before he goes, MacFadden has to write a letter from the Prime Minister to all Labour constituencies, explaining directly to them why the war is necessary. He pulls at a chocolate bar from the basement machine ('I'm starting on this stuff early today'), and ponders: 'We have to do the process, do the business, but we must never forget what has been voted for.'

Others in the Campbell zone are in more combative mood. 'The BBC put George Galloway on the *Today* programme again this morning. Saddam's best friend in Parliament. MP for Baghdad

Central. Totally unrepresentative. It's an insult. What can we do about it? And then there's that pompous, self-righteous...'

The tirade is interrupted by Vera, the messenger, who brings a bunch of red carnations from the front door and a card: 'God bless you Tony. I am so ashamed of my elected members.'

Campbell himself comes by. For him last night is 'just one more bloody thing over'. He is thinking forward to Brussels tomorrow. 'Imagine having an Economic Reform Summit amid all this.'

Is Chirac going to make a great fuss?

'Who knows? If the French want to rant, let them rant.'

Two hours later, Prime Minister's Questions are over for another week. Tony Blair has reassured MPs about the importance of Britain's 'thirty-seven army chaplains, twelve RAF chaplains and nineteen to twenty navy chaplains'; he has quoted President Bush at some length on the importance of the Middle East road map; and he has failed to reassure an MP from Halifax about the use of bombs that 'melt people'.

Afterwards in his office, the focus of conversation is still on Dundee and Brussels rather than Baghdad or Kirkuk.

'Iraqis are one thing; the Scottish Labour Party is quite another,' says John Reid.

Campbell is looking at MacFadden's letter. He wants more about avoiding civilian casualties. 'Back to the drawing board, Pat.'

According to a Foreign Office note, Chirac is claiming that the British have made a 'deformation' of his views on the veto.

'Does he mean we got the translation wrong?'

There is general amusement. 'If the French want to grandstand tomorrow, they will. That's what they're in the mood for,' says a male voice outside.

Jack Straw is asking about a secure phone on which he can talk to Colin Powell in the US State Department. There is not one here.

Tony Blair is signing cards to congratulate a woman on her hundredth birthday.

'What's her name?' he asks.

'It's in the computer,' comes a voice from the travelling secretariat.

He also signs a bottle of champagne, two bottles of whisky, a postcard of Westminster Bridge and a copy of *Labour's First Year* by J. Hall, a Penguin first edition, 1946.

John Prescott comes past in a rush. 'He's disgusting, that man. He must be dealt with.' It is not clear whether he is talking about a Scot, or a Frenchman, or one of his own still-dissident MPs. He does not seem to have in mind Saddam Hussein.

Thursday, 20 March

Morning headlines…American 'decapitation' attack on Saddam Hussein begins war…condition of target not known…troops advance to the Iraqi border…France, Germany and Russia strongly object at UN…

George Bush began the bombing of Baghdad rather earlier than his best ally expected. At 8 a.m. the members of the 'War Cabinet' have just begun a discussion of how they heard the news, whether they were reading red boxes in bed, watching football or enjoying the sleep of the just. It is becoming a bit like that 1997 election-night game: 'Were you still up for Portillo?'

The Downing Street machinery was set to work soon after 3 a.m. by Jackie, the grey-trouser-suited, black Duty Office Clerk, who was sleeping in the first-floor spare bedroom. Her job was to respond to alarmed politicians and agitated journalists. 'Calls came from all over.'

'Did you have a good night?' asks a messenger innocently as she makes shorter-than-usual strides across the hall this morning.

'You could say that, yeah,' she replies.

Jack Straw has a permanent instruction to his staff that he is not to be woken unless a decision is needed from him. 'News is not reason enough. Otherwise it is all very well for me. I go back to sleep. But it is not so good for my wife.' Last night Colin Powell and the Downing Street switchboard succeeded in subverting this

system by asking the duty policeman outside his house to ring, repeatedly, on his entryphone.

Gordon Brown woke up at 5 a.m., turned on the radio and learnt the news from the BBC. His worry now is what the French will do, what the Russians will think, what the markets will say.

John Prescott learnt it from the BBC somewhat later, and did not like what he heard. 'The *Today* programme's got to understand there's a war on. They have to be told that they can't always have answers. We have just got to shut down.'

He does not mean that the BBC should be 'shut down', though he would not weep for that this morning, only that Ministers should not respond to every request for information. A vigorous debate begins. If the government does not make its case, 'the airwaves are wide open for the other side to tell lies'.

Someone tries to persuade the Deputy Prime Minister that Geoff Hoon, the Defence Secretary, did well on that morning's *Today*. 'Fine,' says Prescott. 'Fine' is not a towering accolade in his vocabulary. His anger against the BBC and its man in Baghdad is temporarily directed towards a white china cup. This is certainly the most dangerous moment in that piece of porcelain's life.

The Defence Secretary himself is with the Chief of the Defence Staff. They make a well-matched pair, the disapproving, slightly disdainful submariner and the cool, faraway politician. Hoon was woken by his office with the news, and knows that he now faces as many sleepless nights as the father of a newborn baby.

John Reid, the least cool and distant man in the room, has the most immediate political concern. Who can speak to the Scottish conference? The Prime Minister can be excused duty now.

'Prescott?' suggests Brown in a whisper, returning from the ethereal realms to the real one, and questioning hoarsely whether the conference is really necessary this weekend at all.

Reid sighs. 'You can get back to the big stuff. I'll sort this out.'

'Big stuff?' this very Scottish Chancellor smiles. 'You're the one who's dealing with Lanarkshire.'

The Attorney General, Lord Goldsmith, discusses the fine points of a forgotten court case. He is not relaxed at all. A late arrival into politics after a lucrative career at the Bar, he has already borne the first brunt of responsibility by declaring the war legal.

Campbell never likes to seem surprised. Part of his persona is to be the man who knows tomorrow's news today. Yesterday in the office in the Commons he was told by phone only of preliminary war moves by US special forces in Iraq. He did not know that the 'decapitation attempt' was coming.

When he was woken, he and the Prime Minister spoke. 'It was all slightly dreamy,' says his partner Fiona Millar. 'Like the night Diana died.'

The Americans have begun by bombing a building where Saddam was thought to be at work. Whether they have killed him, no one knows. Tony Blair calls the beginning of war 'momentous', but he does not know, nor does anyone, whether it has ended with the first shot.

The full Cabinet has been called for 10 a.m. The meetings merge one into another, with Tony Blair moving between the Cabinet Room, his den and the outer office, which has the Duty Clerks and the latest information.

Paul Boateng is first to arrive for Cabinet, fresh from his duty as Sally Morgan's secret weapon against religious dissenters. He sits next to the grandfather clock outside the door, as though seeking shelter in an exposed place.

The Media and Culture Secretary arrives, neat, well-dressed, the model New Labour Minister. Morgan brought her friend Tessa Jowell back early from a tour of India so that she could lobby MPs

last night. This morning the two women have fewer worries in Downing Street than in Jowell's own south London constituency, Dulwich, a place of large houses and larger Labour consciences. The activists there may not be rioting in the streets, but they are not at all happy about the war, and many claim a better grasp of UN law than Lord Goldsmith.

Hilary Armstrong is still enjoying the congratulations for last night. 'My job's over now,' she says to Prescott, who snorts in reply.

The Defence Secretary is still trying to hear the latest news from the front so that he can report to his colleagues. He comes out of the den, looks for a phone and finds one underneath the Chief of the Defence Staff's headgear. Struggling to hear over the hubbub of Scottish political chat, Burnley Football Club chat and chat about where everyone will sit in Cabinet now that Robin Cook has gone, he shouts: 'Anyone hurt? How long to interpret the data?' He hears the answers, breathes out hard and returns to his boss.

The Cabinet meeting itself is short, just enough time to tell Ministers what most of them already know: that war has begun and Saddam has probably, but not definitely, escaped decapitation. David Blunkett, the Home Secretary, is first back into the hall, guided by his seeing-eye dog, Sadie. 'It all sounds disastrous,' he says, to the consternation of passing secretaries. He is talking about Dundee, not Baghdad.

There is fierce talk about what Jack McConnell, the Labour leader in the Scottish Parliament, should be doing about his angry countrymen. Did Tony ever ring him that morning when Cherie told him to? Gordon Brown has almost lost his voice and cannot make the speech. No one wants to make the speech. Why is this conference happening at all? It would cost £350,000 to cancel it. Right, that's a good reason.

Inside the den, the Prime Minister needs a speech of his own, a sooner than expected TV address to the nation announcing that

British troops will tonight be engaged from 'air, land and sea'. This afternoon he has to leave for Brussels. The BBC is summoned and, after negotiations which enrage the sleep-deprived Campbell and have him calling tartly for commercial rivals Sky and LBC to do the job instead, a large Corporation crew is setting up a studio in the White Drawing Room.

'How should I start?'

Tony Blair is sitting at the same desk, in the same position, as he was when preparing to meet the women of ITV. But this time the question is not rhetorical. He wants his Communications Director to give him an answer.

In front of him is an outline of the broadcast text drafted after the team saw the Bush version in the Azores. How should he begin it?

'My fellow Americans…' suggests Campbell.

Tony Blair does not even begin to laugh. There follows a testy discussion of whether 'tonight' will seem the right word when the address is broadcast in Korea.

'It doesn't matter if the Koreans misunderstand the bloody time.'

'What about the end?' asks the Prime Minister, impatiently scratching the side of his face. He is now being made up so that he can deliver the message. As soon as it is complete he will fly to Brussels and President Chirac. 'I want to end with "God bless you",' he says.

There is a noisy team revolt in which every player appears to be complaining at once.

'That's not a good idea.'

'Oh no?' says the Prime Minister, raising his voice.

'You're talking to lots of people who don't want chaplains pushing stuff down their throats.'

'You are the most ungodly lot I have ever…' Tony Blair's words fade away into the make-up artist's flannel.

'Ungodly? Count me out,' complains speechwriter Peter Hyman, who is Jewish and whose plum-coloured neck wound is throbbing hard.

'That's not the same God,' the protesters insist.

'It is the same God,' says the Prime Minister, scribbling fiercely on his text.

Outside Downing Street there is much discussion of whence comes Tony Blair's certainty about this war. Is it from the *realpolitik* requirement to follow an American President (the poodle principle)? From religious concepts which he and George Bush share, even if his advisers mostly do not (the 'Did you pray together?' question)? Or the thoughtful weighing of argument (weapons of mass destruction held by dictators of mass destruction versus the unavoidable bombing of children)?

The answer, if there can yet be an answer, is 'all of the above'.

The *realpolitik* is very real. Britain and the United States are linked at almost every level of military and security operations. British Prime Ministers have long needed the strongest of reasons to refuse American requests for support.

Tony Blair and George Bush trust each other to keep to a bargain more than most leaders can do. Shared religion has helped to cement that trust. Either man may yet be disappointed.

Most of all, Tony Blair believes that the policy will work – for Britain and for the world. He does not know that it will work. He knows that he cannot know. But he has weighed the balance for himself. The Prime Minister asks his team to act on his behalf, to plot on his behalf, to persuade on his behalf. He does not ask it to think on his behalf.

Inside Downing Street there is less discussion of Tony Blair's confidence than there is outside. The big decisions have long been

made – last June, last December, at the end of January. For Campbell there is enough to do in following through the consequences.

No one will talk about religion. Advisers will only say that the Prime Minister is less patient than before, less ready to make time for the consensual approach, more confident, more ready to take some risks before he moves on. He believes that Bill Clinton's error, which went far beyond the absurdities of the Monica Lewinsky affair, was not to make that change – to shy away from his big domestic and overseas ambitions, not least a tougher pursuit of Osama bin Laden.

For everyone in Tony Blair's team an explanation for his certainty is much less important than the certainty itself. The Prime Minister regularly takes small pieces of advice: the broadcast to the nation ends not with God but on a lame 'Thank you.' But knowledge that the boss is not going to change his mind on the big issue provides the concrete on which everything else is built.

Before the team leaves for Northolt airport, the broadcasters remain the topic of tired talk. The television producer wants to give a copy of the text to the BBC's political editor in advance. No, she can't hand it out. News of the address has already begun to leak. It could endanger British troops. What the hell is going on?

The TV van-driver wants to leave from the back of Downing Street, ahead of the motorcade. 'Just remember: when we get our own dictatorship here, I will control all the media,' rasps Campbell.

'That will be good: non-stop football videos from Burnley,' says the Prime Minister.

A note of some new internal opinion polling is produced. The 'slow-handclapping war women fiasco' did not turn out as badly as first feared. It may have even hardened support among viewers

who felt that the Prime Minister was being unfairly harassed.

Videos of the various 'duff' recordings of the TV address, the ones that were a minute too long, where words were fluffed and zooms were not approved by Campbell, are left behind to be 'stamped on'. There has to be a quick call with Bush before the convoy can depart. What is the first appointment in Brussels? Berlusconi. Then dinner with Jacques Chirac and a few friends.

Friday, 21 March

Morning headlines...ground attack begins...Baghdad bombed for second night...two US marines killed in action...twelve dead in helicopter crash in Kuwait...Rumsfeld declares 'Operation Iraqi Freedom'...

News of the first dead Britons comes while the Prime Minister is asleep in Brussels. Campbell is told at 5 a.m. There has been a helicopter crash in Kuwait. On the 'Jack Straw principle', he lets Tony Blair sleep on.

Both men come down to breakfast at the British Ambassador's ornate residence looking troubled. Campbell is bluff and tracksuited but still anxious. The blackest rings around the Prime Minister's eyes have gone, but he is very pale.

The meeting last night with Silvio Berlusconi, held in a peculiar 'Brussels glass box' in the Justus Lipsius building, was 'fine' as long as the pair were prepared to talk like animals at a zoo or like 'ordinary people' in a focus group, with aides and visitors watching through a screen. They soon grew tired of that, and soon afterwards stopped altogether.

The Italian Prime Minister looked strangely orange. Perhaps it was the peculiar artificial light. Perhaps he had just been made up for television. Perhaps all Prime Ministers should wear 'concealer' all the time in days like these.

At the heads of government dinner, as has been well reported by

now, the British and French leaders barely spoke. Their handshake was of the lightest, shortest kind, the category known by diplomats as a 'Robert Mugabe'.

Breakfast is in the Ambassador's dining room, under the swiveling eyes of tapestried Indian dancers and elephants. While the croissants are being brought from the kitchen, the travelling Downing Street office is already being moved to a new glass room, a short distance away, back in Justus Lipsius.

One elaborate gilded box, filled with bare-breasted angels and Anglepoise lamps, is being abandoned. In another, Tony Blair and an expanded team can eat, admire the wall-hangings and plan the machinations ahead.

The knights' zone of Number Ten has been moved to Brussels. Only Sir David Manning has stayed in London. This is not his world. This is the 'unreal world', a European summit. A senior official is turning the pages of a draft communiqué while the Prime Minister turns over a piece of orange.

'You need to get in the stuff about zones of protection,' he says.

Tony Blair nods. Any reference to protecting rather than bombing is a benefit.

Campbell's spirits are perking up. He rarely seems miserable for long. He looks down at the text messages on his phone.

Jack Straw has shown 'very good tone' on the *Today* programme, reports the spokesman on duty in London. The Foreign Secretary, aided by the ex-Apathy sound recordist, has been giving the BBC his thoughts about the French in another high-gilt corner of the building.

Gordon Brown is going to be late. He arrived early at the airport, decided to leave without his motorcade escort, and is stuck in traffic.

'What's the difference between Jacques Chirac and Graeme Souness?' asks Campbell.

Tony Blair, sensing some jibe too far about the French President and the manager of the Foreign Secretary's constituency football team, waves his friend to be quiet. He ticks his way through the agenda, saying where he wants to delegate ('Gordon can take the load'), where the Spaniards are sensitive (not a time to trouble his main ally, José Maria Aznar), and where the French may try to make up lost ground (smiles and English marmalade all round).

There is a brief discussion of appointments to top European jobs. 'The Greeks will only accept a Socialist for this,' says the official. The Prime Minister nods wearily at a word he does not often now hear. At least he is going to miss Labour's conference in Dundee.

Straw comes in brightly and late after his *Today* interview. 'It was amazing. They allowed me to speak. They were almost respectful.'

'Even the BBC can be respectful when people are dead,' says Campbell, cutting up his Embassy bacon.

'And I got in three sycophantic references to the Prime Minister, one to Gordon Brown and none to the International Development Secretary.'

For the second time this morning, Tony Blair curbs the breakfast laughter. He does not want any more jokes about Clare Short. She can be breakfasted upon when all this has gone cold. He picks up a piece of toast and makes a point.

'The extraordinary thing about these meetings now,' he muses, 'is how the French and Germans don't automatically get their own way any more. Aznar and Berlusconi have made a big difference, but the others won't put up with it either.'

The meeting is over. Later in the morning, as the summit leaders arrive for their first session, the French President is not among those giving public condolences on the British deaths. This is

beginning to be reported alongside increasingly colourful accounts of the chill last night. The murmurs in the corridors are beginning to resemble a party at which the host and hostess can only be addressed separately, without even reference to each other. The French want the EU to issue a statement of regret that the war has begun. The British want a statement of regret that Saddam failed to disarm. In the end they regret nothing. This is the Piaf summit. Then rumours filter out from a session on economic reform that Chirac has passed a note of regret for the casualties. That is some small progress for those who judge progress by good manners and good will.

Just before the meetings are over for the day, the unmistakable back of the French President can be seen among a thin crowd of chatting officials. The great bulk turns. He briefly withdraws. Perhaps there are still too many witnesses for what he wants to do. When he comes back out of the room, he draws Tony Blair away from Alastair Campbell as though by simple force of gravity. He takes the British Prime Minister along the empty corridor, settles him against the half-lit wall and makes his points.

French aides approach and are motioned away. To some observers it looks like the meeting of a gangster with a man who owes him money. But others are more optimistic. The hosts of the house-party are sorting out their differences, or so it seems.

Few people are there to see the scene itself. But everyone who can decently watch does watch. German Chancellor Gerhard Schröder, who gave initial support to the stance of his friend Tony Blair until his voters told him otherwise, looks at his colleagues and seems to be wondering, as is everyone else, who will win and who will lose.

Saturday, 22 March

Morning headlines…'Shock and Awe' over Baghdad…
Chirac attacks 'illegal' assault…British and American
forces surround Basra…US 3rd Infantry overcomes
Iraqi defenders at Nasiriya…

Security men have built a maze of metal fences in front of the railings between Downing Street and Whitehall. Today there is to be the biggest protest in London since the war began.

Politicians find it harder to criticise Tony Blair when British forces are fighting and risking their lives. But tens of thousands of voters feel under no such constraint. The cries of 'Not in my name' have begun well before breakfast.

Parliament Square has become a tent city. Its inhabitants move between the blocked entrance to the House of Commons and the blocked entrance to the Prime Minister's domain. The statue of Sir Winston Churchill, once the easy refuge of TV cameramen seeking comparisons with a wartime past, is now hidden, protected by a wooden jacket daubed with red and black graffiti. It is as if the great man has come back to life as a model in a Milanese fashion school.

The Number Ten team – and anyone who does not arrive by limousine – must now trek around complicated metal tunnels and fences, turn left and right through bends and straits, before they reach the main Downing Street gate. It looks a bit like a queue for

a busy ride at Disneyland. 'You should see what it looks like inside,' retorts one of the Scottish contingent who is early for the Saturday Cabinet.

The police are looking nervously at a white van marked 'Ecovert' which is parked where parking is discouraged. Those in the queue for the great Number Ten attraction this morning have time to wonder what Ecovert might be. Is it the e-mail name of a covert surveillance company, some sort of elaborate double bluff? Is it an ecological group, some reassurance to the angry youthful crowds that Tony Blair is as keen now on Kyoto, the green agenda, an end to global warming, as he has ever claimed to be?

The Defence Secretary, Geoff Hoon, and Sir Michael Boyce, the Chief of the Defence Staff, arrive. The mood inside Number Ten has been slowly warming to its 'CDS', the gloomy submariner. Yesterday afternoon he spoke firmly to the War Cabinet about the need to take Saddam and show him dead. That is the kind of approach that nervous politicians appreciate when the intelligence chiefs keep saying that the Iraqi leader 'could be anywhere'.

Last night politicians and demonstrators saw the first showing of America's 'Shock and Awe' bombardment of Baghdad. Tony Blair had a preview a few weeks ago when the US Defense Department mocked up a video of the burning sky in an underground bunker on the other side of Whitehall. He did not go again for the pictures of the real thing. He watched the twenty-four-hour news coverage on the TV at home like everyone else, and less of it than most.

In the Number Ten hallway there is the ceremonial rolling out of a new carpet. The dirty mud-stained russet with the arrow-shaped 'Robin Cook rip' is being replaced with clean squares of black. A red vacuum cleaner, marked 'Hetty' in handwritten capitals, is picking up the last bits of fluff.

The stern blonde weekend Press Officer, standing guard by the

front hall in a black suit, is one of the first to tread the new surface which the men from the Ecovert company have laid. 'There's no trouble yet,' she says, listening to the occasional shouts of 'Tony out' and 'Don't attack Iraq', 'but by the end of the day we'll all be under house arrest in here.'

Just before 9 a.m. Tony Blair comes down from the flat, does not notice the carpet, steps past Hetty and walks down to the den. He is in blue jeans.

'Damn,' says the Press Officer, 'I could have worn jeans. But then, if I had,' she goes on, 'he would have been in Paul Smith or Gucci. That's what always happens.'

The Prime Minister has a peacetime habit of occasionally entertaining the media with plum-coloured jackets and cartoon-monogrammed cuffs. The inspiration for these is often credited to the therapist friend of Cherie Blair, the fashion model, fraudster's mistress and cause of deep Downing Street rifts, Carole Caplin. In the days leading to war neither Caplin nor the plum jacket has been seen.

Sir Michael Boyce, as ever in heavy braided uniform, begins his retelling of the 'Awe of Baghdad'.

Clare Short arrives. She is feeling 'much happier today', she says. 'It's terrible when you're under such assault, but I've experienced it before.' She is not talking about the bombing victims but the battering in the press which she has taken since her decision to stay in the Cabinet.

She is satisfied that the 'precision weapons' are working and that civilian casualties are being kept to a minimum. Her former friends outside in the streets today, who used to look to her as 'the conscience of the Labour Party', are not satisfied.

It is a smaller War Cabinet than usual. John Prescott is away calming Labour supporters on the east coast of England. John

Reid is calling in favours and knocking heads together to curb the dissidents of Dundee.

Lord Goldsmith is talking of 'legality' to the Cabinet Secretary again, a little away from the coffee bar. He is standing against the 1940 picture of the smashed house in the countryside, the one without either a roof or any sign of violence. Its pink and grey interior could be from a promotional picture of what a precisely guided weapon can do.

On the way into the meeting, he barely gives the image a second look. On the way out, having had more than a lawyer's fill of 'Shock and Awe', he looks at it again. The Cabinet's text for the day? He gives a muffled 'Oh, God.'

Boyce leaves with his white Admiral's hat and with new instructions from the Prime Minister to announce that very large numbers of Iraqi oil wells have been mined by Saddam Hussein. This is a 'pernicious threat to the country's future prosperity'.

Every morning there is an argument about how much intelligence information to divulge. What are the risks? What are the benefits? Today the Cabinet's worries about the effect of 'Shock and Awe' on British opinion outweigh the natural caution of the security services. When Jack Straw talks about 'the battle out there' he means in Parliament Square.

Campbell is struck by the fact that the Iraqis have not organised more visits by TV journalists to hospitals full of wounded civilians: 'That must mean their Information Ministry has taken heavy hits.' Just as Finance and Foreign Ministers often have more in common with their international counterparts than with fellow members of their own governments, so Campbell sees effortlessly through the eyes of his counterparts on the Tigris.

Straw still thinks that the TV message from Baghdad is a problem. Reporters are saying that 'Shock and Awe' is a deadly show for the media, a form of aerial theatre, like the worst pornog-

raphy, in which real people get hurt. The Foreign Secretary never uses the 'S and A' phrase himself, but he is very aware of the impact of others using it. The bombing may be precise, but to noisy doubters in the street – fewer but angrier than a month ago – and to one or two quiet doubters in Downing Street, it did not look very precise.

Straw is one of the last to step out into Downing Street, before his short walk through the side gate to the Foreign Office court-yard. He is on his way to brief his colleagues in the newly opened emergency bunker.

Once all the politicians have gone, a man in a suit from Cabinet Office 'facilities' can finally vent his frustration with the carpet lay-ers. 'They've spent all this time, and the bloody thing's the wrong size. It should be 550 centimetres and they've made it 533 cen-timetres. You just wouldn't believe it. They'll have to come and fix it next week. Nice colour, though.'

<p style="text-align:center">*　　*　　*</p>

There are two framed letters from Margaret Thatcher on the bunker wall, one from Edward Heath and another from David Owen. When the men and women of the Foreign Office emer-gency unit leave their underground dormitories, the first thing they see above the kitchen sink is this set of yellowing congratula-tions from past political leaders.

Jack Straw's wartime retreat is not used very often. Edward Heath's note of thanks, marked by his tiny crabbed initials, was to those who had worked and slept in this corner of Whitehall dur-ing Jordan's 'Black September' more than thirty years ago.

The letter from David Owen, Labour's glamorous young Foreign Secretary in 1978, thanked staff for their efforts while the Congo National Front was carving up its colonial enemies in Zaire: on that occasion it was the French who sent in their Foreign Legion while Britain and America stayed at home.

Margaret Thatcher congratulated everyone for their parts in the Falklands victory in 1982 and the Yemen civil war in 1986. They deserved 'great credit' for the Falklands, she wrote, underlining the words and adding a handwritten 'well done', which is now partially obscured by tomato sauce. Of all those emergencies, only that in the South Atlantic has yet ended fully in peace.

This morning the underground Foreign Office rooms are filling fast. A week ago they were empty. Since Monday they have been manned twenty-four hours a day. In Downing Street the clocks may still show Moscow time, but here the third dial, next to London and Washington, is set for Baghdad.

Six small offices are connected by low corridors, stained white walls and scuffed blue floors that much need the attentions of Ecovert and Hetty. The mood is more military than diplomatic. A young team of shift-workers, operating both encrypted computers and antique compressed-air communication tubes, gathers intelligence, turns it into memoranda and tries to make sure that the right people read it.

There are sheets of written guidance at varying levels of security. No one is supposed to use the word 'war'. This is an 'armed conflict'. But when 'Our Man in Amman' wants to know what to tell King Abdullah of Jordan about the assault on Iraq he is not looking for a vocabulary lesson.

When Edward Heath's men were here in 1970, the British government was hedging its bets between Abdullah's father, the young King Hussein, who it thought might lose the Jordanian throne, and Yasser Arafat, who it feared might win. The month of 'Black September', like the crisis today, had begun with hijacked aircraft, then a terrorist novelty, and ended with a bloody war. Heath, who opposes Tony Blair and George Bush now, had horrified the Americans then by releasing a captured female hijacker to the Red Cross. For a few months Leila Khaled was as famous as Osama bin

Laden is today, and relations between London and Washington were like those today between Washington and Paris.

The British were frightened of the terrorist threat. So, with somewhat better cause, was King Hussein, who took many years to forgive the infirmity of his British friends. When Saddam Hussein invaded Kuwait in August 1990, the King opposed the action to drive him out. Today, his son is supporting the British and Americans, but can be forgiven for needing both supportive calls from Tony Blair and a regular ambassadorial brief.

In Room Five, Jack Straw is reporting back to his officials. Here he has his own diplomatic knights, his own 'smart casual' office chief in a thin black sweater and just-visible red tie, his own old-jumpered political director, fresh from his day in Brussels helping to draft the 'Piaf communiqué'.

Every morning now a senior official from the Foreign Secretary's vast upstairs office, with its high views over St James's Park and close-packed mementos of Empire, takes a brief from the Desk Officer down here. The Desk Officer's job is to have attended already the 6 a.m. Cabinet Intelligence (CIG) meeting in the Cabinet Office. There is then an Iraqi political meeting at 7.30 a.m. before Jack Straw is briefed for the War Cabinet. Behind the decisions of Downing Street a bureaucratic web is growing.

At the long Room Five table the subjects include Gordon Brown's new plans to engage his fellow Finance Ministers around the world in paying for post-war reconstruction. These economic men are thought likely to cause less political fuss than their diplomatic colleagues: 'Excellent, sensible,' agrees the meeting.

There is talk of the post-war political conference ('Better not a Spaniard in the chair') and a post-war currency for Iraq ('What sort of legal authority do we need for British companies to print the banknotes?'). In the Foreign Office 'We do pre-war and post-war but not war.'

In Room Three, the head of the Iraqi Political Section is eating a neatly cut half-hamburger in a half-bun. The television is turned to twenty-four-hour news: part of the job here is to compare what reporters say is happening with what other sources say is happening. The port of Umm Qasr has been taken – but didn't they say that yesterday? Basra is under British control – no.

Away from here, in the more rarefied knightly zones of David Manning and John Scarlett, the questions are about what events matter, what images and reports are important and what are just entertainment. But there is a more basic task of simply assessing whether an act of attack or resistance has happened at all. That is the job of Room Three.

Jack Straw's bunker has a 'Crisis Manager', a 'Deputy Crisis Manager' and an 'Assistant'. One of them is always here on duty. Only some of the crises are Iraqi. Others are closer to home. A bunker that gets fresh air only twice a decade is not likely to be the best-equipped. 'This bedroom is a pit. Where is the second scrambled egg pan?'

There are signs warning of the time it takes the shell-shaped cylinders to shuttle through the communication tubes. Five minutes might have been good enough for Churchill, but Alastair Campbell is used to a quicker service. Why is the Baghdad clock not working in Comms? Those clunky blue phones are said to connect us with other emergency bunkers around the country. They would be more believable in a Cuban missile crisis movie.

The rhythm of the rooms is set by random queries, random events and the regular need for a restricted 'Briefing to Ministers' every day at 2 p.m. But there are permanent issues too, like money. 'This is not coming off the budget,' says a nervous knight, pointing to a line of numbers as the session ends in Room Five.

'No, not ours,' says Jack Straw cheerfully. 'We're just running the policy.'

Has the Prime Minister been down to see them yet? No one has seen him. But next time the Foreign Office emergency kitchen is reopened for business, next time the dormitories discharge new diplomatic 'shifters' into the artificial light, there will doubtless be a letter from Tony Blair (do you remember him?) somewhere on the greasy wall.

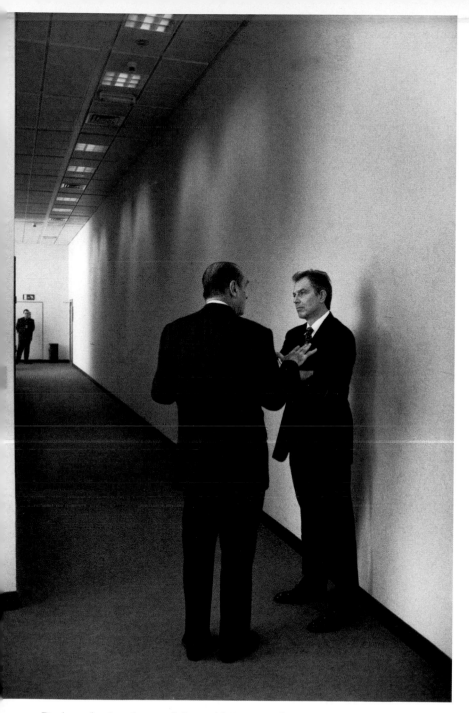

During a frank exchange of views with Jacques Chirac in a Brussels corridor, interpreters and aides are waved away: 12 p.m., 21 March.

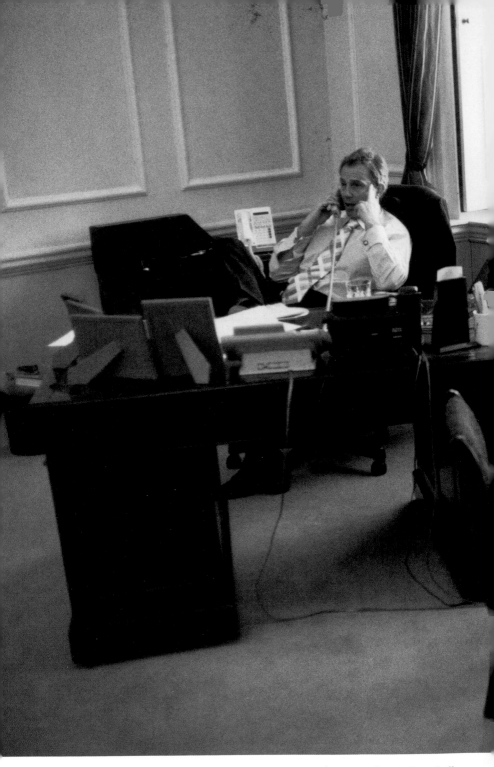

Tony Blair, watched over by his Communications Director, Alastair Campbell, urges the Middle East 'road map' on Yasser Arafat in the Downing Street office, known as the 'den': 3.30 p.m., 14 March.

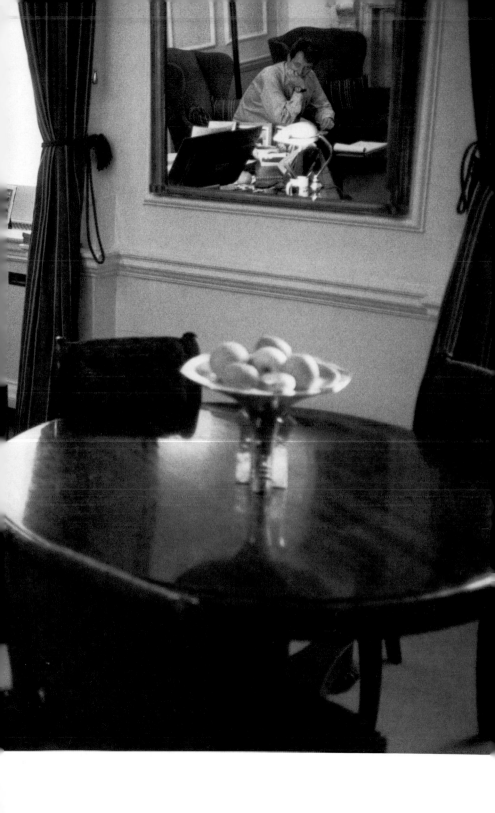

The Number Ten 'team' watches Tony Blair go up the main staircase,
past the portraits of previous Prime Ministers, to sell the Middle East 'road map'
to a sceptical press: 3.55 p.m., 14 March.

Above: In the sitting room of the Downing Street flat, Tony Blair starts work on the 'Back me or I quit' speech he will make to the House of Commons: 2.30 p.m., 15 March.

Below: Alastair Campbell takes Tony Blair through draft communiqués during the flight to the Azores. Also in the 'flying office' are, from left, Private Secretary Matthew Rycroft, government spokesman Godric Smith, foreign policy adviser Sir David Manning, and Chief of Staff Jonathan Powell: 1.10 p.m., 16 March.

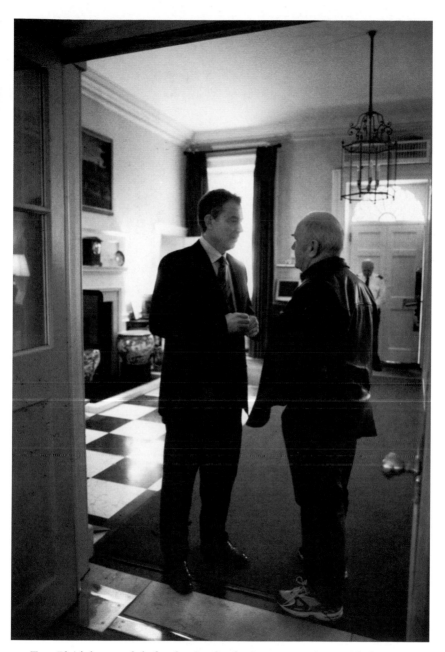

Tony Blair's last words before leaving for the Azores summit are with the Party Chairman, John Reid, whose job is to spend the day urging MPs to back the government and Ministers not to resign: 10.50 a.m., 16 March.

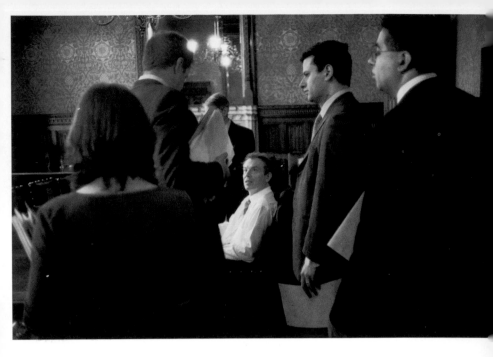

Above: In the Prime Minister's office at the House of Commons, Tony Blair finalises his speech asking MPs to back war with Iraq: 12.20 p.m., 18 March.

Below: Tony Blair, flanked by Sally Morgan and Pat MacFadden, sits and ponders with the team whether they have done enough to win over Labour MPs in the crucial Commons vote: 9 p.m., 18 March.

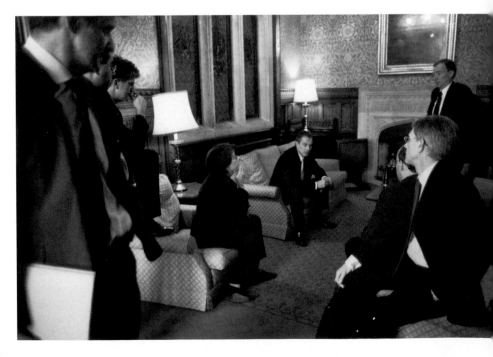

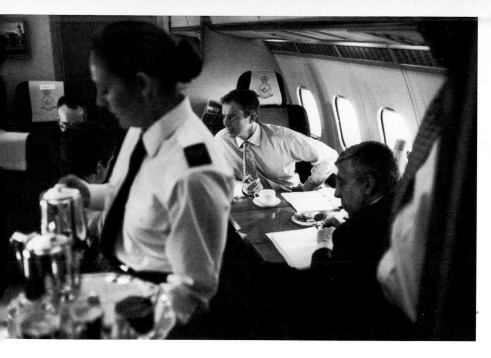

Above: On the Royal Flight to Brussels Tony Blair discusses with Jack Straw how to deal with French opposition at the European Council: 5.45 p.m., 20 March.

Below: In the Prime Minister's outer office in Downing Street, it has been a Sunday of bad news – deaths from 'friendly fire' and the capture of servicemen. President Bush, on television, is predicting hard times ahead: 6.22 p.m., 23 March.

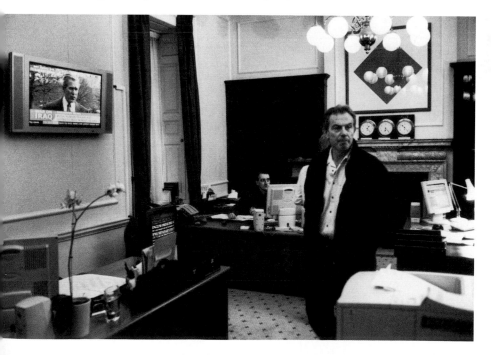

At a press conference aboard the flight to Andrews Air Force Base, USA, journalists ask about the role of the United Nations in post-war Iraq: 9 p.m., 26 March.

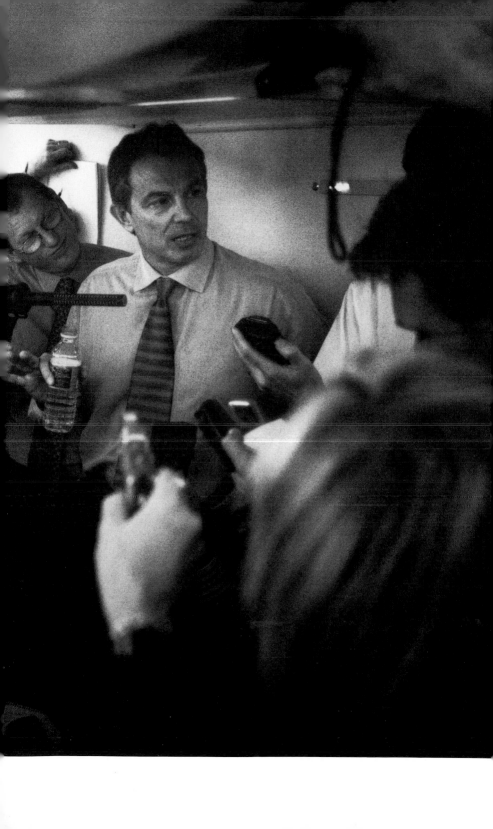

Prime Minister and President prepare for their 'walk in the woods'
while Secretary of State Colin Powell and Foreign Secretary Jack Straw take a
Camp David golf cart: 11.20 a.m., 27 March.

Hillsborough Castle, Northern Ireland, becomes coalition headquarters for the day.
Clockwise from left: Alastair Campbell, George Bush, Tony Blair,
US National Security Adviser Condoleezza Rice,
White House spokesman Ari Fleischer, Jack Straw and Colin Powell: 9.30 a.m., 8 April.

Above: The hall of the Blairs' flat is both playroom for the three-year-old Leo and a place for playing the blues: 7.45 p.m., 2 April.

Below: Cabinet papers and newspapers as Tony and Cherie Blair fly back from RAF Lyneham to London after a visit to servicemen and their families: 5.30 p.m., 3 April.

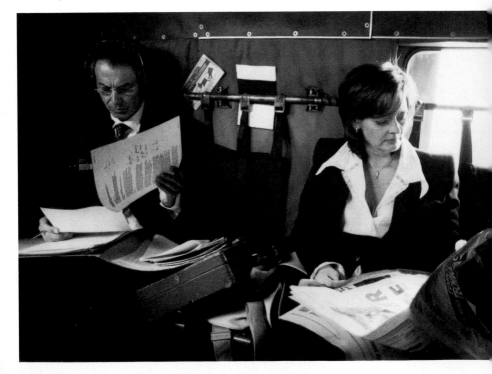

Sunday, 23 March

*Morning headlines...US Patriot missile brings down British
Tornado, killing two...British journalist feared dead in
American advance...two Royal Navy helicopters collide...
Basra close to surrender...*

It is late afternoon on the first fierce spring day of the year. The
sunlight pours in a torrent through Sally Morgan's window, which
looks onto St James's Park, and through her door, which is nor-
mally closed, into the hall outside the Cabinet Room, which is
always dark. In the rare natural light it is possible to see the cracks
and warps in the polished furniture, the slight bowing of the
grandfather clock, the bent angles of the armoire drawers. The
long oil-painted landscape of Richmond Hill is no longer fixed in
permanent twilight. Only the white marble busts of Pitt and
Disraeli are unmoved on a day which has been perfect for anyone
protesting about the war, not so good for those fighting it.

Tony Blair has been in the country. He returns cheerfully, in
jeans and open-necked blue shirt, his face coloured by safely sit-
ting outside where the only mooing and moaning is from farm
animals. His mood does not stay light for long.

'Anyone watching TV would think we'd lost already,' says an
angry voice in the outer office. 'There's nothing but Americans
killing Brits, Brits killing Brits, Americans being captured, even a
dead reporter.'

The Chief of the Defence Staff begins a lecture on how 'friendly fire' is a factor in all warfare, always has been and always will be.

'We have helicopters that can't stay in the sky and missiles that don't know whose side they're on. Isn't there any good news?'

John Reid was not in the best of spirits before he arrived. He is wearing a thick dark suit, and has just returned from Dundee.

'How were the heathen Scots?' John Prescott asks.

'It was a shambles to begin with, but by the time I got up to speak it was just about OK. The idea that it might be immoral to leave Saddam in power seemed impossible for anyone to grasp. The trouble today,' he goes on, 'is that there's been no political message from us. If we don't say something positive, the negative is all that anyone else is going to give.'

Prescott seems about to begin another tirade against the BBC and all its satellite friends when he is distracted by Reid's choice of dress.

'I'm glad you've noticed I'm in a suit,' says the Labour Party Chairman.

His leather jacket and trainers at Downing Street last Sunday attracted hostile comment in the Scottish press. He was accused of dressing to draw attention away from bad news. Worse still, the appropriateness of his 'old man's' jeans was compared to Geoff Hoon's suburban choice, harped on just as eagerly by the press, of lounge loafer shoes for the desert.

Prescott has a theory about Sunday dress. The working-class types, like him and now Reid, are in their best clobber. The middle-class types, most of the civil servants and Hoon, wear cashmere and 'smart casual'. The public-school toffs, like the Prime Minister and Jonathan Powell, wear jeans, sometimes, like the head of MI6, very old jeans.

Campbell is in a tracksuit. He has just run seventeen miles of the London Marathon course. He had begun a run yesterday but

had suffered an asthma attack and stopped. It didn't help that the police and protesters had between them closed almost every road on his way home. So yes, the government had not done much to accentuate the positive. Can't a guy get a break?

Clare Short arrives. 'What are we all doing here on such a beautiful day?' she asks airily. It is as well that Gordon Brown is here, or his friend might have been strangled by her trademark scarf.

Short is pleased because her 'good ship *Sir Galahad*' is about to dock in Umm Qasr and distribute food to the needy. This might be a positive media message. It is not likely to clear the front pages of stories about colliding helicopters.

Just before 5.30 p.m. the military men have finished their preliminary briefing for the Prime Minister. Boyce and Hoon are back in the hall now, talking to each other, not being talked to, like teacher's pets who have somehow let the side down.

Campbell goes into the den. He is working on ways to persuade the broadcasters not to show Iraqi propaganda pictures of American prisoners of war. Tony Blair has to make a broadcast to British forces. Should he stress his sorrow at the deaths, or the justice of the cause? A bit of both is the answer, but more of the 'just cause'. That is Boyce's view too.

The last job of the Press Officer's weekend is to manage the cameramen and the reporter who are to record the forces' message. They arrive early, when the War Cabinet has barely begun, and want to be 'done and out' as quickly as they can. They are keen to catch the natural light, they say.

Everyone outside recognises that this is a nasty day of war. No one says that the policy might be wrong. The way of suggesting that is to wonder, only very quietly, what Gordon Brown might be thinking.

* * *

For anyone interested in the machinery of government, these have been instructive weeks. In the time of John Major and Margaret Thatcher, indeed at most times, the main departments of British government have had distinct personalities, often distinct policies, on the future of Europe, on the Middle East, on inflation, on incomes policy and much else. Under Tony Blair this has been much less the case.

Number Ten has become more powerful. Jack Straw's Foreign Office would not be able to stand against this Prime Minister as Geoffrey Howe stood against Thatcher or Douglas Hurd against Major, or even Robin Cook against Tony Blair in his first term. Doubters call this alliance of minds 'Horace Wilsonism'.

Horace Wilson was the most formidable mandarin of the 1930s. Neville Chamberlain was his boss. Together they promoted the appeasement of Hitler, that policy of which so much has been spoken in the past few days. At the time almost everyone agreed with them.

'Horace Wilsonism' is very efficient when the policy is right. It does not give scope for questioning if a principle begins to look wrong. Wilson and Chamberlain fell together. While Churchill was changing the policy, its architect found a new career coordinating local government in Bournemouth.

On this war the central commitment has been fixed, not seriously challenged, for at least a year. Tony Blair and George Bush arrived individually at the view that there was a new threat to the world from terrorist groups linked to terrorist states and terrorist weapons of mass destruction. Both men made speeches. Only some people listened.

Tony Blair wanted the President to attempt to win the backing of the UN to disarm Iraq. But, if full backing were not possible, Britain would not let Washington down.

Inside Downing Street this 'Blair map' of the way ahead has

been the map by which the team has steered. What if it comes to seem wrong? Was there ever a Cabinet meeting at which the policy might genuinely have changed? No, there was not.

Nervous observers look to Gordon Brown, the one man with the strength, the independence and the distance from the policy who could oppose it and be heard. No one suggests he is in fact sceptical about the war. As far as anyone knows the Chancellor's view on so sensitive a matter, he supports it. But, if the inner circle's certainty needed to be broken, he is the one man who could look in from the outside, make his case, and break it.

It is just before six o'clock. There is now only yellowing daylight in the dark hall. Long shadows lie on the green carpet as though on the grass outside. It feels more than ever now as though nothing has changed here since Chamberlain appeased and Churchill stamped. The air is dusty and still.

Only the TV crew, increasingly restless at the lost time and light, disturbs the scene. Clare Short is not alone in wondering why anyone should be inside on such a day. The reporter is sitting with a damp napkin round his neck to keep the make-up from his collar. He has just torn it off for a fresh one when the International Development Secretary rockets out through the door. Gordon Brown leaves next, hardly less fast.

Others stay and chat while the cameramen set up their store. John Reid is grimacing hard. 'It's going to be a hairy few days,' says Sally Morgan, who enters her office just as the sun and shadows disappear. The two talk more of Dundee and demonstrations. For those who have spent so long in Labour politics, there is a calm in discussing it, a 'default mode' when they have done too much Iraq.

Yet why does all this 'friendly fire' come at once? Are they just practising out there? Remember that the soldiers pulling the

triggers are no more than 'pumped-up teenagers'. That is what the Generals warn. There are bound to be mistakes. Submariner Boyce may be gloomy, cautious, often mildly irritating, but he is right about that.

For Jack Straw the answer is 'Poisson theory'. When deaths by 'friendly fire' come in groups, as they have today, that is not a foretaste of rising numbers to come. It is the random way. They bunch like London buses or shark deaths in Florida.

Nineteenth-century French mathematician Simeon Denis Poisson has been used by nervous military thinkers before. Prussian data on how many cavalry officers per campaign would be kicked to death by horses were subject to the same comforting thought.

For Jack Straw, almost always the most cheerful and intellectually open of Tony Blair's Cabinet, a little philosophy of numbers is just what a tired mind needs. For Tony Blair, there is still the last broadcast. As he goes upstairs to change into an interview suit, the face of George Bush in the White House rose garden is on the flatscreen TV. The President is predicting 'a tough time ahead'.

The camera crew is ready. The reporter is grumbling about when the tape can be released. Morgan's office is now the Prime Minister's make-up room. Why can't he be made up in the same room as the cameras? President Bush, the Press Officer says sternly, has just been caught on film combing his hair. If the same disaster were to happen on her watch, it would not be good for her career.

Campbell arrives and suggests to the reporter a question he might ask. The Press Officer looks down the viewfinder to check the cameraman's shot. The Prime Minister arrives, blue-suited instead of blue-jeaned, and the business is swiftly done. He stumbles once over 'oil wells', which Saddam has mined, and 'oil wealth', which, unless the Iraqi dictator has gone into bank robbery, he has

not. The cause for which men have died, he says, is of 'vital impor-
tance for the world', and that is forcefully said.

Afterwards, when the light in the hall is wholly gone, he talks
quietly of how 'This is always the worst time, when the fighting
has begun and the end is not near, or even known.' He might be
the veteran of a hundred wars. He is right, he says. He sincerely
believes he is right. Then he goes upstairs to see his wife and chil-
dren and the train set.

Monday, 24 March

Morning headlines…American and British troops face
fierce resistance in southern Iraq…advance continues
on Baghdad…Iraqi TV shows four dead US soldiers
and five prisoners…

Leo Blair waits until the War Cabinet is well over before beginning
his deliveries. A fortnight ago it was said that one clear beneficiary
of a Blair defeat would be the Blair family: Downing Street, what-
ever anyone loyally claims, is not the ideal place for an indepen-
dent wife and teenage children to live their lives. But for three-
year-old Leo today, watched from a discreet distance by his nanny,
it does not look bad at all. Once the Ministers have gone back to
their departments and the language of the house is fit for impres-
sionable ears again, it is a place full of possibilities, yards of old
soft carpet, calming decoration (grandeur does not begin till far
above his height), staff who find him amusing and a father who,
however busy, is close at hand.

Before 8.30 a.m., while John Reid is abusing the media for their
obsession with 'friendly fire' and Iraqi civilian deaths, while the
intelligence services deal patiently with politicians who want
Saddam dead immediately in front of their eyes, while health and
education advisers complain that their coffee routine has been
interrupted by the war, the youngest Blair stays in the flat upstairs
with his large collection of stuffed Leo-the-lions. But later, unless

there is a delayed emissary from the days of diplomacy, a Russian or an Indonesian, or an urgent visitor from Ireland, there can be hours of near calm when a boy may safely distribute gifts.

Now that the war has begun, the action against Saddam Hussein is not directly run by the Prime Minister. There is no tempting sandpit of tanks for father or for son. That sort of thing all happens elsewhere, in the offices ruled by the man in the stiff white hat who is called CDS. But Tony Blair is still happy to take the opportunity to postpone other tasks that he never wished to do anyway.

At 11 a.m. Blair Senior is sitting back on his balcony outside the Cabinet Room. A sight of the sun, according to Vera, is vital for 'my Tone's morale'. While the Prime Minister prepares to report to MPs on Saddam, Jacques, Gerhard and other subjects from Brussels, there is an unseen visitor in his den. Tony Blair, face up to the sky, asks anyone who is in earshot a question about something the Chief of the Defence Staff said this morning. After only a few minutes, the sun goes behind a cloud. The wicker chairs are brought back inside and the sun-lover follows.

On the desk from where he is due to talk soon to President Bush is a chocolate Wagon Wheel that was not there before. This is not the kind of confection served at Brussels summits. The Prime Minister takes a bite and brushes away the crumbs that fall onto his draft statement for the Commons. He hands what remains to Campbell, who takes another bite. Campbell passes the relic to Jonathan Powell, who decides that this rite has gone far enough. He drops what is now slightly less than a half-wheel into the wastepaper basket.

Outside in the formal hall, between a tall polished clock and an armoire of secret drawers, the back of a blue plastic delivery truck is still just visible as its owner pulls it past the marble bust of Benjamin Disraeli.

* * *

In Iraq, according to the words for Parliament supplied by the Ministry of Defence, the southern oil fields are out of Saddam Hussein's control, there are only 'pockets of resistance' in Umm Qasr, and Basra cannot any longer be used as an Iraqi base. The American 5th Corps is about to engage the Medina division of the Republican Guard about sixty miles south of Baghdad. After four days of conflict, a 'crucial moment' is approaching.

In his room high in Westminster Tony Blair adds his own final rhetorical flourish: 'That we will encounter more difficulties and anxious moments in the days ahead is certain. But no less certain, indeed more so, is coalition victory.'

He pauses. His Generals are still doing better against their opponents in the desert than he himself is doing against his opponents here. The war is still unpopular. 'We have 40 per cent of the sand,' said the Chief of the Defence Staff this morning, and for once seemed quite pleased. Forty per cent political support would be welcome too.

John Prescott and Alastair Campbell, both known as 'the Deputy Prime Minister', the one because he is, the other because he seems to be, blame the press and TV. Today the War Cabinet was like a media-studies seminar in a metropolitan high school.

For Prescott the fault lies with the war reporters who, on American advice, the British forces have 'embedded' in their ranks. 'They've got no story,' he says. 'They want to get ahead of a story they don't have, they make things up, and then we have a crisis before we've even had a problem.'

For Campbell the editors are the trouble. 'They're a bloody disgrace. All they want to put on is a Baghdad B-movie every night. If they had had this lot running the airwaves in the Second World War every armchair in this place would have a man in lederhosen in it.'

Tony Blair takes a cautious path amid the rage of his lieu-

tenants. He writes of the 'tragedies and accidents' that are 'in the nature of war'. He writes of the 'vivid, shocking pain and blood' that is in the nature of 'instant live reporting of war'; those reports, he says, miss what they cannot immediately see, 'the barbarity, the hunger, the torture and the weapons of mass destruction'. He rejects any hint from his unofficial deputy that he might make further comparisons with Nazi Germany.

He stops and signs a bottle of champagne. He will report with pleasure on his meetings last Friday in Brussels. The French opposition to the war, his text states, is not shared by the newcomers to the European Union. It is most certainly not shared by the Poles.

With just a few minutes left before he must begin his statement, he leans back in his chair and asks the exact number of British casualties. 'If I'm asked, I say sixteen, right?' The Private Secretary who is charged with knowing such things goes outside to check. She finds news of a slightly better opinion poll on the war which is to be published in the *Guardian* tomorrow. This does not seem to cheer the Prime Minister very much.

Campbell, who usually cheers him most, is not here. He is giving his own speech, on the Mechanics of Crisis Management, at the Savoy Hotel.

Tuesday, 25 March

Morning headlines...American forces attack Republican Guard positions sixty miles from Baghdad...British artillery pounds pockets of resistance in Basra...protests rise at humanitarian 'horror'...

'Telic with a T.'

The shout comes down from the top of the stairs to the Campbell corridor.

'Telic. It's what we're calling it.'

The Press Officers are gathering at the bottom of the staircase, outside the waiting room. From all over Whitehall they have come. Every government spokesman, whether in education, health or sport, needs to understand why British forces are massing on the boundaries of Basra, pouring artillery fire where civilians need water.

This is the stairway where Robin Cook emerged to meet his unmaker. If he had climbed further after his first ascent from the Downing Street bowels, he would have reached the spot where the Press Officers are rising now. On the walls is a set of prized alphabet prints by the 1890s poster pioneer Sir William Nicholson. A is for Artist, B is for Beggar, C is for Countess, D is for Dandy...

'Good morning, Prime Minister.'

Tony Blair is on his way back to the flat from his morning military report in the den. The news from Basra has been bad. 'We

do not have real access,' says the Chief of the Defence Staff. 'A humanitarian horror is looming,' fear those who like to match what they hear in Cabinet against what they read in the newspapers. Resistance from Fedayeen militia, as predicted by Scarlett's intelligence men, is 'patchy but fierce'. Do British forces have to risk more Iraqi lives in order to risk fewer of their own?

The Prime Minister has to change clothes for a visit to Labour's National Executive Committee and his first Downing Street press conference since the war began. He promises to be quick.

E is for Executioner, F is for Flower Girl, G is for Gentleman...

'What's T for again?' says the voice.

'Telic. It's Greek for The End.'

'Great. Why couldn't we have "Operation Enduring Freedom" or "Sod Off Saddam" like everyone else?'

'If you remember, we had to send out the troops before we knew exactly what the end was. But the MoD knew there would eventually be one. So they called it Telic.'

John Reid comes into the hall with one of Gordon Brown's band of Scots. Iraq has temporarily replaced football as the favoured male metaphor. The talk between the two men sounds like military tactics, but its purpose is closer to the Gorbals than the Gulf.

'You see, the Republican Guard is here,' Reid says, tracing out a map on the back of his hand. 'And we are here. So we can go round the back and take them on – like this.' He clenches his fist, imagining the grim fate awaiting some dissident section of the Glasgow Labour Party.

The Defence Secretary and the Chief of the Defence Staff are still linked together as though by invisible wire-guidance. They are wondering, with one voice, what to do about TV reporters announcing the deaths of soldiers before the families have been informed. The Press Officers on the stairs are having to deal daily with complaints that news of casualties is being held back.

The Chief Whip, Hilary Armstrong, who delivered the vote for war but is not in the War Cabinet, asks the two men nervously, 'Is everything all right?'

It is Hoon the politician who answers: 'We're winning.'

Admiral Boyce looks at his watch. This is not as easy as it sounds when the owner's shirt-sleeve is hanging below the long, triple-gold-braided arm of his uniform, and the wearer is carrying both a briefcase and a hat.

John Prescott has given himself a new personal trademark in this campaign. As well as being known as a bar steward from his days as a trade unionist at sea ('Two pink gins,' Conservative MPs used to call out when he first spoke in the House of Commons); as well as being 'Two Jags Prescott' in his Cabinet career and 'Basher Prescott' after he punched the heckler in the 2001 election campaign, he has adopted a new Prescottish line in forgetting the names of those he does not like.

On the morning of the Commons war debate, he won both admirers and disbelievers for never having heard of the junior Health Minister who had just resigned with Robin Cook. Nobody else had heard much of him either, but it was thought that the Deputy Prime Minister ought to know. He is now impressing colleagues with his dislike for newspaper reports by 'that woman with the burqa who got lost in Afghanistan' and 'that bloke who pretended he had single-handedly recaptured the Falklands'.

The government aides on the stairs are paid to know the names of Yvonne Ridley of the *Daily Express*, who for a few days enjoyed fame as a prisoner of the Taliban, and Sir Max Hastings, first British correspondent into liberated Port Stanley, historian of the Korean War and editor of the *Daily Telegraph* and the *Evening Standard* for more than a decade. But today, to the Deputy Prime Minister, one 'unreliable' reptile of Fleet Street is much like any other.

P is for Publican, Q is for Quaker, R is for Robber, S is for Sportsman, T is for Trumpeter...

Pat MacFadden is waiting hound-like by the hall portrait of Sir Robert Walpole, the first occupant of the Prime Minister's residence and the man for whom this warren of knocked-together houses was made. Tony Blair is about to visit a group that George II's wily confidant would have recognised, barons who have been cleverly deprived of their power but to whom ritual respect must be paid. Labour's National Executive Committee, made up of trade union bosses and party activists almost always from the extreme left, used to give orders to Labour Prime Ministers. Now it only listens and protests.

This morning, with MacFadden as his pale escort, Tony Blair plans to tell his hostile colleagues that 50 per cent of Iraqis are out of work, and that the only way for their families to get food is to take the regime's vouchers to a shop which the regime has designated. Any disloyal behaviour, or even the hint of it, brings a phone call to the shop and an end to the food.

The NEC is not a group of the Labour Party that is naturally averse to central control. But with politeness, a bit of humility and a recognition that, whatever he says, there will be some members who want him out, the Prime Minister should survive unharmed.

By 10.45 a.m. he is back, still smiling. He has been told by his party opponents of all the terrible consequences of the war for the Middle East and the world. He has told them in return of his certainty that they are wrong. He is now able to begin the main business of the day.

The team assembles in the den to prepare him for the press conference. Upstairs in the wood-panelled State Dining Room, chairs are being arranged and cameras erected. Downstairs the Prime Minister has to decide what he wants to say.

Campbell, sitting as usual on the sofa in front of the high doors,

has not yet given up the earlier battles. 'One thing is bloody certain. You wouldn't want to go into the jungle with the British press. You'd never know what they were going to…'

Tony Blair purses his lips in a 'that's enough of that' smile and looks towards Jonathan Powell and David Manning who are sitting on hard chairs, sharing the room's round table with the loaded fruit bowl.

'Is Basra a military target? That's the big question which they ought to ask you,' says the Chief of Staff.

Manning, whose rehearsal style is to respond as he would in a genuine diplomatic row, comes in sharply. 'It depends what you mean. It is a strategic objective.'

What Powell actually means is: 'Are British forces shelling Basra, and inevitably killing some of the people we are trying to save, or are we waiting to be welcomed there?' No one answers that question.

'We are on course according to timetable,' says Campbell.

Tony Blair makes notes.

'We should not make too much of the timetable,' says Manning. 'Two days of sandstorms and we would be behind, and it would not mean anything.'

Tony Blair is growing impatient. 'What *is* happening in Basra?' he asks, stressing the 'is' loud and hard.

No one speaks.

He looks fiercely at Matthew Rycroft, the blond and normally jovial Private Secretary on Downing Street duty from the Foreign Office. Rycroft gets up to go outside. He is a civil servant being trained for the top; he likes to be certain before he speaks.

'No, Matthew,' says the Prime Minister, rising from his desk and pointing with an outstretched finger. 'Speak to me. Communicate.'

It is as though he is about to take off his jacket and say 'Come and get me.'

Manning takes over before there is any risk of accident. 'We are building a water-supply pipeline, Prime Minister.'

Rycroft returns to the fray. 'Remember, Mike Boyce says we don't have access to Basra.'

Tony Blair tries to move his mind away from grim thoughts of bombed city streets, reminding himself that there were desperate shortages before war began. He asks about what is happening outside the cities in what, after too much exposure to military jargon, he calls Iraq's 'agrarian areas'.

'They're just doing what they always do,' says Powell unhelpfully, evoking images of donkeys and dry fields of weeds.

Campbell stands up. 'We have got to get out the humanitarian stuff, the UN stuff. We are going to Camp David tomorrow but we are also going to Kofi Annan in New York.'

At the sound of the name of the UN Secretary General, the air immediately lightens. Tony Blair picks up a piece of paper from his desk. 'Do you know that 400,000 children have died in southern and central Iraq of avoidable diseases…?' He starts to write on his script. 'I've been asking for these numbers for ages,' he says, with another severe look at Rycroft.

Sally Morgan, who has been sitting quietly so far, suddenly moves forward. 'Yes, we want more Kofi. We seriously have to Kofi now.'

This regular African name has been absorbed, it seems, by the Anglo-Saxon taste for grammatical exotica. Kofi is a verb, an adjective, an adverb as well as a noun. Labour MPs like 'a Kofi plan'. 'We'd better Kofi this' means we had better obscure this bit of military planning with a good coat of humanitarian waffle. 'Let's speak Kofi' is what the mood in London demands.

George Bush is not a Kofi-phile. The United Nations, never popular in most parts of Washington, has been held in near contempt since the diplomatic 'Second Resolution' dances. The less

the White House has to Kofi, the better it likes it.

'Right,' says the reinvigorated Prime Minister. 'Throw some questions at me.'

'We're taking a lot of desert but no towns,' says Powell. 'What's going wrong?'

'We're not an army of occupation,' responds the man at the imaginary podium, now still with his feet up on his desk.

'Why haven't we found any chemical weapons?' asks Manning, as though he would really like an answer to that.

'We're concentrating first on the campaign,' says Tony Blair.

'Why has the UN oil-for-food programme not restarted?' asks Morgan.

The feet swing down from the desk. 'Yes, why hasn't it, Jonathan?'

'Well, the Russians want compensation for their oil companies, and the French don't think there's the right legal authority.' He pauses. 'Why aren't we in Baghdad?'

'Look,' says Campbell, beginning to lose his patience again. 'The main issue on their minds up there is the role that the UN is going to play when the war is over.'

'The UN is determined to have at least an umbrella role,' says Manning. 'And the Americans are dead against that,' he continues, like a tutor answering his own question in a class.

Tony Blair gets up and sends for make-up. 'That is only a matter of timing,' he says, with a confidence that is not widely shared.

Campbell takes one last opportunity to suggest a few points about media behaviour.

'I'll keep that for later,' Blair whispers with a grin.

Twenty minutes later, the questions to the Prime Minister, who is standing with a mug of tea between two large lion-shaped lamps, are in full swing. The session lasts for more than an hour. Tony

Blair's policy at these events is never to leave until the last point has been put, the last question posed, and a good many journalists have guiltily gone off for lunch. American correspondents, used to the 'two questions and that's it' philosophy of the White House, are amazed.

He makes one point that he has not rehearsed. He is asked whether he might have won more pre-war support in the Middle East and elsewhere if he had made his target 'dictators of mass destruction, not weapons'. The Prime Minister now admits what has been clear for many days, that he has been 'uncomfortable, frankly' within the context and confines of international law and United Nations resolutions. 'If Saddam had disarmed and remained in place,' Tony Blair would not have been 'comfortable' at all.

'To remove that regime will send a huge signal not only to Iraq but right across the world,' he says, using language that is more familiar in the city he is flying to tomorrow than the one in which he is speaking now. He looks across at Campbell and makes a few gentle points about the responsibility of the media to show the whole picture of a war, not just the part illustrated by the best footage.

The team members return to their offices. Tony Blair returns to the den for a 'secret' meeting with the Sinn Fein leaders Gerry Adams and Martin McGuinness. An event which would normally have been the pivot of a Prime Minister's day is now pushed into the diary where there is a short free space.

Tony Blair has personally devoted hundreds of hours, as did John Major before him, to attempting to persuade the IRA and its representatives to give up their war against the British; at the same time both Prime Ministers have had to persuade the Unionists, the Loyalists, all the many and various versions of the Protestant cause in Northern Ireland, that they are not about to be ruled from

Catholic Dublin. All the parties have grown used to Number Ten's keen attention.

Jonathan Powell has given more time to the Good Friday Agreement between the rival parties than to anything else: he has watched over the ceasefires, the beginning of local government, the suspension of local government, the bitter distrust that has survived even when most appetites for violence have been assuaged.

Lately Baghdad has required attention that Belfast has come to expect. Prospects for a permanent end to the IRA's war, carefully choreographed so that it appears in no way a surrender, have begun to fade. Hopes were higher only weeks ago. Momentum has been lost. Perhaps, the team has begun to think, the problem can be made part of the solution. Perhaps George Bush can be persuaded to help the Irish peace process. He has shown signs of interest. Perhaps the President might find the Irish peace process useful in promoting his best hopes for Iraq and its neighbours. He could find a useful comparison there to link hopes to a near-reality.

Perhaps he might even learn himself from the example of the Irish peace process, which has been long, difficult and time-consuming, has moved only by tiny steps, but is now close to success. The British fear American impatience both in post-war Iraq and in the Middle East. Belfast might be a lesson.

Tony Blair needs to hold his usual detailed meeting with the Sinn Fein men on the latest problem at the forefront of Republican minds. But he might also begin to persuade Adams and McGuinness that America is now determined to put pressure on the IRA, and that it should finally disarm and declare an end to its war. Might all the people of Northern Ireland then make the province a 'beacon for peace' elsewhere? It seems a distant ideal. There are problems in keeping even the current deals alive. That

does not mean they should be dismissed. The Prime Minister is in a mood for risk.

His aides are in a mood for something to eat. From the bottom of the stairs where the secret visitors come, there is a steady climb, up past each of Sir William Nicholson's bold woodblock posters from the last years of Queen Victoria.

A is for Adams and Alastair, B is for Basra and Bloody-minded hacks, C is for Counting and Casualties. E is still for Executioner. F is for Foreign Office and Fiasco.

K is for Kofi, L is for Liberators ('Let us, please, be liberated from all this soon'), M is for Mother of All Battles (Saddam's only soundbite), N is for Not in my name.

O and Q are for Outrageous and Questions. P and R are still for Pub (a chance would be a fine thing) and Robber (every chance in Basra, it seems).

S is for Sunshine (none of that right now) and T is for Telic. What does that mean again?

Wednesday, 26 March

Morning headlines...US forces closer to Baghdad...Shia
'uprising' reported in Basra...two soldiers killed when one
British tank fires on another...Germans say Washington
should pay bill to rebuild Iraq...

Tony Blair misses his 8 a.m. briefing for Prime Minister's Questions this morning. While the team attempts to read Conservative minds and prepares answers to questions on anti-terrorist law and the future of Sutton Magistrates Court, the Prime Minister is along the corridor in the bath.

He does not need any more briefing on Iraq. His mind is still full of Telic data from his first visit to Old War Office Room 218 last night. In Washington the Secure Area for the Chiefs of Staff is called 'the tank'. Here it is a 'box', made from dark wood-panelled walls and heavy dark wood doors.

But the invitation was just to Room 218. The words 'Operation Telic', in huge underlined capital letters, were written across the paper in case the peculiar name – purpose, destiny, or whatever – had slipped anyone's mind. The military table was shaped like a shell casing without the tip, or, on reflection, not unlike a bathtub with a thin 'head end' where the top man sits. The uniformed brigade appear on a large screen opposite, above the thicker 'tap end'.

The top 'talking General' gave his report by video from Northwood, a few miles away. Geoff Hoon, no more cheery than

usual, was there at the table. So was the Deputy Chief of the Defence Staff, who two weeks ago was off getting his new gong from the Queen.

Then came the Downing Street team. Campbell never looks at his easiest when there are uniforms about. It has taken the Prime Minister himself a little while to throw off all the prejudices of a sixties childhood. In theory the soldiery is wonderful. But the look of the boots and buttons, particularly close up, brings back memories of Combined Cadet Forces to every former public schoolboy of his age.

On his left was Michael Boyce, with the heads of the army, navy and RAF alongside. Boyce performed well. He has become a bit more comfortable since the war began.

It is always amusing to sense how much each service resents the fact that its own boss is not head of 'the whole shooting match' when a chance like this comes around. The navy has done the least in Operation Telic. But by good luck and the honoured principle of 'Buggins' turn', the navy man has been in charge.

Military progress is slow, the Prime Minister heard, but so far without disaster. Seven trucks full of humanitarian aid have now arrived through Umm Qasr. The battle for Baghdad is still in the future. Or at least that was the case last night.

In a few minutes he must get up, leave the flat and go down to see Hoon and Boyce again for the last War Cabinet before flying to Washington this evening. Hoon, the team agrees, is fine for running the Ministry of Defence. His only problem is not knowing as much as he might about the American Defense Department. The Pentagon is not Hoon's 'special subject'. Hoon is not Donald Rumsfeld's special friend.

Campbell, Manning and Straw seem to speak regularly and easily to their equivalents in the US government. Tony Blair's own talks with Bush are vital – and useful when he wants to challenge

a journalist's view of American policy, as he did in the press conference yesterday: 'I am not having to pick up the newspapers and read what the State Department may be saying or the Pentagon may be saying. I am actually talking to the President every day so I know what the situation is.'

Unfortunately, the reality is not quite as clear as that. Donald Rumsfeld is highly influential on the President, and does not speak to Hoon in the way Colin Powell speaks to Straw. Dick Cheney, the most powerful American Vice President in anyone's memory, does not speak to anyone here very much, certainly not to John Prescott.

If the vote had gone the wrong way last week and he had failed to meet his target of half the number of Labour MPs, Hoon, who had never wanted a vote in the first place, would have been vindicated. John Prescott, at least until Gordon Brown could organise a leadership election, would be master of this Downing Street flat.

The BBC is reporting that the Baghdad TV station has been bombed. Those who said that the war would be very brief argued at first that the channel should be spared. The victorious allies could then have immediately used it for broadcasts of their own. Some of the Generals also wanted it to stay on the air. Iraqi pictures of bomb damage, designed to arouse sympathy and anger abroad, were also useful to the bombers, giving them a ground-level view of what had been hit and what had not. But, with the war no longer certain to be quick and the Iraqi people still fearful of Saddam's sway, the TV station had to go: and now it has gone.

When the Prime Minister comes into the Cabinet Room hall his hair is still wet. Campbell is looking unusually glum. Either he has not heard of the TV station attack, or Burnley FC has lost. It turns out that, to Campbell's mind at least, Burnley has had a worse night than Baghdad.

'What do Saddam Hussein and Blackburn Rovers have in

common? They both put people in football stadiums and torture them.' The Blackburn-supporting Foreign Secretary has heard the joke before – about General Pinochet.

John Reid and Pat MacFadden are applying a series of military analogies to the success of Glasgow Celtic over both Jack Straw's Blackburn and Liverpool FC, the team supported by the Attorney General, in this season's Uefa Cup. Tony Blair can sustain a football conversation if he has to. But it is not clear that he really likes to. He certainly does not care to today.

The meeting starts quickly. John Prescott takes in his coffee. 'There was once a time when only the Prime Minister took his coffee into Cabinet meetings. Now we're much more democratic. We all can.'

'Can you make a camomile tea for the Chief?' says one messenger to another.

Hilary Armstrong soon gets her cup. Downing Street may be at war, but 'the Chief' is still the Chief Whip, not the Chief of the Defence Staff. He, as always at this time of day, is represented in the hall only by his hat.

Three hours later, the Questions team set off for the 'dash' to the Commons past large piles of luggage for Washington. All for just one night? Well, he needs to have clothes for George Bush at Camp David and Kofi Annan in New York. This is not as easy as it sounds. Camp David has a rather complex 'casual' dress code. There is just one small green, not even bulging, case marked 'Sir David Manning'.

Outside in Downing Street there is a rare warm breeze. A few ducks from St James's Park have settled on the tiny pond beneath the Chief's office. Even the hyacinths look more blue than grey. The three privets, twisted by topiarists into corkscrew shapes, look as though they might almost be part of a garden.

On the stairs leading up to the office in the House of Commons there is either a power cut today or a multiple lightbulb failure. Any kind of political assassination could happen in the dark. On the table inside, beside the bottles of Scotch and the birthday cards, the Cabernet Sauvignon to be signed for 'Eddie', the Pinot Noir for 'Jackie', is a pile of Hansards for Tuesday, 18 March, the day of the war debate. The speech has now become a collector's item.

Tony Blair does not show much worry about the coming questions. He knows more about Iraq than anyone in the Chamber. Any question that he does not want to answer he can say is militarily sensitive. His ignorance on any other question can be excused because of the pressures of war.

He is careful to tell MPs how important is a UN role in post-war Iraq. Only this can ensure a future administration 'the broadest possible support'. He promises a detailed written response to the MP who is worried about the fate of Sutton magistrates.

Before the motorcade is ready to leave for the airport, Jack Straw is polishing his shoes and worrying about American attitudes to the UN at the same time. The first seems the more immediately enjoyable task.

Tony Blair has been studying press reports on himself. Or rather, Cherie Blair has been reading them out to him. 'Why do people keep writing that I live on bananas? I don't. It's ridiculous. One week I'm living on a diet of Kit Kats, next week it's carrot cake. Why am I only allowed to eat one thing at a time?'

Clare Short drops by for a last bit of pre-Kofi talk. 'Here we are, in an international crisis, and here you are, signing bottles of champagne and your own speeches,' she jokes. Or at least it seems to be a joke.

Campbell still does not find much funny in Depleted

Claranium, as the newspaper diarists have begun to call her. He is more fascinated by the shininess of Straw's toecaps. 'I know how you do it,' he says. 'You put them outside your bedroom door each night when you're staying in a British Embassy, and someone always cleans them.'

Straw is deaf in one ear, and does not hear Campbell at first. When he does, he could hardly be more appalled if Campbell had told another Blackburn Rovers torture stadium joke. 'I've always shined my own shoes, ever since my schooldays,' he says, holding up a brush as though to prove it.

Then Campbell does tell another joke. 'Saddam Hussein decides he wants to show he's still alive. So his man says: "Why don't you hold a newspaper headline, so that everyone knows the film isn't a prerecording?" "Great idea," he says, and gets a page headed "Blackburn Disappoint in Dull Match." "That's no bloody use," says the man. "That could have been written any time in the last two years." '

Straw has begun signing 'powers', routine appointments and letters which require a Secretary of State's name on them. He does not look up.

'Good answer just now about the UN,' Campbell suddenly says.

'Yes, now we've got to deliver it,' says the Foreign Secretary to his left shoe.

Clare Short leaves. They all leave. Down by the cars a group of schoolchildren from Sunderland are enjoying a short break in the sun from their tour of dark, gothic corridors. Tony Blair shakes each one by the hand, even the shy ones who lack the desire to have their hands shaken. He forms everyone up for a photograph and fixes a passer-by to press the button on the camera. The children's guide and local Labour MP, who is not a particularly loyal supporter of the government, cheerfully beams.

* * *

'We've been hit,' says a voice from the Business Class seats.

'Bloody hell. Is it a Scud, or what?'

It is 9.45 p.m. London time. Most members of the team are dozing. There is still ahead a helicopter ride to the Catoctin Mountains and a home-style dinner with the President and First Lady in the First Cabin at Camp David.

The sides of the aircraft shake like a tin tray struck by a stone. Then nothing more is heard but a tense string of jokes about Patriots and friendly fire. After about a minute the captain comes on the Tannoy and confirms that the Prime Minister's plane has been struck by lightning.

It has not been an easy flight. At the VIP terminal at Heathrow, when Tony Blair was chatting with the British Airways Chairman and a few stewardesses, he suddenly realised that David Manning was not with him.

'Where's David?' he cried, looking around anxiously.

'He came separately. He's already on board,' was the reply.

'Get him off. I need to talk to him urgently,' said the Prime Minister. The soon-to-be Ambassador to Washington was brought back down the steps like some stowaway.

There is a new UN problem. Jack Straw has already told a press conference for European correspondents today that a second post-war phase of UN reconstruction will follow the first phase of humanitarian aid.

This does not look as though it should be a problem. Why is it a problem? It is not that the UN role is exactly wrong. It is just not exactly right. Any kind of precision on this issue needs to be avoided until the President and Prime Minister have 'talked and walked', or 'talked and gone buggy-riding', or 'talked and taken cherry pie together', or whatever else they get up to at Camp David.

Tony Blair is impatient. He and the President agreed in the Azores on a post-war place for the UN. Surely they can build on

that, not bury it? Suddenly the problem may be more than the mere 'matter of timing' that he described to his team yesterday in the den.

Has Number Ten been hearing too much Texan politeness from the White House and too much Foggy Bottom optimism from Colin Powell? Has the team heard much from Donald Rumsfeld since the night when the Downing Street Chief of Staff mused about which site in London would be best for his statue? Who has spoken to the Vice President lately?

Soon after take-off the Prime Minister goes to the back of the plane to brief the travelling press. In a jumble of cameras and tape-recorders, BA sleeping suits, black-and-red notebooks and tottering wine glasses, the UN role slips further into uncertainty and the future.

There are new British casualties. Two men are dead beside their truck in the desert. They are without helmets and armour. No more details are known.

Twenty minutes before arrival, the travelling office is packed away. Speech notes, lines for tomorrow's press conference, biographies of US aides, letters to London, all go back into boxes.

At 10.15 p.m., London time, the 777 lands amid the featureless suburban landscape of Andrews Airforce Base. The British Security Services may be good at predicting morale in Basra but they are not, it seems, much good with the Washington weather. The hosts' first view of their British guests is of the cleverest men in Whitehall, without a raincoat between them, muttering nervous words about having 'only one suit' while rain lashes in horizontal lines over the tarmac. The itinerary states that 'White Top' and '46' are the military helicopters designated to take the team to Camp David. But 'White Top' and '46' are several hundred yards away.

Eventually, within a wall of umbrellas, the team reaches a bus. There is a short receiving line and Rebecca from the State

Department, the young, curly-haired and sensibly mackintoshed official charged with monitoring the British Prime Minister's political survival, gets to shake the hand of the man she has studied so much in the past weeks. She appreciates that handshake a good deal more than did the children of south Sunderland.

Thursday, 27 March

Morning headlines...Iraq claims fourteen civilians killed in Baghdad bombing...Tony Blair to meet George Bush at Camp David and Kofi Annan in New York...30,000 US reinforcements leave from Texas...

On a map of Maryland the site of the Presidential retreat is a great white space. 'Take a left at Stottlemeyer and Foxville Deerfield,' mutters the driver. 'Look for Camp 3. Follow the Nature Trail signs. And there's the Red Caboose.'

A caboose is not an item of wildlife but the guard's van on a train. This one marks the entrance to Caboose Farm, one of the neighbours. Further on, past low hedges and open fields, is the key that navigators seek, the 'No Entry' sign. To go past that, even just for a peek through the razor-wire ring, can cost a fierce fine unless the park ranger is in a pardoning mood.

Or, alternatively, the distinguished visitor arrives on 'White Top', looks down on a giant hairbrush of forest, lands lightly and is whisked by motorised golf-buggy to one of the cabins in the woods, each named after a species of tree. There, safe from terrorists, bears and all bar a direct nuclear attack, he will sleep.

The Prime Minister's cabin is Dogwood, the flower of fidelity. For a man known to his enemies as President Bush's poodle, this seems a little tactless.

Those in the British team who failed the test for a tree cabin

have spent the night at the local – not very local – Super8 motel. Alison Blackshaw, the tall civil servant whose task is to run Alastair Campbell, is a Super8 guest. Across the parking lot from the low ground-floor windows is Rocki's Pizzeria Parlor, which last night served chicken parmigiana and wine in small milk-churns to British travellers and American security guards.

'See you tomorrow,' said an Embassy official to a friendly black guy at the next table as he left.

'You won't see me, but I'll see you,' came the reply.

A friend of Saddam could not get into Camp David, even dressed as a bear. Or so runs the legend of Rocki's. Some guards are said to dress as bears themselves. But that might just be what they tell visitors from London.

Campbell's assistant leaves for her temporary mountain office at 6.20 a.m. She is ahead of the traffic, and has a driver who knows where he is going. After a brief view of rising mist and dancing deer she is behind a desk at Holly cabin, the temporary Number Ten today.

George Bush is waking in Aspen cabin. The Prime Minister has slept well in Dogwood, after a supper of chilli, chicken and cherry pie. The only nervous moment last night came when Kate Garvie, his former Diary Secretary, political fixer, assistant, friend and occasional make-up artist, drove her buggy 'a bit close' to a Presidential dog.

Across the path, through a scattering of logs and golf-buggies, the British team can see Laurel cabin. If there were ever to be *Camp David: The Movie*, this would be the hero's home. On the outside it is a rural shack, an essential element of the American dream, planked, brick-patched, with a woodpecker perching by the chimney. On the inside it is a place from which to fight a war, with video screens, communication links to US bases, coded computers and electric shades on the windows.

The classic story of American politics is the journey from log cabin to White House. Laurel is both log cabin and White House.

At 8 a.m., after a quick conference call designated for 'Australian and Polish allies', the President and Prime Minister sit down here and begin the daily intelligence briefing from the battlefields of Iraq. Colin Powell and Jack Straw have arrived together this morning after their own dinner last night at the Secretary of State's Washington home. The President listens carefully to his National Security Adviser, Condoleezza Rice, whose high heels are worn with no concession to the ways of rural Maryland. Dick Cheney appears on the screen by video-link. The British side cannot easily read his mind.

In Holly cabin the desks of Campbell and Blackshaw are beginning to look like home. There are press reports and telegrams from Basra. They are seeking more information on the two dead Britons found without armour or weapons. Had they been stripped after capture? Had they been executed?

Down below at the gates the President's other guests for the day are finding access rather hard. 'Welcome to Camp David,' Marine Langley tells journalists arriving for the 'press availability' scheduled for later this morning. No one feels very welcome.

First comes the vocabulary lesson. There must be no 'contraband', no mobile phones, no personal organisers, laptop computers or other essentials of media life.

A few yards from the polished, shinier-than-Jack-Straw boots of Marine Langley stand a muddy band of network TV stars, veterans of the Westminster 'lobby', Americans from London, Italian intellectuals and Lebanese aficionados of the 'road map'. None of them, says their guide, may engage in 'smoking or dipping'.

What is 'dipping'? Is it chewing? Those who have watched John

Reid in Parliament this week, chewing his way through other people's speeches to kill the urge for nicotine, wonder how he might cope here. Smokers wonder how they are going to survive themselves. But no. 'Dipping' is sniffing snuff. Snuff boxes are banned at Camp David. Men and women with cold feet mutter about how Sir Winston Churchill, famously photographed with Roosevelt in what is now Holly cabin, would have stood for that.

The sniffing of substances other than snuff at Camp David is what Marine Langley now has to prevent. From the tone of his voice and from the spelling in his handout guide for reporters, it seems as though a K-9 will do the job, a mechanised improvement on the usual sniffer dog. But an ordinary bony Alsatian, which would not impress a Blue Cross inspector, begins work on the reporters' bags.

Then there is 'EOD'. What is that? The *New York Times* man, who is rapidly losing his national pride, does not want to know any more about explosives, ordnance or detection.

Everyone has to get 'magged'. 'I might not want to get "magged",' says the woman from the BBC.

In Laurel the 'War Councils' are beginning. There is no hiding behind the 'Ad Hoc Committee' label on the printed schedule here. Geoff Hoon and Sir Michael Boyce appear by video from London. One of their British colleagues describes them as looking 'expectant'.

An American says that this is the wrong word. 'Expectant' means 'about to die'. If a soldier is found in the desert with his skull rearranged and his life running out into the sand, he is labelled as 'expectant'.

Death is not what the British Defence Secretary is expecting. If all goes well, he would like promotion.

Donald Rumsfeld is also on screen. It is not clear if he is expecting anything at all, although less British fuss about 'friendly fire'

deaths would be welcome. Even the official note-taker appears by video-link.

In Holly cabin, the government spokesman on the trip is checking who is here from the media. Blackshaw is harassing e-mail answers out of officials in London.

Down by the gate, stretched out on mattresses in a military dormitory, the journalists plan the questions they want to ask. This will not be like the press conference in London two days ago. This is an 'availability', and the two leaders will not be available for long.

What the TV reporters most want is to be seen on air by their editors and their viewers, asking and being respectfully answered. But there is still room for discussion of what they should ask about. Is the key issue the post-war future and the role of the UN, the problems that are most on Tony Blair's mind? Or is the real problem the war itself?

According to this morning's *Washington Post*, whose pages are trodden into the mud all around, the Pentagon, though probably not its boss Donald Rumsfeld, is predicting a war which will last for months, not the quick 'Shock and Awe and Out' which the media and the great mass of voters have been expecting. That, the questioners on the mattresses decide, is the line to pursue.

Tony Blair is already planning his own statement. He has seen Al Jazeera TV images of the two British dead, shot in the back. 'These are 'pictures of executed British soldiers', the prepared text runs. 'If anyone needed any further evidence of the depravity of Saddam's regime, this atrocity provides it.'

The site of the 'press availability' is best described, to adapt a phrase of a former occupant here, as a 'military-agrarian complex'. It is a tractor barn for Marines. George Bush and Tony Blair are standing on black crosses before the same dark-green velvet curtain that was their backdrop in the Azores. 'This is its home,' says

the President's genial Chief of Staff, Andrew Card. 'I'm delighted we're getting so much wear for our money.'

In the second row behind the British TV stars sit Colin Powell, Condoleezza Rice and Alastair Campbell. Powell looks as though he is on holiday, Rice as though she were waiting for exam results, Campbell as though there is a message waiting for him somewhere else. The rest of the seats are filled with reporters, each with a square blue badge which is a photographic reminder of the last Bush–Blair meeting here in September 2002. At that time Colin Powell was the most influential voice, war was a distant option, the UN weapons inspectors were to bring Saddam Hussein into line with his promises, and George Bush was pictured in a fighter pilot's jacket. Today, with war in progress, the President is in a dark civilian suit.

Powell smiles at Campbell when a voice behind the curtain announces that 'The programme will begin in forty-five seconds…thirty seconds…twenty…ten…' At the end of the countdown, President Bush has already lived up to his reputation for punctuality; he has left his cross-mark, taken measured steps over the thin grey carpet and begun to speak. Tony Blair follows smartly behind.

Loyalty, the President makes clear, is something he prizes even above timekeeping. 'Americans have learned a lot about Tony Blair over the past weeks,' he says. The Prime Minister's face tightens and he looks only half towards his encomiast.

'We've learned that he is a man of his word. We've learned that he is a man of courage, that he's a man of vision and we're proud to have him as a friend.' The art of looking good while accepting high praise is not an easy one. Tony Blair ought to be used to it by now, but this is plainly tough.

The pattern of a musical duet emerges as the two men continue. The President is much more articulate than he is often held to be, but he is not an orator. He talks softly, in snatches, like a

nightclub singer, calling out the shared times together of Britons and Americans against Nazis and Cold War foes, their shared determination to 'loosen the grip of terror around the throats of the Iraqi people'.

The Prime Minister gives the more formal piano accompaniment, filling in the gaps and the facts, and flourishing, on his own account, the lines about depravity and executions. He speaks more slowly than usual, matching the President's beat and drawing deep draughts of air at moments when, at a press conference in Downing Street, he might have taken a sip from his mug of tea.

The reporters are restless. As theatre this may be better than a barn dance, a best bear-costume competition, or whatever else normally happens here. As a source of news there has been nothing worth getting 'magged' for, not on the Middle East, not on the UN, where the Azores declaration safely stands, not even on the war itself, apart from that word 'execution' which both men use, the President taking his cue from his friend.

The music goes on. When George Bush is asked about the *Washington Post*'s 'months not weeks' story he takes hold of the podium, leans forward and almost hums. This campaign will take 'however long it takes', he says, lightly at first and then a little louder. 'And that's important for you to know, the American people to know, our allies to know and the Iraqi people to know.'

The answer is then repeated, modulated as though it were a song. The question comes again, and the words return as a refrain: 'However long it takes. That's the answer and that's what you've got to know.'

The response to this in the 'availability' is mixed. To some, these are the empty words of two men so far out on a plank together, so tightly bound by the need for success, so suddenly aware of the potential for desert disaster. What do you expect them to say? But on others the effect is very different.

Tony Blair seems almost mesmerised by the President's song, just as at times George Bush is said to have been wowed by his ally's Westminster word-play.

When the Prime Minister is asked how he knows the new deaths are executions, he says: 'The reason I used the language I did was because of the circumstance that we know.' That is the rhetorical nadir. When asked by the same reporter why there are so few allies alongside Britain and America, he sweeps up into a great finale of the duty to future generations as well as of the need, 'when it is all over, to go back and ask why this has happened'.

'Because you two are both crazy,' says a last voice from the left side. The men leaving the podium do not hear.

The reporters depart with Marine Langley. Condoleezza Rice looks as though she has failed her exams. Alastair Campbell wants to get out as fast as he can. Colin Powell smiles. The inquest on the journey to war is perhaps the bit he is looking forward to the most.

Behind the barn there is a rush for the Camp David buggies. Kate Garvie, recovered now from her encounter with a First Dog, is directing the British traffic. Alison Blackshaw is Deputy Buggy Mistress for the Downing Street team. Some carts have girls' names, some have government department names; one is today labelled 'Prime Minister of Great Britain'. Some of these symbols of the simple life have fully charged batteries, some do not. Some go fast uphill, some go fast only downhill.

The President and his lauded guest are already hurrying up the incline to the Bush family's Aspen base. The other members of their teams are ranged behind, strung out in direct relation to their battery levels.

'This is my little piece of heaven,' the President tells the late arrivals.

'It's certainly as difficult to get into,' says a voice behind.

Since Tony Blair is changing into clothes suitable for the scheduled 'mountain walk', praise of him can now flow even more unstinted than it did down below. 'Americans admire character and courage,' says George Bush, loosening his tie. 'And Tony Blair has true character and courage.

'I know about world leaders,' he goes on. The security men look sharply as though they know all about world leaders too. There are those who have looked the President in the eye and said yes and meant yes. And there are those who have looked him in the eye and said yes and meant no.

A junior aide nods in agreement and wonders if it is time the President changed into his walking clothes to meet his guest. George Bush is not in any hurry to leave the sun, which is now high above his 'piece of heaven' and casting shadows on an army of thin grey trees.

The talk goes on. While French fries have been replaced by Freedom fries from California to the dining rooms of Congress, France's world leader does not seem, at least not yet, to be among the ranks of the Camp David damned. Whatever the President's fellow Americans and his British visitors may feel, Chirac never gave anyone his word. He is French, and takes a different view.

From US State Department to British Foreign Office, the assumption about Germany is different to that about France. Relations here, according to conventional wisdom, can be patched up relatively easily after the war. The Camp David mood does not seem so forgiving. Chancellor Schröder looked America in the eye. Then he had an election.

So sauerkraut may soon become salvation cabbage? The British view is that there must be 'a reckoning', but that eventually things will be fixed with France and Germany. The host campers seem to agree. And as for the UN? The verdict here is less certain. It depends what the organisation wants to become and whether, in

the short term, it is prepared to put up someone serious and practical for its top job in Iraq.

Those 'executions' are on the President's mind too. They divert him to a few choice thoughts about Uday Hussein's way with women. 'There are a few fathers, after this, who will be out for him if he ever goes walking in the woods.'

Before he leaves to change, he returns to his original theme. He and his advisers have in the last two weeks become close students of Westminster. Prime Minister's Questions has always been a popular entertainment in Washington, but now White House advisers ask about Erskine May and Early Day Motions. 'I know what risks he has taken to be here,' the President says, pointing to his guest who is walking down from Dogwood in light trousers and a pale open-necked shirt. 'That's the courage. That's the character.'

As George Bush goes in to change, Secretary of State Colin Powell, renowned as the most reckless buggy-driver on the Camp David roll, pulls up with Jack Straw in the front seat and David Manning in the back. Tony Blair smiles at his Foreign Secretary. 'He's taking me for a ride, Prime Minister,' says Straw.

'As usual,' comes a jocular cry from somewhere behind. Tony Blair stops smiling and gives his team one of the 'not too far' looks normally reserved for Alastair Campbell.

The United Nations is high on his mind. He wants the minimum possible gap between his own view and the President's view. That is what this coming walk is all about. 'A lot depends on who the UN coordinator for Iraq is going to be,' he says. 'If they choose a good man, someone who doesn't faff about, that's fine. If they choose the wrong man, I won't back them either.'

The Prime Minister has learnt both the limits of working alongside the new overwhelming American power and the possibilities of doing so. Time alone with the President to ask difficult UN

questions and to judge genuine determination about the Middle East and Europe is the most important part of the trip for assessing where both limits and opportunities lie. So, while others may be winding down, the Prime Minister is winding up.

When George Bush returns he is in blue tracksuit and trainers, as though for a power walk, not a stroll in the hills. The two set off along the path, alone except for a security buggy with a faulty horn. 'Peep-peep, Peep-peep' sounds the escort in perpetual distracting cry, as they map out the next steps for their nervous audience around the camp and around the world.

Outside Holly cabin, the team is taking time out. Alison Blackshaw, English plaid scarf and long hair trailing in the wind, takes a buggy called 'Milaide' for a drive.

Kate Garvie is regaling a group with her own buggy adventure last night. 'It was dark, and all I could hear were shouts of "Dog, dog! Mind the dog!"'

'Spot or Barney?' comes a lazy American voice.

'It was the black one. I couldn't possibly see it. My whole life flashed before me.'

'His too,' comes the reply.

'The President's or the dog's?' comes a second voice from inside.

The official spokesman is working. He has to explain to journalists outside exactly why the British soldiers' deaths might have been 'executions' and why possibly they might not have been.

There is a desultory inquest on missing e-mails from the MoD and the lessons of those First World War nuns from Belgium who were not, perhaps, raped in quite the numbers that the British said at the time.

In the dining room there are cases of letters from the key moments of the most celebrated Camp David Accord, Jimmy Carter's peacemaking twenty-five years ago between Israel's

Menachem Begin and Egypt's Anwar Sadat. The noises from the TV in the corner, its picture blocked by security men piling cheese on their plates, tell that Jerusalem is still not as Carter intended.

'If Arafat concedes too much, he's afraid he'll take the same route to assassination as Sadat,' says a man with a pizza. Tony Blair has won praise for taking political risks in the past weeks. But he is not gambling in quite the way that the murdered Yitzak Rabin did, or Sadat, or in the same deadly way that the Israeli and Palestinian leaderships are being asked to gamble now.

No one knows what is happening out on the walk, only that the beeping buggy was eventually replaced by a quieter model. When the pair first went into the woods the talk was of 'running regimes' – not of how to run Iraq, but of training regimes to make one a better marathon runner. How long did that go on?

The Prime Minister can bluff his way through 'boys' talk' about football. Can he do running too? Did not George Bush boast earlier of finishing the Houston Marathon? And did Tony Blair really ask how many miles that was? Whether the team gossip is true or not, it is amusing in the mid-afternoon sun.

A few more serious lunchers revive the problem of producing new Iraqi dinars. Britain has the production plant, but is there still some legal problem? There may be.

Then comes the woosh of Alison Blackshaw's buggy, after a slow haul up the hill, in a fast run down again. 'She'll be coming round the mountain when she comes,' sings an elderly staff man in admiration. There is a wave of hand, a stream of hair, a pause – no one is looking any more – and finally, a bang. As the Security Officer at the scene might later have put it, 'Camp David cart "Milaide", driven by Ms A. Blackshaw, assistant to Mr A. Campbell, suffered offside headlamp damage after collision with Camp David cart, unnamed, allocated to the White House Communication Agency.'

Shards of black and cream plastic litter the path. That is the end

of the dinar discussion. The telephoned attempts to clarify what is an 'execution' are over too. Kate Garvie remembers the President's dog and says, 'It could have been worse.'

The team assembles in order to 'Kofi a bit' in New York. Not everyone is needed on this last leg of the trip.

The head of White House protocol wishes the British goodbye. The Brits are 'always good guests', he says, 'not high maintenance at all', leaving no trouble behind them this time except a slightly bruised buggy and a First K-9 in need of a quiet night.

Friday, 28 March

*Morning headlines…US paratroopers take northern
airbase…row over 'executions' of British soldiers…Rumsfeld
denies Pentagon split on 'long war' tactics…British ship,
Sir Galahad, begins unloading aid…*

It is 7 a.m. in Downing Street. There is the smell of bacon sandwiches in the basement. The team has returned and scattered, the fortunate homewards for some rest.

The hall table is empty but for a bowl of tired lilies. The mobile phones which will later make its mosaic for today are still in the pockets of the powerful, the seekers of power, carpet-fitters, clockwinders and caterers all over London.

Leo Blair is at large in the Campbell corridor, dressed in elastic-waisted blue jeans and light shirt. Forget the elastic and he looks as his father did for the Camp David walk.

Above him is Ruskin Spear's ghostly seascape, *Low Tide*. Its mud and clouds are as monotone and still as the grey March outside. Leo knows neither sky. Each is beyond his view.

Will he remember anything of these 'corridor days'? Will he look back and see the stiff white military hats, the cases with 'Prime Minister' labels piled by his train set, the men waving at motorcades when the motorcade is still at his own front door?

His mother does not think so. Cherie Blair's own memories start only when she was older than her son. Her father, Tony

Booth, who was later to become a TV comedy star in the series *Till Death Us Do Part*, left the family when she was two. She first remembers 'sherbet dips', sweets made at home in Lancashire by her actress mother, piecework for extra money when she was 'resting' from the stage.

Tony Blair's first memories also start later, after his sister's birth, when the family was spending three years in Australia. Some children grow up to be prodigies of early recollection. If Leo does not, he will have to rely in later life on outside aids, at least for these very first years.

There will be plenty to choose from. That unusual photograph from President Chirac of France, congratulating 'Cherie et Tony' on his birth, should still be in its silver frame. Not only does it show the baby of parents in their mid and late forties, a special cause for celebration by an ageing Frenchman. But the baby's name is the national emblem, Leo, the lion of England. Presidents appreciate that sort of symbolism, even when it is from countries that are not their own. Leo Blair was named, in fact, after his father's father, a Durham lawyer and would-be Conservative MP. But there was no need to tell Jacques Chirac that. He was a good friend in the year 2000.

Who is the other man in the shot? His parents will be able to tell Leo that Bill Clinton and his wife were guests at Number Ten on the very first night that they themselves visited the house. That was in 1995. The American President and British Prime Minister, John Major, were discussing Middle Eastern, Northern Irish and Balkan problems. There was a party in the evening. John Major was very unpopular. Everyone said that the Blairs were checking out the furniture for when they moved in. Two years later they did move in.

There will be family snaps. His mother is an enthusiast with a camera. But if a teenage Leo Blair finds any likeness of his three-

year-old self in a yellowing newspaper, he can be sure that the picture will have a story behind it. Either his parents will have complained at the time – about an invasion of privacy, a threat to security or a breach of the voluntary rules to which newspapers mostly adhere. Or a newspaper editor will have complained – about hypocrisy, the use of children for political ends only when it suits the politician.

There will be piles of newspaper cuttings to remember the Number Ten years of Leo's eldest brother Euan, bundles of columns about where he went to school, what kind of school it was, whether it was the school to which a Labour leader's son ought to go. Then there was the time he had a few drinks too many and was found in Leicester Square by a policeman, who took a while to work out who he was.

Nicholas and Kathryn, Leo's other brother and his sister, are much less recorded. Perhaps the newspapers at the turn of the millennium became bored with the Blair children, preferring to write stories, fascinating but not easy to follow now, about their mother.

As for little Leo: when his father was celebrating his fiftieth birthday in the middle of one of the Gulf Wars, he mentioned his help often. Leo helped to keep Tony Blair sane. Leo helped him to keep foreign affairs in proportion. Even when bombs were dropping on Baghdad – especially when bombs were dropping on Baghdad – Leo got his bedtime story.

That is what the newspapers will say. If the youngest member of the family is to have any direct recollection of his Downing Street years, his father will have to stay in Number Ten a little longer.

That now seems almost certain. An extended stay for them all seems much more likely now than it did eighteen days ago. Leo Blair will probably get his own Number Ten memories.

Saturday, 29 March

Morning headlines...US forces ready for assault on Baghdad...bomb falls on crowded market...Rumsfeld warns Syria and Iran...Tony Blair appeals to Iraqis' sense of history and national identity...

'Tony Blair has gained in confidence,' says the old Arab professor in the Churchill Café on the opposite side of Whitehall from the Downing Street gates. His younger companion, perhaps a pupil, shrugs.

'Two weeks ago he said that history would judge whether he was making the right choice. What did that mean?' He does not wait for a reply. 'Today Mr Blair says that he was right, that history will judge him to be right. And he is asking the Iraqis themselves to believe that.'

The tourists and Saturday-morning civil servants continue with their cappuccinos. A Middle Eastern historian, talking to a silent youth over a sandwich, is less trouble than the demonstrators in the street.

Far worse for the Churchill Café regulars are the anti-war leaders, the ones who sit in the corner with a tape recorder and a glass of water and record the rants which later everyone has to hear, much amplified, all over Parliament Square. Do politicians ever wonder where the constant loud-hailer speeches come from when there does not seem to be a speaker? They come from here.

The Prime Minister has written a message to the people of Iraq, appealing to their sense of their own history and promising them a prosperous future once Saddam Hussein is gone. Has Saddam Hussein gone? John Scarlett's intelligence analysts, who have been in their office a few yards away since 5 a.m., are both tired and tired of being asked.

Scarlett makes only the most careful predictions about the future. He prefers firm facts about the present, calculations of what is happening in Iraq and its neighbours on which Tony Blair can make a calculation of the national interest. He treats sceptically and equally the images of horrors caused by American bombing and those from Saddam Hussein's torture cells. Scarlett has an interest in history. The first judgement has to be of which happenings are events, which have meaning and which do not, which matter and which do not. Television pictures are not much help in this. Nor are anxious politicians and their aides. With a proper approach it is possible to predict which of Iraq's forces are likely to resist and which will run to the nearest sand hole. When the Prime Minister asks if Saddam's Iraq is closer to Ceausescu's Romania than to Ho Chi Minh's Vietnam, he can answer yes. He also knows what the Syrians and Iranians might do – or at least what they are thinking now.

Will the Middle East afterwards be more stable? Will Tony Blair and George Bush merit a statue in some future Baghdad museum? John Scarlett doubtless has a view. But that is a call, as they say in the CIA, which is 'above his pay grade'.

The café tables, both inside and on the Whitehall pavement, are becoming crowded. The war is good for business here. Protesters may not make the regulars comfortable. Arab intellectuals may not spend much. Ranters may spend nothing. But the long, slow flow of angry people needs to be fed and watered.

On the other side of the road in the Foreign Office, at higher levels than the Emergency Bunker, the weekend workers too can see the protests. But here the theorists and the planners are turning their minds to the more distant diplomatic future. They assume now that Saddam Hussein is already 'history' in the American sense. Whatever the cautious 'spooks' may say, he is as good as dead.

But how did it all happen? It was not supposed to happen as it did. What lessons can be learnt for what will happen next?

Tony Blair understood early what George Bush was determined to do. He shared that determination. Few doubt that now. Even the public evidence is clear. But was that certainty passed down through the diplomatic machinery? Did enough people in London and abroad understand how much America had changed since the attacks of 11 September?

Everyone knew about the battles within the White House between 'hawks' and 'doves', 'go-it-aloners' and 'get-a-new-coalitioners'. But did diplomats think too much like journalists, stressing the splits, not the agreements? Had anyone been reading the traffic from Capitol Hill? This was not a nation in a mood to do nothing, whatever the TV chat shows and pictures of San Francisco demonstrators might suggest.

How hard was the White House working for that once-famous Second Resolution? Tony Blair said he was working 'flat out'. For days no one in the government could say anything without using the words 'flat out'. Tony Blair had gambled on getting America to fight Iraq with international support. How 'flat out' had George Bush been working to meet his side of the bargain?

Then, what did the French really think? If President Chirac had just asked for more time for the UN inspectors, instead of saying he would veto war in any form, it would have made life much harder. When the Frenchman 'showed his hand' in George Bush's

Texan poker game, it was a straight win for the Washington 'war party'.

Perhaps that was exactly what Chirac wanted. Perhaps his aim was to make inevitable the most unpopular and least supported American and British war. If he does want a world in which the US and Britain are hated and everyone can love the French instead, he has made a good start, not least with the people protesting today in London, in Athens, in Rome, in Madrid.

But never forget the 'cock-up theory'. One mandarin memo points out that the French Ambassador to the US had barely arrived when all this was happening. His telegrams home may not have been as masterly as those from 'our chaps'.

In the Churchill Café it is the 'conspiracy theory' that is now on the table. The Middle East thrives on conspiracy. The elderly Arab professor is telling his sullen companion about oil companies and Israeli spies and Russians whose names have not been heard since the Communist days. All of these are working together, he says in clear, rotund English tones. Whatever historians of the future discover, such stories will never die.

Yet some big decisions have certainly been made. Who made them? Why did they make them?

The coffee-drinking historian is looking doubtful.

'So Tony Blair wants to be judged by history,' he declares. 'It does not much matter what he says. He will have the judgement of history whether he wants it or not. So, let us treat history for the moment as a genuine judge, a kind of god,' he goes on.

His companion remains wordless.

'This deity has many different priests. All will look at the Prime Minister's character, his words and deeds and the relationship between the two.'

The professor leans forward. He is beginning a lecture that he has given before.

'Some will take seriously the principled claims that he and George Bush are making. "Public figures," they will say, "are often sincerely attached to the ideals for which they claim to act. Do not be cynical. Look for sincerity. A genuine belief behind an action needs to be cited in any attempt to explain it." '

The pupil blinks. He knows he should be listening.

'Others will just as certainly argue that the Prime Minister's beliefs were at best irrelevant, at worst deceiving. Look only at what they do, not at what they say.'

If the professor had been with Tony Blair these past three weeks, he might adjust his argument. It will be impossible, even for the toughest-minded historian, to ignore entirely what Tony Blair has said during these weeks. On many days he has done virtually nothing else but speak.

'Look out carefully for spurious claims of morality and purpose,' the professor intones. 'When Tony Blair and George Bush claim to have concern for Iraqi victims of Saddam, remember how the commercial exploiters of the early British Empire claimed concern for the souls of godless Africans.'

The arrival of the waiter interrupts the argument. The young man seizes the opportunity for departure. Maybe he is going to join the demonstration.

So, when Tony Blair finally meets his judge, he may find himself compared with neither Churchill nor Eden, nor Macmillan nor any of the other names that have been called up in all the pre-war debates, but with earlier figures, nineteenth-century missionary imperialists, or much earlier ones, the Romans who created deserts and called them peace.

There is no fun in being judged by history. It is not a game the

subject can control. It will not suit Alastair Campbell. But the judgement will not happen yet. For Tony Blair, that is still the best thing about it.

In the Churchill Café and in the offices across the street the inquest continues. Soon it will spread to seminar rooms, doctoral theses and the very first books: not yet books of history, but books that may help history to be written.

Sunday, 30 March

*Morning headlines...Robin Cook says 'end this bloody
war'...British soldier killed by 'friendly fire'...US denies
Iraqi claims on marketplace attack...fears of epidemic
in Basra...Turkey reinforces its border...*

There are more tourists than protesters around Downing Street
today. Because the 'Disneyland' maze is still in place, it is not easy
even to poke a nose through the gates. But there are many who
want to. Tony Blair may not be more popular as a result of this war,
but he is more famous.

The rest of Whitehall is even more of a mess, not from political
threats but from political change. Any visitor hoping to admire the
fine façades of British government has to peer beyond canvas and
scaffolding. The Civil Service strongholds, or at least their bricks
and mortar, are under the sway of Bovis Leasing and fellow
financial engineers. These great imperial properties are not being
'privatised', since that is a word from the Tory era of Margaret
Thatcher and John Major which Tony Blair brought to an end in
1997. They are being 'privately financed' or 'privately initiatived'.
They are being 'modernised', 'improved' and 'leased back' to their
original owners.

To the traditionalist, the Treasury and Cabinet Office look like
some speculative office development, newly up for sale. It is 'leased
out like a tenement or pelting farm', as Shakespeare's John of

Gaunt put it, describing what 'this blessed plot, this earth, this realm, this England' had become under weak King Richard II.

To the team from New Labour, those of them inside working on this Sunday, it is just another symbol of how much the party of state ownership and central planning has changed. It is another victory for strong King Tony.

Robin Cook, a character perhaps more like hunchbacked Richard III in Downing Street minds, has chosen today to call for an end to 'this bloody and unnecessary war', accusing Donald Rumsfeld of going back to the cruel tactics of a medieval siege. 'People go hungry. Sinews snap. Children die. And there will be a long-term legacy of hatred for the West.'

If Tony Blair is worried about that, he is worrying elsewhere. Tourists hoping for a glimpse of the Prime Minister today will be disappointed. The man whose job Cook will seek if catastrophe comes is away in the countryside for the weekend with his family. Apart from having to make telephone calls to the former Foreign Secretary's supporters abroad, Jacques Chirac, Gerhard Schröder and Vladimir Putin, the so-called 'Non–Nein–Nyet alliance', he is trying to have a quiet time.

Monday, 31 March

*Morning headlines...Iraq threatens new suicide bomber
attacks...British soldier killed outside Basra...protests rise
at civilian casualties...*

Tony Blair is growing tired of his fellow politicians and more
solicitous of his new friends in the military and intelligence.
Sir Michael Boyce, Chief of the Defence Staff, naval officer, sub-
mariner and a man once seen as 'a bit dull' even by those unexact-
ing standards, is beginning to look more sprightly.

'The CDS walks around like the Chancellor of the Exchequer.'

'You mean, as though he owned the place?'

'Yes, almost. In fact, today he looks much more cheerful than
Gordon does – more cheerful than Prescott, too.'

The Deputy Prime Minister has just arrived in the back hall for
the War Cabinet. Never the most spring-heeled of men, he appears
today to be testing for the role of mattress on a municipal dump.
He sits and waits.

Jonathan Powell, in pink-and-green rugby shirt and trainers,
pops out of the den and asks for 'Tony's coffee'. All of Prescott's
prejudices about public schoolboy dress are present in a single
bang of his cup against the table.

This first 'military' conference in the den seems, certainly to
those who are excluded, to be getting longer, at the expense of the
War Cabinet itself.

'All we do is decide who does TV news and *World at One*,' says a dissident voice from the Cabinet Room pillars.

There is even time now to poke about in the Prime Ministers Library on the right-hand wall. Each book is supposed to be a gift from a Cabinet Minister.

What is there?

Harold Macmillan's copy of *Bartlett's Quotations*, the speech-writer's friend.

The Geography of Strabo, a pioneering guide for rulers of the first century BC who wanted to know what countries were worth invading. Anonymous donor.

Europe: The Future that Works, by John Major, bound in blue leather, signed and donated by the author.

Each one bears the legend, in Latin, that 'A Library is a Gateway and Refuge for the Workers'.

John Reid needs his own refuge. Basra may be in British control. Saddam Hussein's statues may be coming down. This is a good day for the cheerful den-dwellers. But the Labour Party Chairman does not like being accused of calling the BBC the Baghdad Broadcasting Corporation. First, he 'never said it'. Second, whatever he did say he said in the Lobby of the House of Commons, where conversations, by convention, are never attributed to individuals.

'What nobody says is that if you did that sort of thing to a member of the government in Baghdad, you'd be taken off and tortured.'

'That's not on,' says a sympathetic voice, referring to the breach in Lobby privilege rules.

The War Cabinet begins at 9. a.m., thirty minutes later than in its heyday after the House of Commons vote. The TV pictures in the outer office are of distressed Iraqi civilians and dead allied soldiers.

'What we need when this is over is a reckoning with the media about whether a democracy will ever again be able to fight a fascist dictatorship,' Reid goes on, as the second meeting gathers. 'The broadcasters are in Iraq not because they want to tell the truth, but because of commercial competition. They don't think what they're saying. It's a disgrace. Take this story of the American A 10 pilot, said to be "out on a jolly" when he was shooting up our tanks. You never hear about all the times American and British pilots come to each other's defence, do you?' he adds aggressively.

'No, but…'

An eyebrow is raised, not quite disloyal, just a little sceptical. Campbell closes the Cabinet Room doors.

Shortly afterwards, the Chief of the Defence Staff emerges. He is still talkative and top-of-the-morning in spirit. 'We need bigger maps,' says Defence Secretary Geoff Hoon, who, although still seemingly hard-wired to his colleague, has not fully absorbed his *bonhomie.*

Back on the Alphabet stairs, the media meeting is about to begin.

A is for Al Jazeera. B is for Baghdad Broadcasting Corporation, because even if he didn't say it, it's bloody well true. C is for CNN (ditto). D is for Daily Everybody-Who-Hates-Us. E is for Executioner, just as Sir William Nicholson wanted originally, and for E-mails, the ones which the MoD never got to Camp David, and for Et cetera, which includes the animal-rights groups banging on about bear welfare in Saddam Hussein's zoo.

* * *

At 6 p.m. Tony Blair welcomes to Downing Street a ninety-year-old man whose legacy to the Labour Party he has spent much of his recent life dismantling. Today is the birthday of Jack Jones of the T & G, the General Secretary of the Transport and General

Workers' Union in the days when that job was one of the most powerful in the country. As the Prime Minister says when meeting him outside the State Dining Room, 'You owned this place once.'

Across the floor are the once-familiar features of other trade union ghosts, some bronzed now, their faces a bit more leathery, retired men who might play a mean round of golf in the Algarve, still recognisable as the 'barons' who once brought British factories to strike after strike and always seemed proud of it. To invite them into Number Ten again is like asking the Bad Fairies back for another feast. If it seems like that to Tony Blair, he disguises it well.

'Yes, you owned this place once. It's not quite like that now. But it's very good to see you here'

He makes a short speech in which he pulls together every possible belief that he and his birthday guest have in common – compassion, social justice, concern for old people and children – and avoids most of the matters that divide them – new rights for union members to control their leaders, no rights for union leaders to control the government. This is the classic consensual Tony Blair in action.

He plays the role so neatly that the Minister responsible for the unions, Ian McCartney, standing brightly beside him, is moved to make a roll-call of all the senior Labour figures of today, including the Prime Minister, who are Members of Parliament sponsored by the T & G. At the end of this long list of names he draws himself up to his full, not very great, height and says: 'If you really look at it, we're a T & G government.'

Only at that point does Tony Blair call a halt to the pretence. 'I don't think that we can go quite that far,' he says firmly, giving 'Little Labour', the name by which McCartney introduces himself, the full 'Straw-Campbell-that's-enough-now' stare.

Jack Jones thanks his host with the words 'I love thee for all thy faults,' and the party goes on.

Most of the trade union leaders of today are here too. Virtually all are against the war. No one mentions it. It is like being in Fawlty Towers hotel when the Germans arrive. 'We may have been difficult, but we were disciplined,' is the closest to a comment on the subject. 'And we're still disciplined.'

Cherie Blair arrives with Leo in her arms. The old men of the trade union movement are not as charmed by him as he has come to expect. His nanny is not far behind, and, in different arms, he soon leaves.

The Prime Minister's wife conducts a tour of the Number Ten silver collection. The Bad Fairies take a keen interest.

The veteran Labour ex-Chancellor, Lord Healey, arrives. He has argued vigorously over the past few weeks that no benefit from bringing down Saddam Hussein can compensate for the damage done to Britain's influence in the Arab world. But he makes no fuss here. He says he may make a few points later.

A grand ninetieth birthday dinner is to take place next, paid for by a television company. By then Tony Blair will have long gone.

Tuesday, 1 April

Morning headlines…Washington repeats warning to Syria and Iran…seven Iraqi women and children fired on and killed in car by US troops…Colin Powell announces 'fencebuilding' trip to Europe…

John Prescott has had a bad night. The war is taking longer than he expected, longer than he has made political plans for.

In the Campbell zone it is necessary continually to say that 'We have always known it could go on this long.' The government spokesmen's office is dominated by a sculpture of Edvard Munch's *The Scream*. The walls themselves must be screaming by now that 'The war will go on as long as it takes.'

In the diplomatic knights' zone, they have genuinely envisaged a war of many weeks, not days. When the Indonesians and other self-styled 'moderate Islamic' states warned David Manning of the danger to themselves of a 'long war', they were not talking of a fortnight. These are people who know what war is like.

But where the politicians are gathering outside the den, the worrying is real. They had hoped it might be over now. They would not admit that. But that is what they hoped.

John Prescott has many virtues. One of them is a lack of pretence. He does not pretend to know whether the policy is right or not: that is a matter for 'Tony'. Nor does he pretend to know whether

the soldiery will work or not: that is a matter for 'Hoon', a name he pronounces as though it were a pet owl, and for 'the CDS', who gets an ex-seaman's respect due to a man whose gold-braided hat is warming on the hall radiator, and for 'Tony' again. The Prime Minister, like all 'bloody students' of his time, has no great feeling for the military, but he puts on a good show.

What John Prescott does know is that when he and Sally Morgan and Pat MacFadden first talked about the local elections, they assumed that they would be held in peacetime; that when he and Gordon Brown first talked about the Budget, they assumed it would be delivered in peacetime; that when he and the Health Secretary, Alan Milburn, spoke first about persuading the Labour Party to accept privately financed hospitals as well as privately refurbished Treasury buildings, it was assumed that they would not be fighting an unpopular foreign war as well.

But now he must plan for the worst and somehow make the best of it. That was his early-morning decision. 'I got out of bed about 3 a.m., put a few thoughts down on paper for a couple of hours and went back to sleep feeling a whole lot better.'

It does not matter for this purpose whether the war is right or not. He and the Prime Minister are 'in the same toboggan'. It is unlikely that any other leader would have him at all.

The war must, therefore, be made a vote-winner. No one wants a 'khaki' election, but Ministers can't just stay in London with their heads down and let Saddam and the media set the agenda. If there is not much certain yet about Iraq, Labour should trumpet the successes of Sierra Leone, Kosovo and Afghanistan.

'Our policy of liberating peoples from tyrants has worked in the past. That's what we can say. That's what we have to say.'

Prescott is angry with himself. He has allowed the firefighters' dispute to keep him in his office and away from the streets. This dispute about 'pay and restructuring' has been an awkward side-

issue throughout the war. Troops with ancient Green Goddess machines have had to take the place of striking firemen. The firefighters' leaders are from the farthest left of the Labour Party, are fierce opponents of the war and have rejected all suggestions that it is unpatriotic to threaten strikes at this time.

'Every time I thought about a visit for the local elections, I thought about whether I wanted to attract a protest from the strikers. I was on the defensive. We can't be like that now. The war will be on and we have to take the attack to the firemen. Do they want to get in the way of winning the war? We'll put that to them. We'll put that to the voters.'

He pauses. Clare Short sails in. Nobody is as punctual as once they were. The meetings are not as punctual either. In the White House it is different.

Tony Blair's meetings merge like ink blots one into another. Ask Gordon Brown how a meeting went, and he seems to have genuine difficulty remembering when one ended and another began.

The International Development Secretary looks at the copies of the *Daily Star* and the *Financial Times* on the table, and hides herself behind the bigger pink pages. Her colleagues would enjoy seeing the one-time fighter against 'page three' female nudity behind the bare breasts of the *Star* bird today, but the *Financial Times*, she says, is less upsetting than any other paper at the moment. It is the one most likely to feature economic fears and diplomatic signals rather than the devastating 'salvation' of Basra, the Iraqi victims of siege and the British victims of American fire.

When the military session ends in the den, Gordon Brown goes into the Cabinet worried about the amount of time spent on 'postwar reconstruction' which ought to be being spent on the Budget. John Prescott still has not told his colleagues about his own 'night thoughts' on the Budget, but they do not seem to have been very

positive. Clare Short wants more money for aid, and carries her pink newspaper as though it might win it for her.

This morning the Prime Minister has the most to say to his worried colleagues. He describes the 'three phases' of the war, as he sees them. The first, securing the strategic assets of the country, has been achieved. The second, the steady advance on Baghdad, is going on. The third, regime change, is still to come. His two civil servant spokesmen, one tall, one short, look at each other and nod.

The short one comes out of the room first and says to the first person he meets, 'Steady advance.' Several minutes later, the tall one comes out and says again, 'Steady advance.' Then they go back to see *The Scream*.

Steady advance is the story of the day, not yet the assault on the British nation that John Prescott dreamt of last night.

Wednesday, 2 April

Morning headlines...US begins full assault on Republican Guard outside Baghdad...investigation launched into US shootings of civilians...Jack Straw calls for UN conference on post-war Iraq...

Tony Blair still wants 'bigger maps' in order to see what is happening on the battlefields. But three small maps and a wooden classroom easel have arrived in the outer office.

'He wanted them pinned up on the walls of the den,' says Sally Morgan. 'But we wouldn't let him. It would have looked awful. He would really have liked a sandpit with tanks. I offered to bring in my children's "Risk" board from home.'

She stops while Jonathan Powell gives his 'too-much-noise-in-my-office' glare. Even the word 'risk', which has for years been a totem of New Labour, has lost some of its allure since the war vote.

A few charts on a cork board, paperback-sized maps pinned one on top of the other, black-and-white snapshots, our-boys-are-here diagrams: none of this looks more alarming than a history lesson at school.

Tony Blair walks down from the flat and along the Campbell corridor on his way to his meeting with the military. The mood of the front hall is more anxious than that of the den.

In the six years that Labour has been in power the messengers

have grown used to having a more crowded house. But more 'team members' for the Prime Minister has meant less space for visitors.

There is one small waiting room, with the loud-ticking clock and the large photographs of shipping forecasts; there is the burgundy sofa outside it beside the 'Robin Cook door' to the basement stairs: 'And that's it,' says a disgruntled messenger's voice. 'We don't like putting more than one group in the room because you never know who it is that's here.'

Beside the window onto Downing Street a group of Poles await a trip to the diplomatic knights. They are talking lightly of how good their special forces look in desert kit and what grade of visitor is allowed to use the Number Ten 'Ambassadors' entrance'.

At the other end of the tiny space are two French-speakers with matching red ties and briefcases. They look unimpressed by the sofa, perplexed by the manual wooden calendar still set to 1 April, and mildly affronted by the sculptured head on the floor, which has its own very slight French appearance and is used as the weight to keep the door open.

After a few awkward minutes the parties of New and Old Europe are separated. The only visitor left is a man in a loose suit, probably a civil servant, possibly from the Department of Health, looking hard at a newspaper photograph on the table.

This is not the main front-page picture. It is a small detail of a larger tableau, the last depiction of a dead Iraqi child, said to be a bomb victim, kohl around his eyes, blood in the crease of his nose, his tiny body taped into a shroud. 'I wonder what he feels when he looks at this,' he asks quietly.

The speaker leaves almost immediately for a meeting somewhere in the domestic zones. This seems set to be a quiet day, but not so quiet that Tony Blair will spend long staring at a down-page newspaper picture. There are Questions to the Prime Minister later this morning, but the chances of 'him' having to

answer such a question in the House of Commons is slight.

Preparation time for this weekly examination has been concentrated on free parcel post for soldiers (known as the 'Pot Noodle point'), Saddam's attempts to destroy Shia places of worship and blame the British (the 'shrine point'), and the antics of the 'traitor' Labour MP George Galloway. The Prime Minister needs no 'point' to remind him of 'Gorgeous George', his maverick Scottish colleague who not only opposes the war but has meetings with Saddam Hussein.

Today's 'dash' to the House of Commons is quiet too, no highspeed chase after the Prime Minister's car. Alastair Campbell passes around favoured newspaper cartoons. Sally Morgan has one of her regular letters from an exotic 'prince' called Ashraf who lives in Luton.

During Questions in the Chamber, Campbell and MacFadden watch the television from the musty office sofa. They sit there like a couple of resting guard dogs, temporarily inactive but liable to bare their teeth at the slightest provocation.

Campbell signs a letter and sighs soft, sardonic comments on the action. 'What would the Prime Minister say to my constituents in Eastbourne who...' asks a Conservative MP. 'Vote Labour,' barracks Campbell, as though he were on the backbenches himself. A Labour MP appears to be falling asleep: 'Wake up, Fraser!' shouts the armchair parliamentarian.

After the session is over, Tony Blair is back at his usual place at the long table, signing bottles and photographs. Life has returned to routine here, too. There is no longer the press of aides persuading for one emphasis or another. It seems a different place from the one where he put his job on the line.

The Prime Minister is often open for questions from journalists

and MPs, but some are less easily posed. I stop and ask him the question which the visitor this morning from beyond the war wanted to ask. What does he feel himself about the deaths of children that are the direct result of his own decision?

That man in the waiting room did not want a public answer, an administrator's calculation which weighs hundreds of thousands of child deaths caused by Saddam against the many fewer caused by British weapons. He could provide that for himself. He wanted to know how the Prime Minister feels about the simpler moral problem, the deaths caused by one's own avoidable act.

Tony Blair looks up at me from his seat. He finds a few words, though hardly his most eloquent ones. 'It really gets to you,' he says, as though he were talking about someone other than himself. His voice is strained. Deep in his eyes there is a pale shudder. 'It does really get to you,' he says, looking at me directly as though challenging me to disagree.

He puts down the fountain pen. Behind his gaze there is a momentary blankness. Aides have spoken of how much he has felt the responsibility of shedding blood. He speaks of being ready 'to meet my maker' and answer for 'those who have died or have been horribly maimed as a result of my decisions'. He accepts that others who share a belief in his maker, who believe in 'the same God', assess that the last judgement will be against him.

He talks of *Journey's End*, the play set in the barbed-wire trenches of St Quentin which he took part in at school, its 'real effect on me'. He talks of how he has to isolate himself when people are dying from what he has decided he must do. He talks of how he has to put barriers in his mind.

He picks up a whisky bottle, signs his name and returns to his normal smile. 'Trust me. I'm not turning into a real Captain Stanhope. He drank one of these a day. If I ever start doing that, you really ought to worry.'

In all these days with Tony Blair I have not seen the commonly held evidences of feeling, no tears or head-held-in-hand. And yet, if I meet that man from this morning again, and if I am asked whether the Prime Minister, as well as feeling the political risk of war, feels powerfully and personally its worst individual results, I will say that he does.

Outside the door MPs are queuing to complain about the government's plans for a new brand of 'foundation hospitals'. Former Cabinet Ministers join the ideological heirs of Jack Jones to protest that private finance and freedom for managers will mean an end to the National Health Service – a service which, however much Tony Blair achieves, will always be the Labour movement's finest achievement.

The Prime Minister's attention is swinging between hip-replacement targets, Republican Guard targets and the ends of diplomacy. 'We have to play down this problem about whether the UN or the US is going to run Iraq,' he says. 'It will be fixed as long as there isn't too much rubbing of other people's noses.'

'Stop rubbing French noses in the...' says the waiting spokesman quietly, as though briefing himself for a future briefing.

<p style="text-align:center">* * *</p>

Back in the den it is time again for Gerry Adams. The attempt to make positive links between Baghdad, Belfast and Jerusalem goes on.

This man who was for years one of the most hated names in Downing Street is now a regular visitor. Some here still feel a *frisson* when they see him in these corridors. Little more than ten years ago, while the Cabinet discussed the possible consequences of the last Iraqi crisis, the IRA attacked them with mortars from Whitehall.

But few ever get to see the Sinn Fein leader here. The most enduring legacies of that day are the bombproof Number Ten front door, which swings now like the entrance to a bank vault, the heavy window panes which have to be craned into their frames, and the reduced count of cherry trees in the garden.

'By the time I got into my third foundation hospitals speech I was really into my stride,' says Tony Blair, sitting back on his sofa thirty minutes later with a mug of tea and the Health Secretary, Alan Milburn. He is smiling, lightly mocking himself. 'Choice is a good, not a curse.' He checks himself. He does not need to hand soundbites to his own Cabinet colleague; they are on the same side. 'But I don't think I persuaded anyone of that back there.'

The two men settle down with Sally Morgan to examine exactly where the opposition to the next New Labour policy will come from, who has constructive criticisms that can be met, who wants only higher taxes, higher spending and that everyone's treatment be second-rate as long as it is equally second-rate.

'The people who oppose privately financed hospitals the most are often the ones who like them the most when they're built,' says Tony Blair, before turning his mind sharply back to the past, when he was twenty-two years old, just leaving Oxford University, and his mother was being treated for thyroid cancer. 'I just think of the place where my dear mother died,' he says suddenly, 'how terrible it was and how much better it is now.'

Milburn looks slightly startled. The Prime Minister does not often mention his mother to his colleagues. His father, Leo Senior, who suffered a stroke in his early forties which put an end to his own political ambitions, is a well-documented part of the official biography. His disappointed hopes are often said to have driven the young Tony Blair. His mother, Hazel, is much less known.

Tony Blair moves back behind his desk. He spoke once in pub-

lic of his mother's death during a very personal broadcast made for the 1997 election. She is said to have been just as influential on his life as his father but in less direct ways, inspiring more by comfort and confidence than professional example.

Milburn looks sympathetically at his boss. 'Yes, that hospital was a terrible hole.'

The use of the word 'hole' does not strike quite the right note. To the lengthening line of recipients of the 'that's enough of that talk' stare is added the name Alan Milburn.

Thursday, 3 April

Morning headlines...Republican Guard falling back...US forces braced for chemical attack outside Baghdad...BBC man killed by landmine...Britain distances itself from Rumsfeld on Syria and Iran...

Since 11 September 2001 it has been hard for aides to lead a President or Prime Minister into a class of schoolchildren without wondering if this will be their 'Andrew Card moment'. When George Bush's Chief of Staff, Andrew Card, interrupted a Presidential reading of *The Very Hungry Caterpillar* to tell a tale of planes flying into tall buildings, he set a standard which many a Private Secretary secretly yearns to match.

Tony Blair is talking his way this afternoon through a room of red-sweatered boys and girls from RAF families, listening to their views on England's football match against Turkey last night ('rubbish'), school food ('rubbish') and where they would most like their next air base to be ('Disneyland'). All the time his Private Secretary Matthew Rycroft, open-faced, slightly stooping, waits close by, blue case and mobile phone in hand, in case his moment is now.

Around Basra the British forces hold a tight grip. Around Baghdad the Republican Guard is crumbling before the American advance. This is the moment when the Indonesians and their

friends, if not every last Cabinet Minister in London, can be sure that this will not be a 'long war'.

The Prime Minister and his wife are around and about RAF Lyneham in Wiltshire, the base from where Hercules transport planes, the winged buses known as Fat Alberts, ply their trade in arms and supplies to the front. This is not the most glamorous of military establishments. It may even soon be closed down. But the 'royals' have already visited the families of frontline fighters. Tony Blair has to take the opportunities for comfort that are left.

If news does come now of Baghdad's fall or Saddam Hussein's suicide, he can swiftly be helicoptered away. He has his clerk-of-the-keys, his red boxes and secure communication links here – as well as his waiting aide.

Any early departure will be sad for his small fans. 'Which one is he? Where is he?' shouts a blond boy with a yellow ribbon while he waits patiently in the HIVE (Help, Information, Volunteers, Exchange) and tears apart ham sandwiches.

'I'm here. It's me,' calls the Prime Minister, pushing through a glass door decorated with bees.

The boy has now queued for a second handshake, and is plotting transparently with his friends as to how he might have a third.

Cherie Blair is a better substitute for royalty than her husband. She is more formal, staid, controlled – even with children. This is not her idea of a fun afternoon. But then, why would it be?

Tony Blair gives every appearance of a man enjoying himself. In the last three weeks he has not often looked fully off-duty. He has not told the jokes against himself that he usually tells. He has saved his charm for those who needed it most – even when most of the recipients did not appreciate it much.

Today he is revelling in this barn of red sweaters. Perhaps he is just enjoying the change. Or perhaps, when politicians tire of this kind of show, they are tired of being politicians at all.

The peppery base commander is barely less scheming than the small boy. He is keen to ride in the Prime Ministerial 'armoured', as he calls the green Daimler. He wants to lobby for the future of Lyneham, which is threatened by planners at the Ministry of Defence. But he also wants a ride in the car.

Ideally this former pilot would be taking it for a 'spin' around the base himself, testing the impact of the armour plate on its cornering. The only thing he would rather be doing today is to be 'up tiddly up' under what he says is a perfect 'shallow stratocumulus' of cloud.

All is going well. But the news from the front, while good, is not worth interrupting the fun in the hive for. In all his future Foreign Office career, Matthew Rycroft may never experience more dramatic days, more closely at the heart of government, than these have been. But these particular hours are not perhaps the finest of them.

Back in the bar on the other side of the runway, the loaders of the Fat Alberts are swapping notes. Tony and Cherie Blair, separately 'working the room', were polite enough not to pay attention to the pole around which exotic dancers strut their stuff on party nights. It was a good idea to hide it, 'like a bit of sculpture', with pot plants.

The men and women of Lyneham have been able to make their points directly about high parcel charges to Kuwait (the Pot Noodle complaint again), desert sandstorms (the right kit in which to be recognised in the dark) and the primitive facilities in the sand when they first arrived.

The RAF knows how to run a visit. The commander has even prepared two versions of the visitors' book, one for Mrs Cherie Blair, the Prime Minister's wife, the other for Ms Cherie Booth, the human rights lawyer. Which does she want?

'Blair will do fine,' says Kate Garvie, who has 'advanced' this section of the military tour today and not driven close to a single dog.

'Ditch the Booth,' says the man who would rather be 'up tiddly up', giving another long, jealous look at the 'armoured'.

Apart from a few technical points (the RAF always works on 'Zulu time', or Greenwich Mean Time, even if the rest of Britain has switched to Summer Time), the problems for a Private Secretary are slight. The Prime Minister of Canada wants to talk. But no one, not even in Canada, would see that as an 'Andrew Card moment'.

Friday, 4 April

Morning headlines... US forces take Baghdad airport... Iraqi
Shia leader calls for civilians not to oppose British and American
troops... US and Europe divided over future control...

The War Cabinet has become like breakfast on the last days of an
ocean cruise. Suspicions have broken down. Friendships have been
made. Even the people who would not choose each other's com-
pany can be civil in the knowledge that they need not be together
every morning for much longer.

The intelligence men are more at ease with the politicians. The
small-talk of the Chief of the Defence Staff is not reserved for
Defence Secretary Geoff Hoon. 'Hi, Mike,' says John Reid chirpily as
everyone gathers to sit down among the pillars; Sir Michael Boyce's
wonted wintry smile is for once almost spring-like in return.

Baghdad airport is in American control. Most of the news is still
good. A secret cache of chemical weapons, safe enough to be no
risk to the soldiers who find them, but certain enough to bring
protection to the politicians who ordered the soldiers in, would be
perfect. But perfection for the moment has to wait.

John Prescott has had a better night's sleep and is almost buoy-
ant. He has been in Coventry to canvass for the local election cam-
paign. 'One good thing about the war,' he tells Clare Short, 'is the
way it's knocked the asylum issue off the front pages.'

Illegal access to Britain by Balkans and Kurds is a much greater

affront to many voters than the war with Iraq. Anything that draws attention away from it, or 'stops the press fanning it up', as Prescott sees the problem, is an electoral bonus. Short, who is as sympathetic to asylum-seekers as she is unsympathetic to war, is the only breakfaster to have missed the end-of-voyage mood.

Reid is even more cheerful after the meeting than before. 'There is about to be something very interesting,' he whispers with a knowing look.

Jack Straw has had a good war. He would not have stayed in his job if Tony Blair had had to resign after the House of Commons vote. He would not have waited to be forced out. He would have quit at once. Both the final diplomatic offensive that failed and the final political offensive that nearly failed were part of his war too. This morning he looks relieved but a bit distracted, like a man who has come back to work from holiday and wishes he had never gone away.

With Sally Morgan following close behind, he slips into the political office. The Foreign Office has discovered a great deal of business that has suffered wartime neglect. 'Before I go back,' Straw says to Morgan, 'let me just have five minutes' peace…as my mother used to say.'

What is Reid's 'very interesting something' to be? There is talk in the diplomatic zone of a new 'big push', not on Baghdad, which is already being pushed quite enough, but on the people around the world, particularly in the Arab world, who are watching what is happening in Baghdad.

'The boss', it is said in the Campbell corridor, wants a new 'Whitehall initiative', with contributions from various different departments, in order that his benign ambitions for the region be better understood. But in the mind of a politician like John Reid, that sort of scheme can be important, useful, but never 'very interesting'.

Suddenly there is a sense of everyone running again. Alastair Campbell, jacketless and tieless for the War Cabinet, is loping. Press officers appear rapidly from little-known rooms off the Alphabet staircase.

This is the sort of excitement that is seen only when the Prime Minister is unexpectedly on the move, or when someone senior is about to lose a job, or get a new one.

A new job for someone would be 'interesting' to John Reid. What would be 'something very interesting' would be for John Reid to get a new job.

And so it proves. The big gap in the government which opened when Robin Cook did his 'ay, ay, ay' walk out of Cabinet is to be filled. John Reid, fierce enforcer of whatever is his leader's will, becomes Leader of the House of Commons.

That is a promotion to great Westminster grandeur. His mother – who, he points out, shares a birthday next month with Tony Blair – will be pleased. The move also suggests hard times ahead for MPs who want a way back after voting the wrong way on the war.

His friend Ian McCartney, 'Little Labour' and link to the trade unions, has not suffered for saying that this is 'a T & G government'. He will become Labour Party Chairman with a brief to find money, members and forgiveness for the war from the movement at large. Such is the Prime Ministerial art of smoke signals.

In the diplomatic zone there are notes to be made of what happened when the Prime Minister finally did talk to Jean Chrétien in Canada yesterday. As Tony Blair himself puts it, striding out of the den through the pack of job-changers, 'That guy needs a way back; he took the hard position that there needed to be a second UN resolution; if that had happened there would be Canadian troops out with us now; but it didn't; so there aren't; and now he's looking

what to do next.' The diplomatic note may be less succinct. That is sometimes the nature of diplomatic notes.

In the hall outside the Cabinet Room the switch of roles between Party Chairman and Leader of the House is happening before everyone's eyes as though in some private theatre. John Reid was just about to go to Wales to give a speech to party members. Now he gives his friend the speech and the name of the person who will meet him off the train.

McCartney sets off proudly down the corridor, strong but awkward, like a cupboard being pushed over carpet.

Reid calls him back. McCartney stops.

Reid follows him down to the Henry Moore statue and hands him his rail ticket.

Over the fireplace in the Terracotta Room is a large royal crest, moulded, gilded and tilted slightly forward in case anyone fails to notice it. The faces of Wellington and Nelson stare out on either side from the Italianate walls, smaller but more piercing portraits of the men who stood behind Tony Blair when he was questioned by the ITV women three weeks ago.

Only one woman this morning is staring in the same direction out onto Horse Guards Parade. Zara Mohammed is standing at the window, looking at the tourist attractions, the men in bearskin hats, the cannon decorated with pyramids and crocodiles, spoils of war against Egyptians and Turks, the statues of British Empire-builders on horseback.

She and her four colleagues have to wait a little while before Tony Blair arrives. If she looks left, the view is to the White Drawing Room, the sofa where the Indonesian envoy said he wanted to mediate with Saddam Hussein. If she looks right, there is the approach to the State Dining Rooms, where Jack Jones and the teachers of 'special needs' children had their parties. But she

looks only ahead, or up to the elaborate gilt ceiling. Of all the five Iraqi exiles who are here as reminders of what the war is now about, she seems to want to be in the Terracotta Room the least.

'Thanks for coming,' says Tony Blair, taking a deep breath as though to say this all looks very strange.

A frail man sitting opposite immediately begins his account of seven years in Iraqi gaols, six hours of 'hanger' torture each day for eleven months, life in packed cells where the only sleep was standing up, routines of captivity broken only by the occasional day when Saddam Hussein paid a personal visit and cut off the air supply for a while so that the survivors knew he had been.

Tony Blair takes a second deep breath. A larger man is in the seat closest to him, immediately below the royal crest. He is a doctor, and shows the scars around his wrists with the diffidence of a man more used to being shown others' scars. He says he spent just three years in cells being hung from the ceilings and beaten, alongside other prisoners, in a kind of punishment show which their families were forced to watch.

Tony Blair touches the doctor's wrists. It is not a comfortable gesture. But words are not easy either, not words beyond his promise that Saddam's regime has gone, that it should have been removed in 1991, that he is sorry and the same mistake will not be made again.

Next to speak is a Shia woman in white headscarf, from a prominent family which was exiled to Iran. She is more poised and political. What Tony Blair wants to hear is both proof that his war is right, proof that others outside Downing Street can hear today, and also some pointers to the future. He leans forward to listen.

She says firmly that she wants a Shia government, rule by the religious majority. This is not what he wants to hear.

The British and American ambition is for an Iraq in which no group dominates the others and all groups share power. The Kurds

have given assurances that they will not break away and form their own state. Great efforts have been made in meetings and seminars to understand what sort of new state there might be. On the table by the window there is a note about whether, in speeches and broadcasts during the 'big push' for Arab hearts and minds, the phrase 'people of Iraq' should be preferred to 'Iraqi people'.

There are so many peoples. Perhaps there might be a Truth Commission to reconcile tortured and torturers, as in Nelson Mandela's South Africa. Who would decide that?

When this steely woman in white claims Iraq for the Shia majority, Tony Blair moves instinctively into his style for a television interview, restating her point in a way which stresses both the important role of the Shia and the role to be played by other groups. If he expects her to smile and accept his version of her views, he is mistaken. She repeats that the Shia are the majority.

He thanks her. She thanks him in return. He says that if the Iraqi people really want to thank him, and to thank the soldiers and people of Britain, they should adopt a tolerant form of government in which all parties and religions have a place. She gives him a hard look and reiterates her majority claim. She has a sense of democracy, but not the hope of democratic pluralism that her host has.

When the doctor speaks again he is especially indignant at Saddam Hussein's prison visits. He looks at the Prime Minister and asks: 'When a President or head of government comes to a gaol he would normally release a few people, not kill them, isn't that so?' Tony Blair is not sure whether to agree or not, whether or not to point out that ideally a head of government should have no power either to imprison or to release on a whim.

For all this time, Zara Mohammed has been moving her eyes between the carpet and the ceiling. When it is her turn to speak she describes her prison life in packed rooms of beaten, broken, raped

and bloodied women. She recalls the shouting of the guards when she arrived, the laughing anticipation of a 'nice party tonight, new virgins'. There were rotting bodies among the living, a pregnant mother and her child, still alive, grasping her cardigan.

Then there was her cell, with the metal ceiling and the ratcheting sound and the descending sharpened screw which drove down and down as she crouched in terror before it stopped. This conjuring from the Terracotta Room air of a medieval Iron Maiden in the modern mind of Edgar Allan Poe is more than Tony Blair needs to hear. He speaks of how difficult it will be for those who have suffered or fear suffering until they are certain that Saddam Hussein will not return. Zara Mohammed nods.

For years after the Emperor Nero died, the early Christians imagined that he was not dead, or would somehow come back. The former occupants of the metal cells may not easily accept that their own tormentor has truly gone. There is not even a body yet.

Tony Blair says goodbye, wishes the exiles well and goes down the main staircase, past his predecessors' faces, and down into the Cabinet Room to take questions from Abu Dhabi TV, part of the 'big push'.

The Iraqis leave by the front door into Downing Street and out to tell reporters what they told the Prime Minister, and what they still want to tell anyone who will hear.

Saturday, 5 April

Morning headlines…Baghdad surrounded…Saddam shown 'defiant' on TV…Tony Blair and George Bush to meet in Belfast next week…pressure grows to find banned weapons in Iraq…

Tony Blair and his family are out of town. The team too is trying to have a quiet day. Sally Morgan often arrives in Downing Street muttering a mantra of surprise that 'out there' people are managing to live sensible, balanced lives. Today she is trying to live like people 'out there'.

Alastair Campbell is training for his marathon run. He is raising money for leukaemia research and stamping stress into pavements all over north London. Next year he wants the Prime Minister to do it too. 'Anything Bush can do, you can do…' he hums.

There would be less stress in the diplomatic knights' zone if some weapons of mass destruction began to be discovered in Iraq. Not everyone is impressed by horror stories from Iraqi torture chambers. Security Council members were asked to back a war against Saddam Hussein because he had broken promises to destroy his chemical and biological bombs, not because, like many other UN members, he had adopted interrogation techniques from the Tower of London.

Where is all that chemical and biological kit? That is the persistent question from French and Germans and Canadians and

many others, all tired already of being portrayed as shirkers from a successful war.

The Prime Minister says that he is sure the illegal weapons are there. The Home Secretary, David Blunkett, says this morning that he hopes the illegal weapons are not there. The Number Ten Press Office has to clarify more forcefully what Mr Blunkett meant to say: 'The government is certain that Saddam Hussein possesses weapons of mass destruction. The Home Secretary hopes, however, that British soldiers will not come upon chemical or biological weapons unprepared.'

So everyone agrees.

Uncertainly, they all agree.

Sunday, 6 April

Morning headlines…Red Cross reports Baghdad hospitals overwhelmed…British hold centre of Basra…hopes for Northern Ireland peace breakthrough at Belfast summit…

When Tony Blair talks to George Bush, as he does today and most days, their conversations are overheard by listeners. Wherever the two men are spending their weekends, their words are recorded and noted by staff who are not even pretending to relax.

The transcripts are studied in London as though they were unknown plays by great dramatists. The written dialogue seems sharp and pointed, with the occasional gap for silence – 'Like Quentin Tarantino without the bad language, Harold Pinter with extra pauses,' as one student struggles to put it.

Occasionally Tony Blair will make a longer speech. Less often George Bush does. The President often makes jokes 'of the kind which Pinter would use to make a character statement, probably not a very favourable one'.

The Prime Minister has accustomed himself to the reality of America's massively superior power. 'If Washington wants to tackle a problem, you've got to see that, make sure it's true, take it seriously and not run away,' he said in the Cabinet Room hall between bouts of the 'big push' yesterday.

People ask him even more regularly now why he and the Americans do not just turn on other unpleasant dictators. 'If they

want to get rid of Mugabe, great, let's get rid of Mugabe,' he retorts rhetorically.

But some people in Washington want to get rid of Syria's President Bashar Assad, the son of an unpleasant dictator who, Tony Blair believes, will be better than his father. The Prime Minister has a great commitment to 'generational change'. He does not believe that George Bush wants to send his tanks against the young second President Assad.

How does Tony Blair know that? How do those listening to the conversations and studying the transcript know?

He has great faith in his powers of personal intuition. He sees at the centre of a politician's art the need 'to know where another person is coming from, where they want to go, and how much they want to go there'.

He is not afraid to talk frankly to the President. He believes that America has to change more as a result of the 9/11 attacks, the Afghan and Iraqi campaigns than many of its most influential politicians want to. 'They need new policies of engagement for all parts of the world, starting with the Middle East. They can't just pally up to a few governments, a few regimes.'

Many British Prime Ministers have hoped to be a bridge between other nations and the US. None has created a bridge as crowded as the present one is becoming.

'Governments are recognising that they made a bad choice on Iraq. They are calling here for a chat. They are looking for a way back with Washington.'

Tony Blair is not thinking only of the embarrassed Canadian government, 'whose people are asking why they've turned out on the wrong side', but of some of the South Americans and Asians too.

And with the 'Non–Nein–Nyet' alliance? 'There has to be some tough thinking. There needs to be a reckoning on all sides. I am

normally a consensual person but we cannot just finish this, wipe our hands and say, please, back to old times. There cannot be a continual and worsening power struggle between Europe and the US. If that is what others want, we will not be part of it'

He is more confident of the Germans recognising the dangers than of the Russians or the French doing so: 'With Putin and Chirac we have to try to make certain that the same problem does not happen again. They are just beginning to "get it". I think so.'

For those studying this latest transatlantic partnership, everything depends on those last words. Tony Blair 'thinks so'.

He and George Bush still seem an unlikely couple. Leaving aside some shared religious beliefs (and that is exactly what students of diplomacy like to do with religious beliefs), their political backgrounds and instincts could hardly be more different. One is from the Texan right; the other is from the British left. One believes in low taxes and has little confidence in making people richer or better with public money. The other is prepared to tax more if he can make the public benefits greater – and he thinks that he can.

Tony Blair has thought of many ways in which he and the President have formed the same outlook on the world. He talks of their shared late entry into politics, their experience of life beyond public office, their instinctive, creative, practical approaches.

Even some of his own analysts are doubtful. Most would like it to be true. Those who have been working in these fields for longer than either man remember how close Winston Churchill thought he was to Roosevelt, how powerful was his belief in the 'personal interchanges' which brought their 'perfect understanding'.

That was a partnership across the Atlantic on which the fate of Britain and America hung. Hitler was a clear, present and huge danger. That was a test of history which few have since doubted. But a shared approach to Nazi Germany, instinctive, practical,

creative at the time, did not bring the understanding in other areas which Churchill wanted to see.

Roosevelt believed fundamentally in better public provision, higher state spending. He also wanted to clear British power from the globe. Churchill believed in none of those things.

Tony Blair, who welcomes George Bush to the UK tomorrow, is unshaken by the pessimism of historians. He does not use the word 'friend' as freely as the President does. Partly that is because of his own more cautious character. Partly it is the British characteristic to avoid language which may sound insincere. Partly, maybe most importantly, it is the wish to avoid seeming to crave friendship from the world's most powerful man.

His instinct is still to trust George Bush until he has reason to do otherwise.

Monday, 7 April

Morning headlines...Baghdad airport clear for US planes to land...British troops secure centre of Basra...hospital chaos...UN must run the new Iraq...

Tony Blair is on train-operating duty at 7.30 a.m. Railway mania in Number Ten is no longer confined to the hall carpet behind the front door to the Blairs' flat upstairs. There is a track across the floor of the White Drawing Room too, a viaduct to be installed and a vista of plastic trees. A dozen three-year-olds are here to ensure that the father of Leo fixes his sleepers to the right rails.

This is Work–Life Balance Day in Downing Street. Leo and some new friends are providing the life. Tony Blair, whose trip to Belfast today to greet George Bush is hardly less troublesome than a trip abroad, is wondering when he will get a life back too.

Thirty parents, mostly mothers, are on the other side of the double doors in the Terracotta Room. Cherie Blair is leading a discussion on how the workplace can be made easier for people-like-them. After fifteen minutes and a few encouraging words the Prime Minister leaves his new train set, treads carefully past the miniature whale-shaped bouncer, looks tolerantly at the ballooning plastic beakers of orange juice on the government's best polished sideboard, kicks a coloured ball at the wall and goes back to war.

John Scarlett, Chairman of the Joint Intelligence Committee, has, as usual these thirty days, been at his desk in the Cabinet

Office since 5 a.m., 'sifting the wheat from the tares', as he puts it, preparing to tell the politicians the difference between what matters and what is on TV. This former British agent now has the job of ensuring that the dangerous work of British agents in the field today is not ignored by those who take the decisions. Following the first 'den' session, he chats with the War Cabinet politicians, but even after three weeks, still charily.

He does not attempt conversation with Clare Short, who is at her cloudiest today, leaning on the table with her back to the CDS's hat and tearing up bits of newspaper. She is pointing at reports from Basra of dead children and no doctors for the dying. She praises writers who share her view that any legitimate post-war administration must be run by the United Nations. 'Oh, so many mistakes have been made,' she says softly.

Scarlett stays on the Pitt the Younger side of the hall, talking to the Attorney General.

Short has been talking to Germans who were children during the bombing of Berlin and Dresden. 'Yes, they recognised that it was right to remove Hitler, but yes, they remember too just how forever irrecoverable was the damage done to them from the sky.' She addresses Tony Blair's public balancing of 400,000 needlessly dead children under Saddam's rule against the unknown, but very much smaller, numbers killed by bombing. 'The deaths today,' she says, 'are caused by us, and that is the moral difference.' That is the point on which Tony Blair has said that he will face his maker and be judged.

Scarlett is not concerned professionally with Short's moral equation, any more than with that of John Reid, who argued to the Scots two weeks ago that it would be a sin of omission to let Saddam Hussein stay in power. His job is the judgement of likelihood. What is likely to happen? What is likely to have happened?

<div align="center">* * *</div>

In the next hour, Number Ten has four separate centres of high activity. Under the mobile-phone table in the front hall red boxes and black cases are being piled up for Belfast. The man in charge is concerned, among a myriad matters of airfreight, with the sudden sprawling arrival of a large Victorian pier-end glass-plate camera, with a circus of accessories that could soon, if care is not taken, be in Northern Ireland. The Prime Minister is having a birthday photograph taken by some fashionable artiste. 'There might be trouble finding his best side at the moment,' says a grim visitor from the Treasury. 'He still looks awful.'

The Budget is two days from now. This is the time when the Treasury likes to feel in the ascendant.

In the Cabinet Room itself Scarlett is answering questions about the whereabouts of Saddam Hussein and, even more importantly, his weapons of mass destruction. He has not much to say. Clare Short has a great deal to say, but in the official parts of the meetings it must be all about supply tonnage and Phase Four finance.

Up in the White Drawing Room the party shows no sign of coming to an end. Leo Blair is painstakingly completing his father's repair programme for the railways. In the Terracotta Room there is animated talk about the government's policy for children, which John Prescott, probably the least 'new man' of any in the Cabinet, is due to speak about this evening.

The view in the room is that Cherie Blair should take the place of her husband for this occasion, being both more thoughtful and more credible on the balance between life and work. But the Prime Minister's wife politely declines. She does not think much of the government's policy, is attacked by the press if she does anything for the government at all, and, following the affair of the stylist, the lover and the time-saving cheap student flat purchase, feels it is

perhaps best to avoid the work–life balance issue in public altogether.

Down in the Outer Office the team is wondering how, before he leaves, Tony Blair is going to fit in a talk with a junior Minister about office technology, a chic photo-shoot for international admirers and a brief on the IRA from the head of MI5. There need also to be phone calls with the Spanish Prime Minister (for goodwill's sake), the King of Jordan (for the King of Jordan's sake) and the young President of Syria, who, hardly surprisingly, wants reassurance from his new-generation friend that Shock and Awe are not coming his way next. The Prime Minister and his Communications Director must also have a short lunch at the *Guardian* newspaper.

At 3 p.m. the Belfast party is almost ready to leave. Last suits and shirts appear among the cases, as though for a family holiday with a bit of business added. Vera makes sure that Tony Blair's brown leather overnight bag is safely in the back of the Daimler. She gives it an affectionate pat as though it were the man himself. The convoy of armoured cars and people-carriers gradually fills, the least taking their places first, the most important last.

John Scarlett, in elegant pale grey suit and pale purple tie, keeps his seemingly lockless smooth black case tight in his hand. David Manning leaves a final note of instruction. The Foreign Secretary has a departing word with one of his officials and sits in the back of the Prime Minister's car. Several minutes later, as the photographers strain for a routine picture in the hope that this time it might not be routine, and as junior passengers inside the cars fret about items left behind, Tony Blair steps quickly from door to door.

The convoy lurches forward. Each driver, even in the confines of Downing Street, is determined not to be left behind. Then everything stops.

There is still more fidgeting. The photographers' expectations rise. The telephone rings in the hand of Jackie, the Clerk on duty today as she was on the night that the war began.

'He's forgotten his glasses' she says, holding her hand over the mouthpiece. 'Where are they?' she asks the detective in the car ahead.

'Somewhere in the den.' She repeats the reply.

She pushes open the door, but Jack Straw is already back on the Number Ten front step. Before there is time to ponder whether Lord Carrington would ever have left his car to fetch Margaret Thatcher's glasses, or whether Douglas Hurd would have made the same leap for John Major, Tony Blair's Foreign Secretary is back in the street with the trophy in his hand.

After one last slight delay, squeezing under Admiralty Arch past a pantechnicon for *Phantom of the Opera*, the team and its leader are on their way to the aircraft of the Royal Flight waiting at Northolt.

* * *

In a small room for domestic staff at the back of Hillsborough Castle, John Scarlett is watching the early-evening TV news. Behind him are box files of bakers' bills and garden-planting schedules. Around him, laptop by laptop, the mobile Downing Street is being assembled. This is the base from which the British hope to manage a successful summit with President Bush, an appropriate Presidential appreciation of the United Nations' role in Iraq and some progress (maybe great progress) to peace in the province over which this castle once held sway.

Before work begins, Scarlett, David Manning and Jonathan Powell are watching the latest pictures from Baghdad, each with a very slight look of disdain. Scarlett's TV memories of this war are of 'illegal Iraqi Scuds' aimed at a Kuwaiti shopping centre which were not Scud missiles at all, a 'popular uprising' in Basra which

was actually a battle between political commissars and Iraqi sol-
diers, and a twisted string of other words and pictures which
might have been events, but were not.

Manning repeats an ABC news reporter's claim, quoting
Pentagon sources, that barrels of Sarin nerve gas have been found.

'That's more plausible than some we've heard,' says Powell.

'It's important, if true,' says Manning. 'And it will be true one
day.'

Jack Straw takes a walk outside around the circular gravel path,
musing on the arguments which might bring the President round
to the Blair way of thinking on post-war Iraq. 'The British, for
example, were always most successful with colonies when they
used a light touch. Their big mistake was being too impatient and
heavy-handed in places like Boston...'

A heavily-built American security man approaches.

'...and therefore, what Iraq needs is a light, international
administration...or perhaps not.'

The security man warns Her Majesty's Foreign Secretary that 'as
long as he sticks to the pathways' of Her Majesty's Belfast resi-
dence, he will be in no danger.

The party to welcome the President assembles in the Entrance
Hall. On each side of the fireplace stand a silver spade and a wood-
en dummy in nineteenth-century military uniform. Above the
door are the antlers, eight feet across, from a long-dead stag.

In the Throne Room the Stars and Stripes are being given a final
steam iron by American advance staff anxious about the lack of
steam. In the Drawing Room the signed photograph of Hillary
Clinton is tidied away in a drawer. Bill Clinton may be in mild
White House favour for his war work on British parliamentary
opinion, but his wife, still a potential Democrat opponent, is not.

After a one-minute warning for the 'honour party', the Presidential car arrives outside. It is as big and solid as a car can be without being designated an Armoured Personnel Carrier.

The Prime Minister, a slim black line framed in the castle doorway, asks if his guest has had a good journey. 'Yes,' says the President, looking warily at the stuffed British soldiers. 'I go to sleep, wake up, and here I am in Merry Old Ireland.'

There is a mild *frisson* among the home side. No one wants to be too sensitive these days about the border between the Irish Republic and the United Kingdom, but 'Merry Old Ireland' suggests that President Bush may think he is somewhere else. Northern Ireland is not normally known as 'merry', and when the White House spokesman first announced the trip he said that the meetings would probably take place in Dublin.

The first thing the President sees on the Garden Room table is a folded copy of the *Belfast Telegraph* with the banner headline DAY OF RECKONING AT PEACE SUMMIT.

'Is that ours?' asks the President.

'No, theirs,' says the Prime Minister. 'Politics is a bit local here.'

Behind the newspaper is a chess set carved as caricatures of the two sides in Ulster's long sectarian struggle. George Bush looks quickly at the pieces he will meet tomorrow. Black Gerry Adams and Martin McGuinness stand with scarlet, black-cowled bishops, protected by black-masked pawns. The Queen, who will not be here, and the most uncompromising Protestant politician, the Reverend Ian Paisley, lead the other side of the green-and-orange board. They are protected by white flat-hatted policemen, and flash mouths full of large white teeth.

It is a bold statement, not of the kind that every host would show a US President. Tony Blair moves in quickly to explain that the black Republicans, whom Americans have traditionally

financed, are against the war in Iraq, while the white Unionists, whom Americans like to see as colonial oppressors, are in favour of it. The President nods.

Tony Blair suggests a walk around the gravel path. He is keen to put his case that the UN's role in Iraq should not be described tomorrow as merely 'important', which is the current agreement, but as something stronger – 'of vital importance', perhaps – in order to keep the wheels of diplomacy in motion.

Neither man takes a coat into the cold night air. Coats do not suggest confident leadership.

Condoleezza Rice, the glamorous black 'David Manning' of the White House team, is grateful that the floral royal sofa can take the strain borne till now by her stiletto heels. She looks more closely at the chess pieces.

Between the two active sides on the board are discarded or reshuffled Northern Ireland Secretaries. John Reid is not here tonight in person, but he is on the board, dressed like a docker in church. Peter Mandelson, once the man Tony Blair consulted on everything from election strategy to shirt colours, is here now as an ex-Minister (twice forced to resign), proof that those who manage Tony Blair can make serious enemies, as well as sometimes neglecting the management of themselves. Mo Mowlam, the woman who ran Tony Blair's campaign to be party leader but who in Belfast was too black for the whites, is the last of the pieces in Rice's sight.

The National Security Adviser, one of the very closest of George Bush's aides, has arrived here not from Washington with her Presidential boss and confidant but from Moscow. She regales the British team with stories of her chilly reception there. The men of the Kremlin are not comfortable with a glamorous, black, female, Russian-speaking political scientist at the best of times. To be lectured by one on behalf of the only remaining superpower is almost

impossible for them to bear. Their Ambassador to Iraq is claiming that his car was deliberately shot at by American planes. This is wholly bogus, she says, but she has had a hard time making her case. The Russian role in Iraq is one of many great mysteries to be explored. Saddam Hussein owes Moscow so much money that Vladimir Putin cannot delight to see him fall. The Russian Ambassador in Baghdad is so close to the regime he is virtually an Iraqi.

While Rice is entertaining her hosts, the rest of the American party look out over the lawns, watch the crows in the darkening sky, listen to the helicopter engines overhead and wonder why there are still pictures of Charles and Di on the desk.

Colin Powell is missing. There are mutterings from the British side of 'We've got our Secretary of State: what have you done with yours?'

When Powell arrives at 7.30 p.m. – 'Precisely the time I said I'd come down,' he makes clear – no one offers him a drink. Jack Straw leaps up, goes out into the corridor and tries to find someone who can offer refreshment to his American friend. This has been a day, from Prime Ministerial reading glasses to fruit juice for the US Secretary of State, which has truly put the 'service' in Foreign Service.

The walkers return. The Prime Minister is not happy that before they had walked more than a hundred yards into this prized place of royal horticultural calm, two Land Rovers full of soldiers had approached them with headlights blazing, somewhat cramping his persuasive style. They had made the 'beeping buggies' of Camp David seem as natural as birdsong.

The British team is happy, however, that the President has agreed to promise tomorrow a 'vital role' for the UN in post-war Iraq. Both sides turn to their Irish beef before turning in for an early night.

Tuesday, 8 April

Morning headlines…US forces occupy Saddam Hussein's palaces…Belfast summit on post-war Iraq…financial markets rise as end of war seems near…

Tony Blair would not have been woken last night even if Saddam Hussein had died.

Soon after 3 a.m. the phone rang in Matthew Rycroft's floral-patterned room on the castle's upper corridor. American bombers had hit a building where Saddam was supposed to have been, some kind of underground restaurant. Rycroft made a few notes. Nothing about the fate of the dictator could be confirmed. He decided on sleep for both the Prime Minister and himself.

He is musing now about whether he would have seized his 'Andrew Card moment' even if Saddam Hussein's dead body had been found at his usual subterranean salon table between the menu and the whisky list. He decides that he would not have done.

The President's spokesman, Ari Fleischer, says that he too would have let his boss sleep on. Fleischer was woken last night by American reporters wanting to know whether George Bush had specifically approved the target and the type of bomb. 'I told them no, but it's not what they want to hear, so they ask again,' he says, flicking through photographs from *The Lost Country Houses of Ireland* beneath a pastel portrait of the Queen in youthful middle age.

When the Americans do awake for their Irish breakfast, it seems to them that the whole country has suddenly been lost. The blue skies under which Air Force One, and full flying escort, arrived in 'Merry Old Ireland' have now gone. A pale glow of possible sun is all that can be seen through confining fog. This is not good news for the men guarding the President. There are only about four hundred White House travellers on this trip; often there are six hundred, but 'This was all done in a hurry.'

The air is pure grey, without a hint of dirt or yellow. A line of bulky shrouded figures stands guard outside the window beneath Bedroom One. Probably yew trees, but who can tell?

'I hope this is the fog of peace,' says a plate-faced attendant with a curly cable to his ears and a hand-held castle floor plan. His colleague almost smiles.

'Gerry Adams is on the phone,' a woman shouts from the landing. Everyone looks up, but all that can be seen is the disapproving portrait of a former châtelaine and a set of black-and-white shields bearing permutations of 'Honi Soit qui Mal y Pense'.

Later this morning the Sinn Fein President will be here, alongside other pieces from the green-and-orange chessboard, all to be lectured by the President and Prime Minister on the need for a final move to full and lasting peace. But for the people of Hillsborough there is something different about Gerry Adams. He seems to be sizing up the place to be his 'Belfast second home' for a United Ireland future.

At the far end of the Garden Room, past the books of lost country houses, past the postcards of empire and the desk still dedicated to the Prince and Princess of Wales, is the Lady Grey Chamber. An American intelligence officer, brown files under his arm, is arranging furniture for the first briefing of the day from Iraq. He gives great thought to the exact placing of chairs.

Meanwhile, at the top of the stairs, in a dining room with plain

linen curtains and a bright Turkey carpet, the President seems to be entertaining the Prime Minister to breakfast. Tony Blair goes in without a jacket, past a still-life painting of *Jamaica Fruits* to a real-life dish of something very similar, and is asked if he had a good night. Both men, thanks to their bomb-proof aides, have had 'a very good night, thank you'.

There is a certain muttering in the corridors that Hillsborough is not quite as 'ours' as it was at this time yesterday. This castle is 'held by the Coalition' now. 'The Prime Minister is not having his normal cooked breakfast; there's just bananas, melon, croissants, because that's what the Americans want.'

The hosts are delighted that their 'guests' are getting what they want. From behind the thin upstairs wall, aides report the unmistakable sound of Presidential quips and Prime Ministerial laughter. Alastair Campbell alone looks a little grumpy. He found it hard to find much marathon rhythm when he was stopped in the garden every two hundred yards by men with big shoulders.

For the rest of the Downing Street team the negotiations go on about the communiqué, the statements for the press conference, the special British concern about the UN's place in the new Iraq. A 'vital role' was agreed before dinner last night, but how strongly would the President stress the point? If he looks unenthusiastic or passes the issue off, as he sometimes does, for Tony Blair to fill in the details, those who fear a new US colony on top of the world's second biggest supply of oil will not be persuaded.

Back in London, the one key word is still 'Kofi'. Backbenchers and European 'partners' want to Kofi as much as they can. In Washington, and in the White House party here too, there are still players who want the UN Secretary General to Kofi off into the sunset.

Colin Powell, the most Kofi-loving member of the American team, comes downstairs at 8.30 a.m. He walks past the *Jamaica Fruits* breakfast room, where the Prime Minister is said to be 'still showing due appreciation of the President's humour', and down to meet Jack Straw.

Powell is the only top American here who is seen carrying newspapers. He has a large pile of them in his hand, and a copy of his autobiography. He also has a warm brown coat.

A few junior aides suggest a tour to what they have been told is 'the world's biggest rhododendron tree'. First they have to find it.

When the President leaves his table of melon and jam he is with Andrew Card, the man who is ready, as ever, to whisper in his ear. Tony Blair follows down the staircase with Condoleezza Rice. The National Security Adviser is dressed in a bright yellow wool jacket with black piping, and has to parry some rapid Prime Ministerial shots as the two walk together past the royal shields.

The fog has lifted. There is a cold spring light on the cedars.

'The sun is shining in Ulster,' says the President as he takes his seat in Lady Grey's Chamber.

'That's very rare,' says the Prime Minister.

'Right, let's get on with it,' says George Bush, and with his glasses down on the tip of his nose, calls the Intelligence Briefing to order. Only the innermost group from both sides hears the latest reports from Iraq. A message is sent out to Cent Com, the American military headquarters in the Gulf, with a request for clarification of a point on the restaurant attack.

The President mocks the idea that his enemy might have been having dinner in even a fortified public place. He recalls the war days of 1991, when Saddam Hussein was being driven erratically around his domain in a taxi. That's more likely what's happening now, he thinks.

Outside, the talk has turned to Irish matters. The team is still

confident that the President can put personal pressure on all sides, especially on Gerry Adams and Martin McGuinness, whose organisations get so much of their money from the US. The question is, 'How strongly will George Bush make the link between the cautious, difficult but still successful peace process here, and the tactics required for the Middle East and beyond?'

The answer, for many observers, is that the Irish part of the proceedings here is a deception. George Bush is in Hillsborough Castle, they say, simply because it is the place that the British are best used to defending from violent demonstrators.

Outside the gates there are women dressed as Iraqi corpses, though, as predicted, not a large number of them. There are also roadblocks, checkpoints, hundreds of uniformed police and giant bulldozers, yellow pieces of construction plant that will both clear a road and give cover for fire.

Certainly, it would have been harder to secure a visit by an unpopular President on the British mainland. But that does not make the hopes of Northern Irish progress unreal. Both George Bush and Tony Blair have huge belief in their individual powers of persuasion. If their will is clearly seen – especially if the President's will is seen – even the hardest men of Ulster may take note.

The Lady Grey door opens again. The President himself puts his head out and calls to a man with a soft black briefcase who is standing by the entrance to the garden. 'Blake, have you got a cheque?'

The case is opened and the Presidential chequebook is waved at its owner.

'He must have lost a bet,' says another adviser waiting beneath a pastel Duke of Edinburgh.

There is an immediate conversation about what the President may have betted on against his British hosts. Was it the time needed to find Saddam's taxi, the world record for the marathon or the

number of steps that can be taken past the yew trees before finding an American soldier?

Tony Blair's first words when he leaves the meeting suggest the last of these options. 'We're going for a walk,' he says, 'and can we have a walk-walk?' He makes mildly menacing gestures to everyone in the vicinity. He means a walk without the help of camouflage vehicles. 'I've never been so protected in my...' he mutters, his words fading in frustration.

Both men again decline coats. The sun has now risen higher above the trees; there is a blackbird's sharp song and a scatter of glittering daffodils, but it is not a warm spring day.

As they set off around the sundial and along the yew-lined path, Tony Blair adopts a brisk officer's gait, his arms swinging down slightly away from his body. The President is immediately expansive, making wide, flamboyant gestures which his aides study with care. After a few minutes both men are out of sight.

Aides to world leaders, particularly aides to Presidents of the United States, do not like their bosses being in places not quite known to them. Guesses can be made of 'the two principals' location' only from the direction of the rotating surveillance camera that has been installed by the gutters above the bedrooms – and by the anticipatory movements of soldiers behind hedges, around the castle's pilastered folly and in the higher trees.

After ten minutes of leaderless standing in the sun, the would-be followers find a point of vantage. George Bush is moving his arms vigorously by the right-hand side of a wrought-iron gate into what is called, in large flowing metal letters, The Granville Garden. Tony Blair, hands in pockets, is on the left-hand side. Behind them is the massive soon-to-be-pink bulk of Europe's biggest rhododendron; someone on the staff has admitted to those seeking 'the world's biggest' that this is a claim too far, and that a bigger one exists somewhere in Japan.

At first the President seems to be taking the lead – and on a grand scale, pointing from place to place as though making giant leaps of thought. When Tony Blair speaks he makes fewer gestures, only occasionally countering a global sweep with the outline of a set of steps. No one knows exactly what this means. Everyone has a shrewd idea.

The Americans think that the Europeans fail to see the extent of the whole world's changes. The Europeans agree that the Americans have a world view – of an almost wholly American world.

Tony Blair knows that the President tends to impatience. He knows that the French and Germans tend to indolence and self-deception. He thinks that he can show the President a step-by-step route ahead. He thinks that he can show the Europeans an end to the journey that is in the interests of all.

This is a businesslike discussion, not a friendly chat. There is never less than half a gate's length between them, either a 'Granville', written in languid italic, or a 'Garden' in the same iron script. The President at one point does a stretching exercise for his thighs, as though in a gym or on one of those power walks, with a posted fitness routine for every stop, which the Washington Parks planners deploy in such profusion back home.

In the castle Throne Room, American officials are giving the last checks to their press conference set. The green velvet from Camp David, which survived the trip to the Azores, is in service again. It seems just what Lady Granville, the Queen Mother's garden-loving sister, would have chosen. The military royals around the walls might have approved of the show too.

Why do the men from the White House have to bring their own backdrop so that a British Prime Minister can introduce his American guest in the Queen's castle? Who knows? All the Stars and Stripes are perfectly pressed.

While the two men are waiting to go onstage the President's commitment to the wording on which everyone has worked so hard seems slightly in doubt. He is handed the communiqué and gives a plain Texan reply to what must seem a tiresome European dance. 'There'll be plenty more communiqués before this thing is all over,' he says, 'and no one is going to remember any of them.'

That is doubtless true, the diplomats concede. But the words, and how the words are said, do matter here and now.

When the press conference is over there is a throng in the Garden Room. Aides and officials are already arriving for the 'Northern Irish dimension' to the day.

The British team is delighted with what Bush has said and how he has said it – on the UN, on Ireland and on the Middle East.

'You were brilliant,' says Jack Straw to the President.

'Vital role, vital role, vital role,' says a voice from the British scrum, as though someone were counting the number of times the phrase was used.

Tony Blair is nodding.

'You were brilliant too, Prime Minister,' says Straw with a smile.

Tony Blair gives his Foreign Secretary one of the now familiar 'looks'. 'Great press conference,' he adds himself as the President turns to talk to his National Security Adviser.

Condoleezza Rice does not look so happy. Someone behind her genuinely has been counting. 'Vital role. Fine. But did he need to say it eight times?'

Rice begins gently to suggest to her boss that some of their colleagues back in Washington might not be best pleased. When she becomes more vigorous, the President leads her away from the crowd towards the garden, where he can be ear-whacked more discreetly. He looks at first concerned, then a bit frosty.

They leave to go upstairs before lunch. The Irish Prime Minister, Bertie Ahern, is about to arrive.

Rice is still making her point when the President dashes into a room and comes back with a box in gold foil wrapping. He gives it to the British 'advance' official for this trip and for the Azores, who is leaving her post to take up a quieter life.

After the commemorative snapshots, Rice continues her commentary on the excess vitality of the press conference. 'Ease it, Condie, ease it,' says the President. The dispute ceases.

George Bush spots Tony Blair in the narrow, crowded corridor, ducks back into the room again, sees another pile of gold wrapping and comes out empty-handed. 'We've got to stop this gift business. I've got one here, but I'm not going to give it to you. It's a bowl.'

Tony Blair looks as though there could be no better proof of the 'special relationship' than a President and a Prime Minister not handing each other top-of-the-range porcelain.

The rest of the day tumbles to its end.

The two men discuss the sleeping habits of dogs while waiting for Ahern.

George Bush says to the Irish Prime Minister: 'I hope this is helpful.'

Ahern assures him that it most certainly is.

While the three men have lunch, not a drop of the white wine in white-linen sleeves is drunk. It can be used, the team is told, when Princess Anne comes for dinner this evening.

The human chess pieces arrive, stand in a horse-shoe shape, and are severally and individually lectured. With what effect? That will not be clear for some time.

Alastair Campbell shows off his cheque from the President of the United States, not a bet, but a $100 contribution to his marathon appeal.

Her Majesty's Lord Lieutenant, with silver sword and medals, waits for his 'moment in the sun' to wish the President goodbye.

Rice still has a few final problems. Sitting on a bench under a large tapestry of Don Quixote tilting at windmills, she is on her mobile phone to Washington. 'Yes,' she says firmly, 'a vital role for the UN.'

She has Donald Rumsfeld's Department of Defense on her mind, and other people and places not quite so Kofi as the British.

'I just want to make sure that the DoD doesn't say anything wrong about this. Yes, it's important that we all use the same language.'

Wednesday, 9 April

*Morning headlines…summit promises 'vital role' for UN…US
'decapitation' raid on Saddam Hussein…three journalists killed
by US fire…Brown to deliver Budget cash for Iraq…*

Two Number Ten policemen look suspiciously at the Chancellor of
the Exchequer's aides as they pass through the front hall on their
way to hear their master's Budget speech to Parliament.

'They look bloody glum,' says one.

'That means we're going to be glum too,' says the other.

The Downing Street cuckoo clock is set differently for this
annual ritual of raising taxes on cigarettes and drink (what most
people care about) and signalling whether Britain is any nearer to
adopting the euro instead of the pound (what brings anxiety
to everyone here). This is the day for the Number Eleven entrance.

Gordon Brown is blocking his door even now by being pho-
tographed with the traditional Budget box held high. This is not
a quick process. Many unnatural poses have to be held. So his
advisers leave through the entrance to the house they would like
to have.

They do look glum. This is not because they plan to punish
hard-working policemen. On this one day of the year when the TV
and newspapers would normally highlight the virtues of their
man, his imagination and prudence, his sense of values, his strug-
gle to stop the Prime Minister giving up the pound, no one is

noticing their efforts much at all. All eyes are on the pictures from Baghdad, where the symbols of Saddam Hussein's regime are collapsing before excited crowds. 'There are bigger things than ours happening today,' says one of the Treasury men with less than the usual Treasury swagger.

In the Campbell zone the Budget papers sit unread in a fat unopened envelope. No one here is taking the opportunity of pre-viewing the level of stamp duty on house sales. There is more interest in the President's message to the chessmen yesterday. He was as good as they could have hoped for. He told them that Northern Ireland was going to be a beacon of hope for the world, a proof that patient reconciliation worked.

What is still not clear is whether the IRA wants to be a beacon. It seems to be easier to get them to stop bombing and allow normal politics than to get them to give up their gangland control of drugs, extortion and cigarettes on which no tax, at yesterday's levels or today's, is ever paid. Jonathan Powell is still in Belfast negotiating an end to a war which has not quite ended yet.

Pat MacFadden passes through the Press Office and stands beside Leo's plastic pedal car at the bottom of the stairs to the flat. He is, as ever, anxious. Today he is anxious about the local elections next month, particularly in Scotland. The Labour First Minister Jack McConnell needs a few calls. He needs a visit from the Prime Minister. He needs a lot of other support too. Party members who hated the war are not helping the party.

'Even worse,' MacFadden says, looking as drained as at any time since the Iraq debate, 'Billy McNeil is standing against Labour.'

The Press Office is not sufficiently impressed by this obviously high new level of Scottish treachery. Who is Billy McNeil? There is a suspicion that he must be a footballer. Any unknown name

mentioned in these halls in these past weeks has always been either a Chilean or a footballer.

'Billy McNeil led Celtic when we won the European Cup, and he's always come out for Labour at election time. Now he's standing for the Higher Pensions Party, one of Jack Jones's people.'

MacFadden looks menacingly at the blocked door to Number Eleven.

'I don't think we'll bother Gordon with that now,' says a voice from behind.

The team is worried that the victory celebrations in Iraq have come too early. All that the CDS told the War Cabinet this morning was that Baghdad was under greater control than yesterday. He was not whooping up Whitehall throwing his hat in the air.

Would he ever do that? There have already been a few words about how, when it is all over, Britain will celebrate victory. Sir Michael Boyce does not seem to think there will ever be much to march down the street about.

Tony Blair leaves for the House of Commons to hear the Budget by his Chancellor's side. The Number Eleven team thinks it would be a good symbol of unity if the two men entered the Chamber together. Sally Morgan agrees.

Alastair Campbell, fortified by his $100 cheque from George Bush, is finishing his marathon preparation. His dark office walls have been hung for a month with wet socks and shirts that are beginning to have the permanence of election trophies.

A marathon runner can either stretch out confidently at his own pace or he can 'slipstream', choose other runners and fall in behind them, watching nothing but the beat of their feet. That is not so unlike the choices facing a Prime Minister. Is Tony Blair going to come out of this war tired and willing to 'slipstream' for a while? Or will he want to stretch out straight away for the next thing? And will that next thing be a referendum on joining the euro?

Campbell is not sure. On the day of the Chirac veto, when the news from the 'irresponsible' French came between the slow-handclappers of ITV and the party for the slow-learners' teachers, he thought the euro question was over – at least for a while. Did we want the French President to have more levers on our money too? But then the question suddenly became as muddied as ever. Now that Tony Blair had proved himself Washington's staunchest British ally since Margaret Thatcher, could he next make himself Europe's best friend since Edward Heath? Sometimes he seemed to want to do just that.

While Campbell gets ready to swing his attention between everyone's political future and the heels of the man running in front, the knights of the diplomatic zone are trying to ensure that the UN keeps its 'vital role' in post-war Iraq. Condoleezza Rice, it seems, did a good job of calming the critics, and so far everything is 'fine'.

Sir David Manning will soon be occupying the Ambassador's residence in Washington. He will have the job of keeping the wartime partnership secure for the next time it is needed.

The Prime Minister and the President have made a strong start together. They have surprised both their enemies and their friends. They have removed a vicious and dangerous dictator. That much is sure. They will probably do so again if they find the same common purpose. But no one can be sure of that.

Manning and his colleagues behind the combination lock have the diplomatic memory. They know how easily and how often Prime Ministers can deceive themselves, and be deceived, at the White House. They know why Winston Churchill claimed his 'perfect understanding' with Roosevelt: he wanted to believe it. They know that Harold Macmillan was a genuine influence on Kennedy, but much exaggerated his part in the Cuban missile crisis: he too badly wanted to think he made a difference. They remember

directly how Margaret Thatcher was often able to influence Ronald Reagan. But she and he were both as ideologically sympathetic as Tony Blair and Bill Clinton, and as temperamentally stubborn as Tony Blair and George Bush. That was the powerful and lasting formula.

Yet this relationship may turn out to be just as durable. George Bush is not a forgiving and forgetting man. Tony Blair has noted closely who his friends are too – at home and abroad. He has never been further from his old Labour Party roots – and has never cared less about being so.

Was what they did the right thing? Tony Blair has asked for the judgement of history on that. He will get it. Since he is only fifty, he will probably get even history's fourth or fifth drafts while he is still alive. When the balance of good and bad outcomes can be properly seen, when all the participants have spoken, he will get his judgement.

The Prime Minister has now returned from Westminster. He is chatting in the hall. The fruit delivery has arrived.

A hollow metal statue of Saddam Hussein is being hauled down from the centre of a square in Baghdad. Iraqis are giving raucous applause and rapturous welcomes to the allied troops. A US soldier who tries to pin a Stars and Stripes to the dictator's head is rapidly shown the error of his ways and an Iraqi flag is found to take its place.

'It's not exactly Trafalgar Square,' says the shorter of the Duty Spokesmen standing at the bottom of the Alphabet stairs. 'It's hardly in the city centre; more like Camberwell.'

'It's just one statue,' says Tony Blair. 'I don't know what all the fuss is about.' The television producers, once blamed for exaggerating disaster and dissent, are now blamed for declaring victory in Iraq too soon.

Yet this is VI day, whether the intelligence chiefs, the Generals, the diplomats and the Prime Minister like it or not.

The TV images are already moving on, past the Budget, which attracted light attention for a few hours, to Basra and Kirkuk, where the best way to get a new leather armchair or an empty intensive-care bed is to take a machine gun to the nearest hospital.

Surely it must be time to plan a victory celebration, whether the stiff-hats want one or not?

Sally Morgan is examining the bits of political wreckage that might still spoil the show.

There are the activists who marched against the war and feel just as unforgiving at its end as does the American President.

There are the voters whose higher taxes are not improving the Health Service.

There is a parliamentary party that has learnt to love rebellion.

There is Robin Cook at loose on the backbenches.

There are neglected problems in English schools, in Scottish politics, and doubtless in Scottish football.

There are rising politicians of the far right in the towns where the War Cabinet watch their favourite teams.

There are asylum-seekers, flowing ill-controlled into Labour constituencies.

There is Clare Short, who will be free on the backbenches soon.

This was not a popular war, not even when it was won. Anger remains, as well as pride. Voters sometimes favour the victorious. Often they do not.

The judgement of history is beyond Tony Blair's control. But whether he wants again to be judged by the electorate is wholly his choice. Probably he will want to be acclaimed for a third time. But he has changed in the past thirty days. He will have to give serious thought soon to how much his voters have changed with him.

Acknowledgements

Thanks to Gill Morgan of *The Times Magazine* for the invitation, Nick Danziger for good company, Hilary Coffman and Gavin Mackay for help on the road, Ed Victor, Maureen Allen of *The Times Literary Supplement*, and to Sally Emerson without whom nothing.

Index